Conten[...]

Introduction

Throughout the latter part of the twentieth century there was a growing awareness of the importance of conserving the world's natural resources for future generations. The 'throwaway' society of today is increasingly being urged to recycle everyday waste materials such as paper, card, rags, glass, tin, aluminium and plastics.

The *aim* of this book is to show how domestic waste materials can be reused and made into creative and very cost-effective artwork, attractive gifts and useful craft objects. The ideas are grouped into sections according to the main type of waste material used in the activity, although some activities will use more than one kind of waste.

The creative use of many of these waste materials can be directly related to folk art, history and the work of well known artists. For example, the mosaic activities, both paper and ceramic, can be related to Greek, Roman or Aztec cultures and also to the work of the architect and artist Anton Gaudi. The water lilies made from the bottoms of plastic drinks bottles would tie in beautifully with a study of Monet's paintings. The dried flower arrangements in glass jars were inspired by nineteenth-century exhibits in the local museum, as were the découpage activities.

The book offers activities for the individual, small groups, class activities and even whole school projects for special occasions such as anniversaries. The activities can also be modified to suit most age groups. There are also endless possibilities for varying the ideas.

A few weeks before the beginning of a project encourage the children to start collecting the relevant waste materials and sort them according to type. It is useful to sort fabrics, wools and plastic bags according to colour and store them in clear plastic containers for easy identification. Beads and buttons also look attractive stored in clear plastic jars.

It is hoped that whilst developing the ideas presented in this book, the children's imaginations will be stimulated and their skills extended. However, the most important aspect will be the opportunity for the children to be creative and have fun. I hope, too, that this book will inspire you to take a fresh look at your old rubbish!

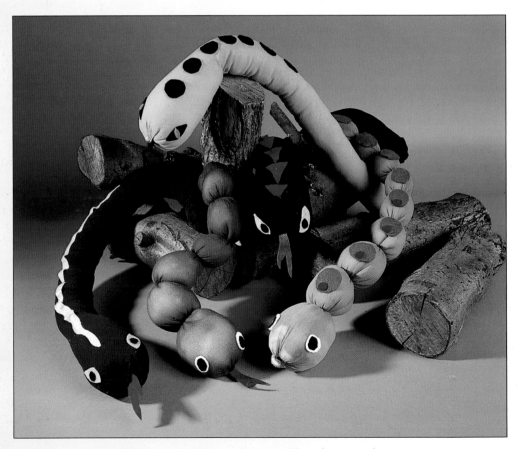

Snakes and Caterpillars (page 50)

art of recycling

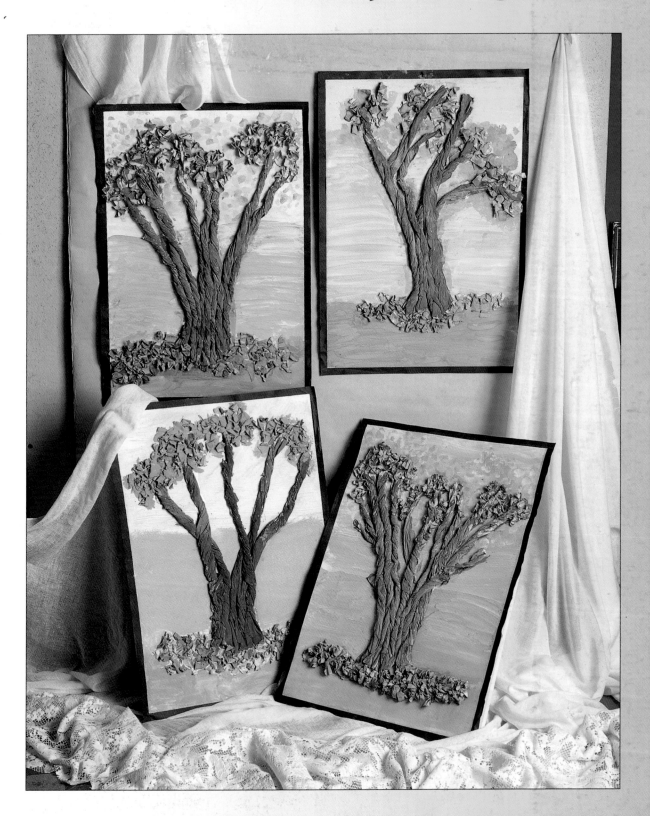

Hilary Ansell

Acknowledgements

I would like to thank the many children from Kingfisher Primary School, whose work has been photographed for this book. A big thank you also to the staff at Kingfisher for all their support and ideas.

I would like to thank the parents, children and staff of Edlington Family Centre for the loan of the Flower Hanging (page 60) and Copley Junior School for the loan of the School Pond (page 57).

Thank you also to my family for their great patience and support despite the mounting piles of rubbish!

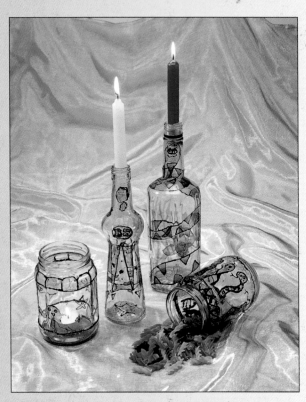

Painted Glass Jars and Bottles (page 38)

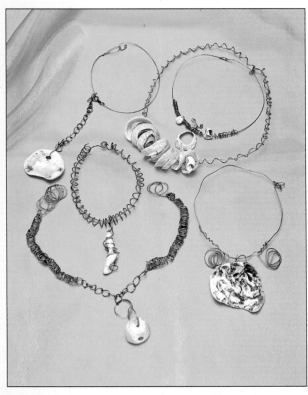

Wire Jewellery (page 68)

First published in 2000 by Belair Publications.
Apex Business Centre, Boscombe Road, Dunstable, LU5 4RL.

Belair publications are protected by international copyright laws. All rights reserved.
The copyright of all materials in this publication, except where otherwise stated, remains the property of the publisher and author. No part of this publication may be reproduced, stored in a retrieval system, or transmitted, in any form or by any means, for whatever purpose, without the written permission of Belair Publications.

Hilary Ansell hereby asserts her moral right to be identified as the author of this work in accordance with the Copyright, Designs and Patents Act 1988.

Editor: Elizabeth Miles/Nina Randall
Photography: Kelvin Freeman
Line drawings: Sara Silcock (Linda Rogers Associates)

Page Layout: Suzanne Ward
Cover Design: Martin Cross

© 2000 Folens on behalf of the author.
Revised edition published 2005.

Every effort has been made to trace the copyright holders of material used in this publication. If any copyright holder has been overlooked, we should be pleased to make the necessary arrangements.

British Library Cataloguing in Publication Data. A catalogue record for this publication is available from the British Library.

ISBN 0 94788 235 9

Handmade Paper

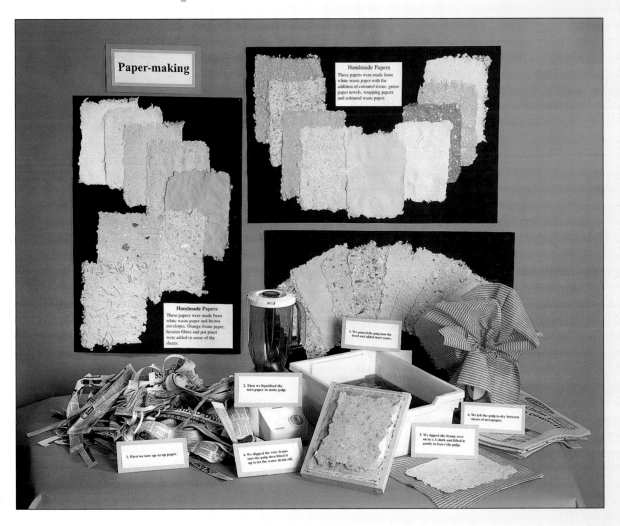

Approach

⚠️ **An adult should operate the liquidiser.**

1. Tear black-and-white newsprint into small pieces, place them in a liquidiser and fill the liquidiser with water. Liquidise for about 15 seconds until the pulp looks like grey porridge.

2. Pour the pulp into the plastic container and add a jug of water.

3. Repeat this process until you have enough pulp, remembering that the thicker the pulp the thicker the paper will be.

4. Spread a wad of newspaper on the table beside the container. Place an all-purpose cloth on top.

5. Keeping the paper-making frame horizontal with the mesh side uppermost, dip the frame into the pulp and pull it out again, draining off the excess water.

6. Tip the pulp onto half of the all-purpose cloth. Fold over the other end of the cloth to cover the pulp. Quickly sponge up any excess water.

7. Place a newspaper on top and repeat the process to build up a pile of handmade paper and newspaper. When the newspaper has soaked up the water from the sheets of pulp, the all-purpose cloths containing the pulp can be separated from the newspaper and spread out to dry. When dry, peel the sheets of handmade paper from the cloths.

Resources
- Newspapers
- Liquidiser
- Large plastic container or storage box
- All-purpose cleaning cloths
- Paper-making frame (see page 6 for instructions on how to make your own frame)
- Sponge

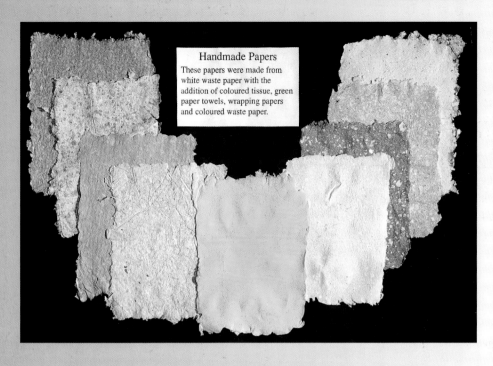

Handmade Papers
These papers were made from white waste paper with the addition of coloured tissue, green paper towels, wrapping papers and coloured waste paper.

Variations

- Add coarsely liquidised coloured pages from comics or newspaper colour supplements to the grey pulp.
- Add torn up sweet wrappers, scraps of coloured tissue or waste display paper.
- Instead of black-and-white newsprint use coloured newspapers. Try mixing varying amounts of each.
- Empty the contents of a hole punch into the pulp.
- Add small fallen leaves, dried grasses or pot-pourri.
- Add short lengths of silk and sewing cottons.

Handmade Paper Using White Waste Paper

Gather together any white waste paper, for example the contents of a waste-paper basket, computer waste and discarded drawing and writing paper. Any writing, colouring or printing does not matter as it will add only a tinge of colour to the paper. Then proceed, using the same method as for Handmade Paper (page 5).

Variations

- To make fawn- or beige-coloured papers, add a used brown envelope at the liquidising stage.
- Leaves and grasses look particularly good mixed with the beige pulp.
- Add a small amount of liquidised coloured tissue to the white pulp.
- Save tea bags and add their contents to the white pulp. Experiment with the ratio of pulp to tea. Alternatively, dab dried sheets of paper with a wet tea bag to stain them brown.

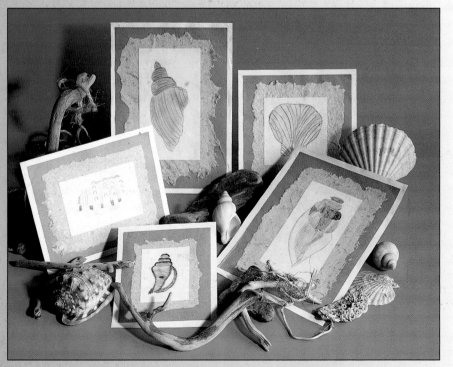

Handmade Paper Mounts

Mount observational drawings of natural objects on handmade and brown wrapping papers.

Paper-Making Frames

To make your own paper-making frame cut four pieces of wood to the required size for the frame. Nail or screw the lengths together. Staple aluminium reinforcing mesh (as used in car repairs) to the frame. This should hold the frame rigid. Alternatively, use nylon ballet net but make sure the net is stretched very tightly as it will give when wet.

Mounted Treasures

All children love collecting things. A school visit, a walk in the park or a trip to the woods or seaside provide ample opportunities to collect a myriad of little treasures. Such found objects look most attractive when mounted on handmade paper and used to make unusual cards or pictures.

Resources
- Variety of beige speckled handmade paper
- Scraps of natural hessian (burlap)
- Brown wrapping paper
- White card
- Glue stick and PVA glue

Approach

1. Tear off a piece of handmade paper slightly smaller than the prepared white card.

2. Cut a piece of hessian smaller than this and fringe it around the edges. Glue the hessian to the handmade paper. Glue both of these onto the white card.

3. Glue the chosen object onto the hessian with PVA glue.

4. Experiment with different combinations of mounts.

Other Treasures

Not all treasures are natural found objects. They could be beads from a broken necklace, the buttons from a favourite garment, a scrap of fabric or lace, a badge or bottle top. They can be whatever the children treasure for whatever reason.

Framed Treasures

Some of the larger found objects will look most attractive mounted in natural frames. Glue the white card on which your treasure has been mounted onto a piece of brown carton card. The brown card must be slightly larger than the white card. Cut or break some cane, dowel or twigs to fit around the card with overlapping ends. Glue the ends together and, if using twigs, wind string around the joins when the glue is dry. Glue the frame in position and tie string to the top of the frame for hanging.

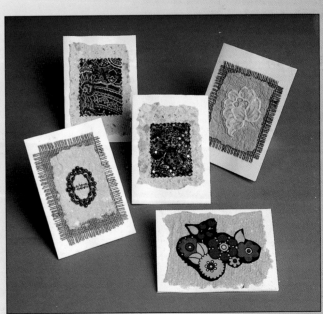

Button and Bead Cards

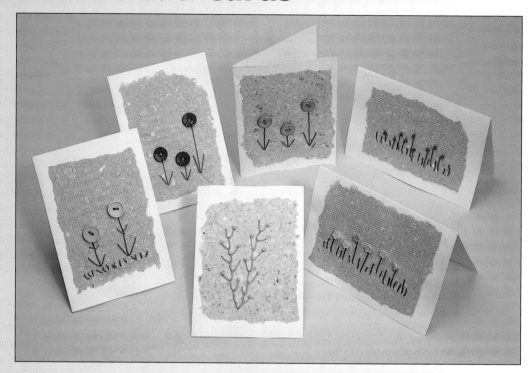

Resources
- Variety of handmade paper
- Buttons and beads (from broken necklaces)
- Cotton thread and needle
- White card
- Glue stick or PVA glue

Approach

1. Sew two or three buttons or several beads onto a piece of handmade paper.

2. Use a simple straight stitch to sew the stems and leaves of the flowers. Add smaller stitches between the stems for grass.

3. Glue the paper to the white card.

Recycled Greetings Cards

This is an excellent way of reusing favourite greetings cards.

Resources
- Variety of handmade papers
- Assortment of greetings cards
- White card
- Glue stick or PVA glue

Approach

1. Choose a simple motif and cut or tear it out carefully. To blend the edges of the motif into the handmade paper it is better to tear the motif from the greetings card.

2. Tear a piece of handmade paper slightly larger than the motif.

3. Use a glue stick to fix the motif centrally onto the paper.

4. Glue the paper to the card and trim to size if necessary.

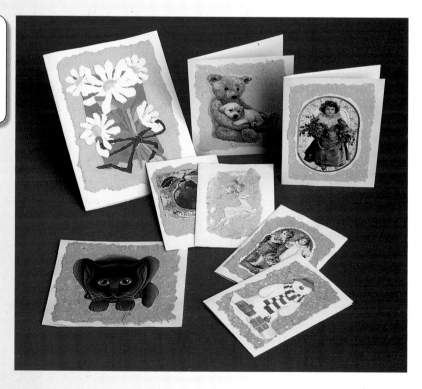

Cast Paper Bowls

Resources
- Paper-making materials (see page 5)
- Small plastic bowl or basin
- Cling film

Approach

1. Make the paper pulp as described on page 5. Make sure the pulp is thick.

2. Cover an upturned bowl or basin with cling film to prevent the pulp from sticking to the bowl.

3. Spread a wad of newspaper on the table beside the container of pulp. On this place an all-purpose cloth.

4. Dip the frame into the pulp, lift out and drain the excess water. Tip the pulp onto the cloth. Lift off the frame.

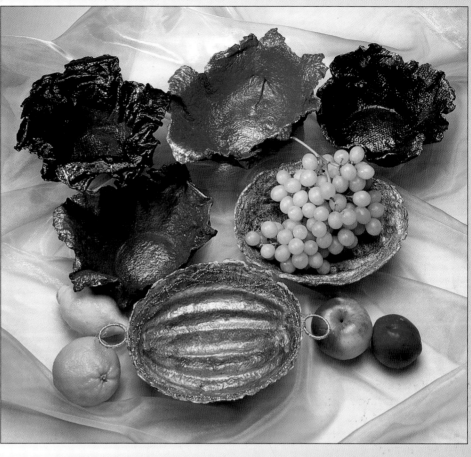

5. Press the layer of pulp with the sponge to absorb as much water as possible.

6. Pick up the all-purpose cloth by two corners with the pulp still sticking to it. Flop it, pulp-side down, over the cling-film-covered bowl. Starting at one corner very carefully peel the cloth off the pulp. Gently pat the pulp around the shape of the bowl or leave it standing away from the bowl.

7. Leave the paper pulp bowl to air dry on the plastic bowl.

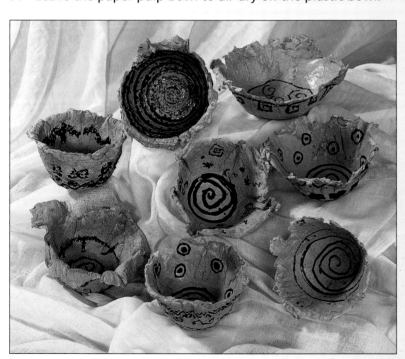

Decorating the Bowls

1. If the bowls are to be painted they need to be sealed. Once the paper bowl is absolutely dry brush the outside with a coat of PVA glue. When this is dry take the paper bowl off the plastic bowl and paint the inside with PVA.

2. Once sealed, the bowls could be painted with household white matt emulsion. This gives a good base for further painting.

Variations

- Mix PVA glue with powder or ready-mixed paint and paint the bowl with this.
- Torn or faded coloured papers from display boards can be used to make ready-coloured bowls that will need the minimum of decorating. These bowls need not be sealed.

Papier Mâché Balloon Vases

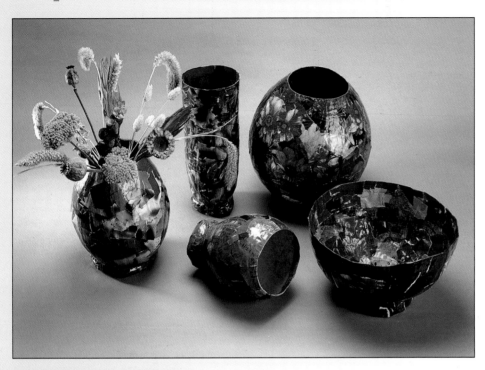

Approach

1. With a marker pen draw a line around the narrow end of an inflated balloon to mark the neck of the vase.

2. Tear newspaper colour supplements into small pieces.

3. Smear the balloon with petroleum jelly or washing-up liquid to prevent the balloon from sticking to the finished vase. Next, paste the scraps of paper with cellulose adhesive (coloured side down) to the balloon.

4. Add two further layers of newspaper. If time allows it is best to leave the paste to dry between layers.

5. Now twist a sheet of newspaper into a rope and join with masking tape to make a ring large enough to fit around the base. If the vase is dry use masking tape to fix it in place, otherwise paste it in place with strips of newspaper.

6. Apply two more layers of newspaper, making sure that the base is well covered.

7. Add a final layer of colour supplement paper. Leave to dry thoroughly.

8. Burst and remove the balloon. Seal the vase with a coat of PVA glue or clear varnish.

Variations

- Use coloured tissue for the final layer.
- Use newspaper for the final layer, then paint with white emulsion. Decorate with painted patterns or pictures.
- To make handles: After stage 5 twist up another sheet of newspaper and tape it to the side of the vase when the vase is dry. Trim and tape the ends down. Continue with stages 6, 7 and 8.
- To make a jug: After stage 5 cut a triangle of thin card. Fold the triangle in half. Using masking tape secure the card to the vase, opposite the handle. Trim away the side of the vase inside the spout. Continue with stages 6, 7 and 8.
- To make a trophy shaped vase turn the balloon the other way up so the narrow end is the base.

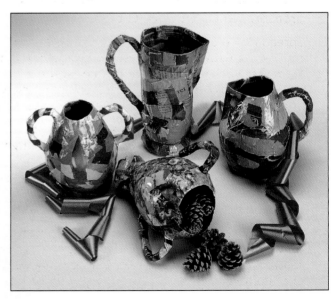

Papier Mâché Elephants

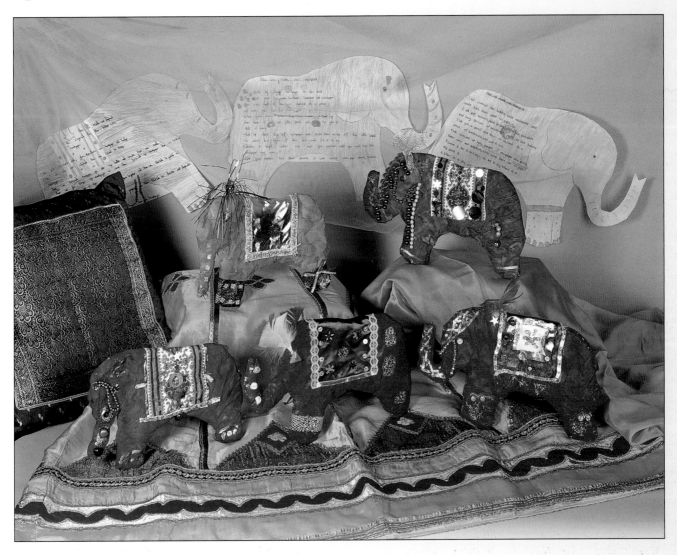

Approach

1. Draw an elephant on thick card. Younger children will probably need a template. Cut it out.

2. Spread PVA glue on a small area of the elephant. Tear off pieces of newspaper and scrunch up fairly tightly. Press these onto the glued area. Repeat this process until the whole of the card is covered. If necessary add another layer so that the elephant is well padded.

3. Tear strips of newspaper and paste these over the screwed up paper using cellulose paste or diluted PVA. Take the ends of the paper strips over the edges of the elephant and paste to the reverse side of the card. Paste several layers of newspaper strips. Leave to dry thoroughly.

4. Paint with white matt emulsion as a base coat (optional). Paint as desired and decorate with scraps of fabrics such as velvets and silks. Stick on sequins, beads and braid.

Resources
- Thick card, for example grocery carton card
- PVA glue
- Newspapers
- Cellulose paste
- White matt emulsion
- Scraps of fabric, braid, sequins or beads

Variations

This method can be used to create any animal. Simply draw the shape and proceed as above. Use wool to add manes and tails or to create a fleecy coat, or add paper scales to make a reptile.

Paper Pulp

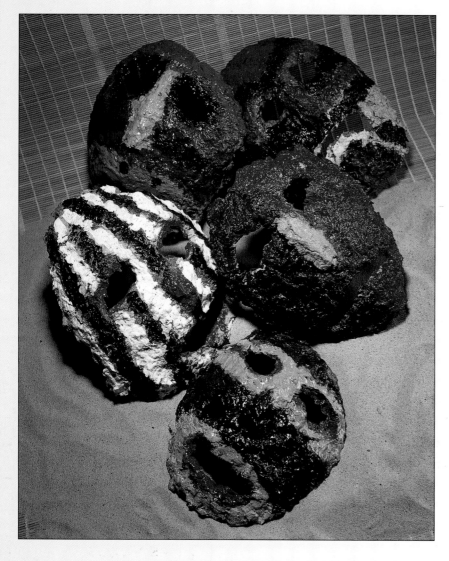

The pulped method of papier mâché is very good for modelling and sculpting and gives a coarser texture than the layered method.

Resources
- Newspapers (broadsheets are stronger than tabloids)
- Bucket for soaking the paper
- Sieve
- PVA glue
- Bowl and metal spoon (the newspaper ink will stain a wooden spoon)

Approach

1. Tear sheets of newspaper into small pieces, just cover with water and preferably leave to soak overnight, although this is not essential.

2. Squeeze and work the wet paper with your hands until it starts to disintegrate into a pulp.

3. Pour the pulp into a sieve and drain and squeeze out as much water as possible.

4. Put the squeezed-out pulp into a bowl and mix with PVA glue until the mixture binds together.

Note: Paper pulp activities are best done in small groups because of the large quantities of pulp needed.

Paper Pulp Masks

Approach

1. Draw a face shape onto an inflated balloon, making sure that the eyes are not too far apart.

2. Balance the balloon horizontally on top of a container and tape it down. The pulp is heavy so the balloon will topple over if not balanced correctly.

3. Smear the balloon with petroleum jelly to prevent the pulp from sticking to it.

4. Apply the pulp a little at a time starting around the eyes and along the nose area. Gradually work it out towards the sides of the face.

5. Add more pulp to build up the nose, forehead, cheeks and chin. Leave to dry for at least a week.

6. Paint and decorate as desired.

Resources
- Paper pulp
- Round balloon
- Petroleum jelly
- Container on which to balance the balloon
- Masking tape
- Felt-tipped pens

Paper Pulp Beads

Resources
- Paper pulp
- Narrow plastic drinking straws or cotton buds
- Petroleum jelly
- White matt emulsion
- PVA glue or clear varnish

Approach

1. Smear petroleum jelly around a straw; if using cotton buds snip off the bud and then smear the stick.

2. Using a little of the pulp, form a bead-shape around the straw. You will be able to shape several around one straw. Try making round, oval and cylindrical beads of different sizes. Leave to dry for a week.

3. Paint the beads with white emulsion while still on the straw. This gives a good base for further painting.

4. Paint in bright colours as desired. Leave to dry.

5. Coat with PVA glue or clear varnish. Several coats of clear varnish give a good finish.

6. Ease the beads off the straw and thread to make necklaces and bracelets.

Paper Pulp Wall Plaques

Approach

Resources
- Paper pulp
- Newspapers
- Plate
- Petroleum jelly
- White matt emulsion
- PVA glue or clear varnish

1. Smear a plate with petroleum jelly. Tear some strips of newspaper, dip them in water and cover the plate. This will stop the pulp from sticking to the plate.

2. Press the pulp evenly onto the plate to the depth of about a centimetre. Add a loop of string at the top of the plate, burying the ends well in the pulp. A relief pattern can be built up at this stage or the pulp can be left smooth. Leave to dry in a warm place for about five days.

3. Ease the paper pulp from the plate. Use diluted PVA glue to apply a top layer of small pieces of newspaper. Leave to dry.

4. Apply one or two coats of white matt emulsion as a base for painting. When dry, paint on a pattern or picture. When the plate is thoroughly dry varnish well.

Paper People

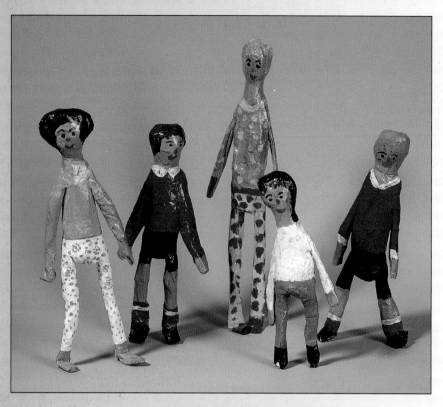

Resources
- Newspapers
- Thin knitting needle or long-handled paintbrush
- Masking tape
- Cellulose paste
- White matt emulsion

Approach

1. Using a long-handled paintbrush or knitting needle to get started, tightly roll a double sheet of newspaper and twist into a 'rope'. Fold it up until you have a sausage shape about 20 centimetres long. Secure the ends with masking tape.

2. Squeeze the sausage shape about a quarter of the way down and bind with tape to create a neck.

3. To make the arms and legs, roll up and twist further 'ropes' of paper. Cut to the required size and tape them to the trunk. Bend up the ends to make the feet.

4. Cover the figure with strips of pasted newspaper. Pad the head with screwed up pieces of paper held down with strips. Wind longer strips around the arms and legs. Leave the figure to dry for a few days.

5. Coat with white matt emulsion to give a good base for painting. When dry, draw the neckline, cuffs and waistline of the clothes. Paint as desired.

Paper Animals

Approach

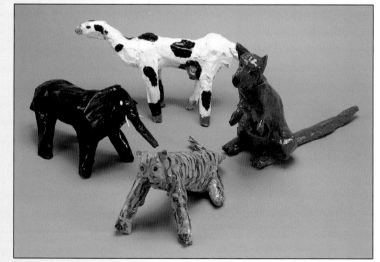

1. Roll up a double sheet of newspaper and twist it into a 'rope'. Fold it up into a flat sausage shape, leaving one end of the 'rope' sticking out for a neck. Secure with masking tape. If the neck piece is long enough, curl the end under and tape it to form the head, otherwise tape a piece of screwed-up paper onto the end of the neck piece.

2. For the legs of the animal, twist up another sheet of paper, cut to the required size and tape in place over the body piece. Make sure that the animal will stand up. Trim as necessary.

3. Paste layers of paper around the form to give a fuller shape and smoother outline. Leave to air dry.

4. Paint with white matt emulsion to give a good base for further painting.

Resources
- Newspapers
- Thin knitting needle or long-handled paintbrush
- Masking tape
- Cellulose paste
- White matt emulsion

Textured Trees

If possible, take the children out to look closely at and feel the textures of tree bark. If this is not possible, show them photographs and illustrations of trees and highly textured barks. Generate a discussion as to how these textures might be recreated on paper.

Resources
- Strong paper or thin card
- Paints
- Newspapers
- PVA glue
- Wood shavings (optional)
- Coloured paper, tissue, magazine pages
- Sawdust or sand (optional)

Approach

1. Roughly sketch the tree on a strong paper or card background. Colour-wash the background of the picture and leave to dry.

2. Twist sheets of newspaper into 'ropes'. Glue several of these side by side to create the tree trunk. Spread out the top ends to create the branches and spread the bottom ends slightly for the base.

3. Tear up small scraps of newspaper. Screw up and glue these around the base of the tree to represent rough grass. Wood shavings could be used instead.

4. Mix appropriate colours and paint the tree and grass, taking care to stipple the paint into all the folds of the paper.

5. The trees can be left bare for a winter scene or seasonal foliage can be added by gluing on scraps of coloured paper, tissue or magazine pages as leaves or blossom.

6. A textured foreground can be created by mixing sawdust or sand with paint and a little PVA glue.

Exploring Tone and Colour

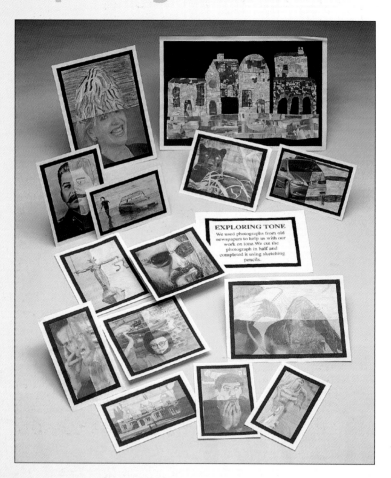

Resources
- Newspapers
- Glue stick
- Black paper
- Black felt-tipped pen

Approach

1. Discuss the kinds of buildings found in a town, talking about features such as size, shape and windows.

2. Draw a townscape using clear bold shapes, or draw individual buildings and assemble them into a townscape.

3. Select different shades of grey print from the newspapers. Cut these into small squares and use them to fill in the shapes of the buildings.

4. When complete, cut around the outline of the town. Mount on black paper for a dramatic effect.

5. If necessary, use a fine, black felt-tipped pen to define the windows, doors or edges of buildings.

Complete This Picture

Resources
- Newspaper, magazines or travel brochures
- White drawing paper
- Glue stick
- Soft leaded sketching or colouring pencils

Approach

1. Cut out a photograph from a newspaper, magazine or travel brochure. (You may wish to have these cut out before the lesson begins.)

2. Fold this in half and cut.

3. Using a glue stick, glue half the picture onto white drawing paper.

4. Using a ruler complete the outline of the photograph on the paper.

5. Complete the picture using the sketching or colouring pencils. Try to match up the shades of grey or colour so that it is difficult to tell where the original picture stops and the drawing begins.

Exploring Colour with Magazines

This idea combines mathematics and artwork. Children can explore tessellating shapes, such as squares, equilateral triangles and hexagons, while working with shades of a particular colour or within a particular range of the colour wheel, for example dark green through to yellow.

If studying the body, they could be asked to search for different hair colours or to fill a sheet with eyes or faces.

Resources
- Card (cartons/cereal boxes)
- Catalogues, magazines, wallpaper oddments
- Glue stick

Approach

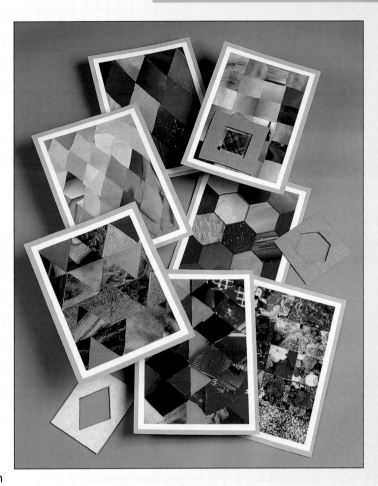

1. Create a template by cutting the desired tessellating shape out of the centre of a piece of card. Use the hole in the card as a window through which to view the motifs you want to cut out.

2. Use the window or template to draw as many shapes as you require.

3. Cut out the shapes and glue them onto paper to make a tessellating pattern.

Celebrity Portraits

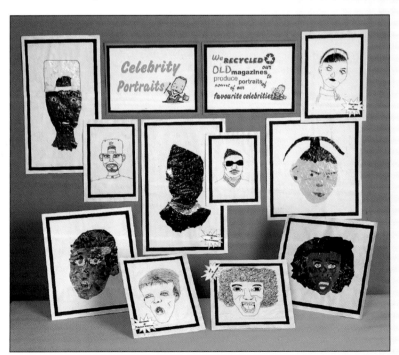

Approach

1. Carefully study the picture of a chosen celebrity and make a pen drawing, noting which areas need to be shaded.

2. Now using a pencil make a large but simple line drawing of the celebrity to be covered with magazine pieces.

3. Tear out a variety of flesh tones from magazines and cut them into small squares.

4. Glue the squares onto the pencil drawing, overlapping the squares to make sure that no white paper shows. Follow the curves of the drawing.

5. Seal the whole picture with a coat of PVA glue.

Resources
- Colour magazines
- White paper
- Handwriting pens
- Glue stick, PVA glue

Découpage Containers

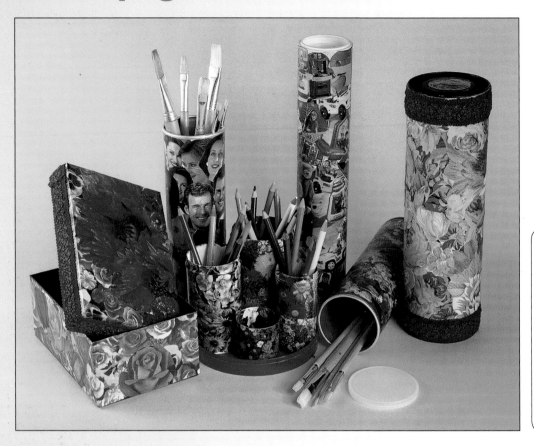

The popular nineteenth-century craft of découpage provides an ideal way of recycling paper, such as old magazines, shopping and seed catalogues, and oddments of wallpaper and wrapping paper. Plastic and card containers can be transformed into pencil or paintbrush cases and boxes for storing treasured items.

Resources
- Magazines, catalogues, wallpaper, wrapping paper
- Tall, cardboard cylindrical container with lid or cardboard box with lid
- PVA glue or clear varnish
- Ribbon or braid

Approach

1. Cut out images of a specific type, such as cars, flowers, toys, clothes or sports personalities.

2. Using an old bristle paintbrush and slightly diluted PVA glue, start to cover the container with the images. Work on a small area at a time. The cut-outs can be wrapped over the top edge of the container but need to be trimmed to fit along the bottom edge. Make sure that none of the original container shows.

3. Finish by painting all the découpage area with PVA glue or clear varnish.

4. Trim with ribbon or braid.

Découpage Desk Tidy

Resources
- Cylindrical card tubes or plastic containers of different sizes
- Large round card, metal or plastic lid in which to sit the above
- Collection of cut-out magazines images
- PVA glue or clear varnish

Approach

1. Stand several cylindrical containers in the large lid. You might need three, four or five containers, depending on their sizes. Try out various arrangements.

2. Cover all the components of the tidy with the cut-out magazine images.

3. Group the containers and glue them together. Leave to dry.

4. Apply glue to the base of the containers and to the inside edge of the lid where the containers touch it. Glue the containers in position. When dry, coat with PVA glue or clear varnish.

Découpage Baubles

Approach

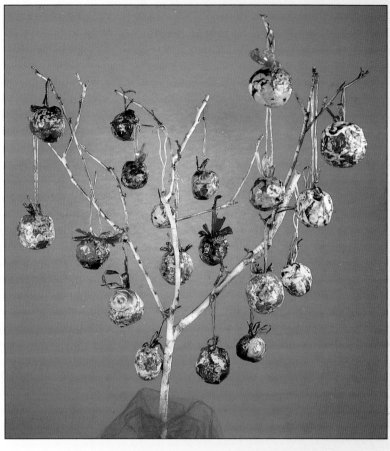

1. Scrunch a double sheet of newspaper into a ball and squeeze tightly. Tear several hand-sized pieces of newspaper and paste them around the ball, squeezing well each time. Try to keep the ball as solid as possible. Using a pencil, make a small hole in the top of the ball in which to glue the hanging thread.

2. Cut out pictures of flowers or other images from magazines and catalogues. Snip around the edges of the pictures so that the cut-outs will fit smoothly around the ball.

3. Paste the cut-outs around the ball, taking care to overlap them so that no newspaper shows.

4. Cut a length of ribbon or raffia for the hanger. Fill the hole at the top of the bauble with PVA glue and poke the raffia or ribbon hanger into place. Tie a bow of ribbon or raffia. Glue on the bow to cover the hole.

5. When completely dry, paint with PVA glue or clear varnish to give a glazed surface.

Découpage Frames

Approach

1. Complete an observational study in pencil, paint or coloured pencil.

2. Cut a rectangular piece of thin card. It should be large enough to form a border around the original drawing.

3. Paste the paper cut-out images around the outside of the card to the desired width. When dry, carefully cut around the inside edge of the frame. Trim the outside edges straight or cut around the pasted images.

4. Cut a piece of backing paper or card to the same size as the frame. Mount the picture on this and add the frame.

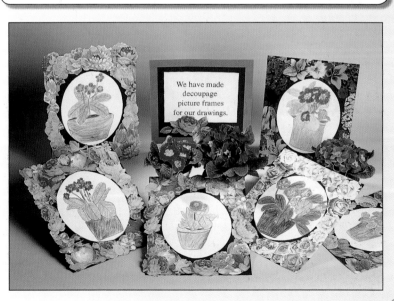

Magazine Spill Boxes

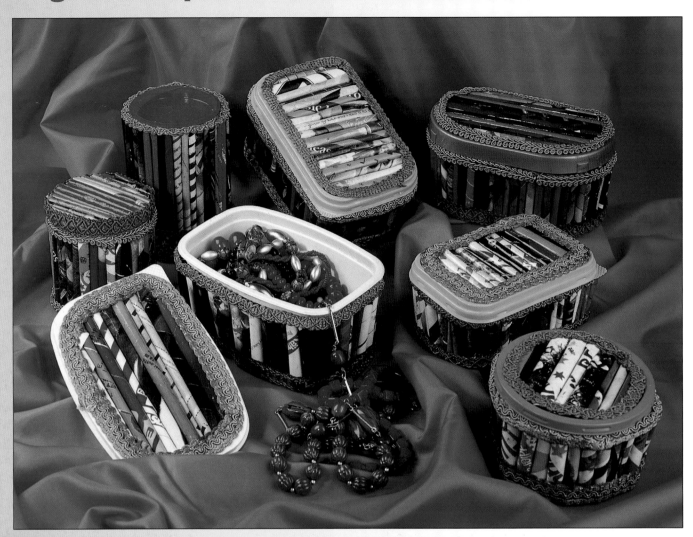

Approach

Resources

- Coloured pages from glossy magazines or colour supplements
- Lidded container such as margarine or ice cream tub
- Thin knitting needle or long-handled paintbrush
- Glue stick
- PVA glue
- Oddments of braid or lace

1. With the least colourful side of the paper facing you, roll a page of magazine paper around a knitting needle or paintbrush handle (start at one corner and roll to the opposite diagonal corner). As you proceed, use the glue stick along the edges of the paper and along the diagonal. Always roll the paper around the knitting needle a couple of times before adding any glue otherwise the spill will not slip off the needle. Hold the paper firmly around the needle as you are rolling it so that the spill does not become too slack. When rolled and glued, slip the spill from the needle. Make several spills in this way.

2. Measure the depth of the container and cut the spills into shorter lengths to fit the sides. It is a good idea to do this with the lid on as you will probably need to leave a clear space at the top of the container for the lid to fit.

3. Spread PVA glue onto one section of the container at a time and arrange the spills vertically, making sure that they touch each other and none of the underlying container is showing.

4. Now cover the lid with spills. In the case of margarine containers or ice cream tubs which have a ridge around the lid, just cover the central depression.

5. In order to hide the cut edges of the spills glue braid or lace around the top and bottom of the boxes and around the lid.

Spill Beads

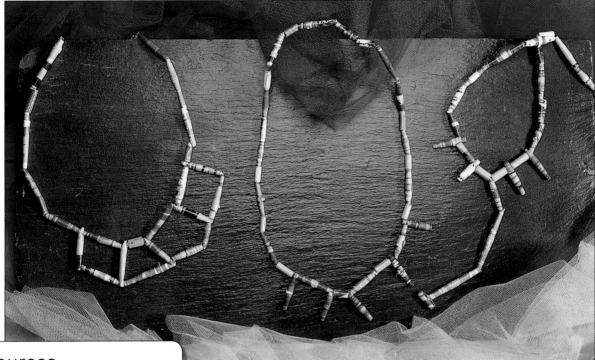

Resources
- Coloured magazine pages
- Thin knitting needle or long-handled paintbrush
- Glue stick
- Sewing needle
- Strong, coloured thread

Approach

1. Cut the coloured magazine pages into long, thin triangles and narrow strips.

2. Roll a strip of paper around a knitting needle or paintbrush handle, starting at the base of the triangle. Make sure the brightest side of the paper is showing on the outside of the roll. Run the glue stick along the centre of the strip as you roll. The number of beads required to make a necklace will vary according to the size of the bead but 20 beads is a good amount to start with.

3. Thread the beads onto strong thread. To add variety, sew through the ends of some beads so that they will hang down. The beads can be threaded in rows to make collars or threaded onto elastic to make bracelets.

Paper Spills Frame

Approach

1. Cut a piece of carton card larger than the mirror.

2. Glue the mirror to the card with latex glue. Alternatively, use double-sided adhesive tape.

3. Roll up coloured magazine pages into paper spills (see Spill Boxes, page 20).

4. Cut the spills to size and use PVA glue to stick them around the mirror.

5. Trim the outside edges of the frame with braid.

Resources
- Carton card
- Old vanity mirror
- Latex glue
- Double-sided adhesive tape
- PVA glue
- Coloured magazine pages
- Oddments of braid

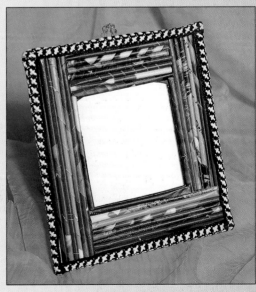

Magazine Mosaics

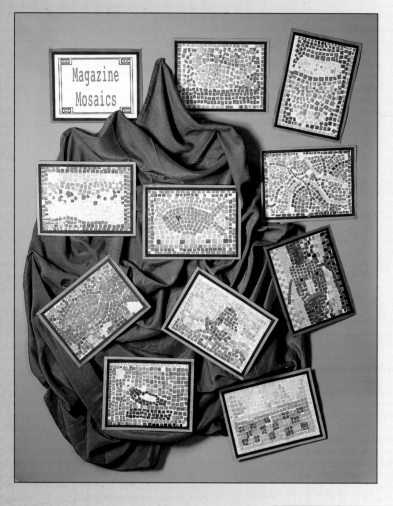

Approach

1. Draw a simple design on the paper.

2. Select the required coloured pages from the magazines and cut into small squares no bigger than 1 centimetre square.

3. Following any curves in the design, position and glue the squares leaving small gaps in between.

4. Fill in the background areas by gluing the mosaic pieces down in straight rows.

Mythical Mosaic Monsters

Draw a mythical creature on black sugar paper. Keep the design simple. Select pages from magazines and wallpaper sample books and cut into small squares. Following the curves of the design, fill in the creature with the coloured squares.

Mosaic Masks

Approach

1. Draw a face on an inflated balloon and smear the balloon with petroleum jelly.

2. Dip newspaper pieces in cellulose paste and place them on the balloon. Add two layers, leaving the eyes and mouth free.

3. Twist up some newspaper to make a nose shape and paste it on with strips of newspaper. Similarly, build up the forehead, cheek bones and chin.

4. Add three more layers of newsprint. Then add a final layer of black sugar paper. Leave to dry thoroughly.

5. Burst the balloon and remove the mask.

6. Select coloured magazine pages and cut into small squares.

7. Thinly cover a small area of the mask with PVA glue and start applying the squares.

8. Complete by filling the eye and mouth holes with tissue paper or leave them open if the mask is to be worn.

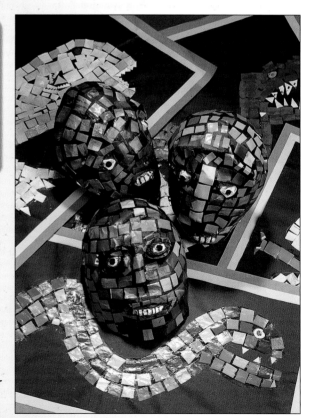

Wallpaper Townscapes and Wax Rubbings

Resources
- Variety of textured wallpapers
- PVA glue
- Wax crayons

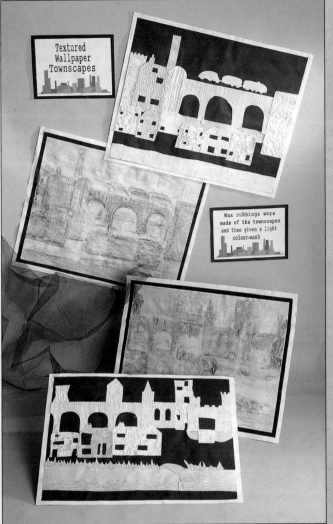

Approach

Townscapes

1. Draw buildings and townscapes on textured wallpaper and cut out. Encourage the children to consider the wide variety of shapes that are found in a town.

2. Assemble the buildings onto background paper, shuffling them around until a satisfactory arrangement is found. A discussion about perspective might be useful here.

3. Glue down carefully on black paper and leave to dry.

Wax Rubbings

1. Position a large sheet of white paper over the wallpaper picture. Tape to the desk with masking tape. This prevents multiple images as the paper moves.

2. Rub lightly with a coloured wax crayon, for example red or brown. Keep the crayoning parallel to the edge of the paper. Repeat this process using a black crayon, rubbing a little more heavily on the edges of the buildings for definition.

3. Remove the rubbing from the wallpaper picture and apply a very watery colour wash. This has to be very delicate otherwise the rubbing will be obliterated.

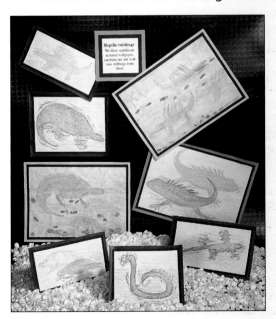

Wallpaper Reptiles

The method used for making the wallpaper townscapes (see above) can be adapted to suit many topics. Anaglypta wallpaper with a pebbly or scaly pattern is ideal for reptiles, dragons and dinosaurs.

Approach

1. Cut out a large reptile from highly textured wallpaper.

2. Place this underneath a sheet of white paper and rub over with wax crayons. The reptile can be reversed to create a creature going in the opposite direction. The rubbing pattern will also be different. Smaller reptiles can be cut out and rubbed to create a group of creatures.

3. Rubbings can be mounted as they are or a background can be drawn in with wax crayons and then the whole picture colour-washed.

Printing on Wallpaper

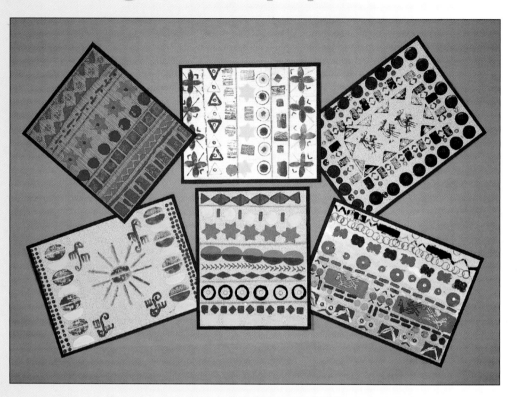

Lightly textured wallpaper provides an interesting surface on which to print as it imitates the texture of fabric. Unprinted or very light wallpapers will need a colour-wash but brightly coloured papers can be printed on very successfully provided that strong, contrasting colours are used. These designs were inspired by Aztec and Mexican cultures.

Resources
- Collection of items that can be used as printing 'blocks', for example: bottle tops, dowelling, small wooden blocks, scraps of wooden beading, bits of sponge
- Printing inks, ready-mixed paint or thickly mixed powder paint with PVA glue added

Approach

1. Colour-wash the wallpaper if necessary. Leave to dry.

2. Apply paint to the printing block by dipping it in paint or applying the paint to the block with a brush. Print in rows or around the edge of the paper.

String Printing Blocks

Resources
- Oddments of string or cord
- Offcuts of wood or strong cardboard cartons
- PVA glue

Approach

1. Design a simple motif to fit the block of wood or carton card.

2. If using card, cut two or three pieces to the same size and glue them together to create a block which is easy to hold.

3. Draw the motif onto the wood or card. Glue the string over the design. Leave to dry thoroughly. Check for any loose ends.

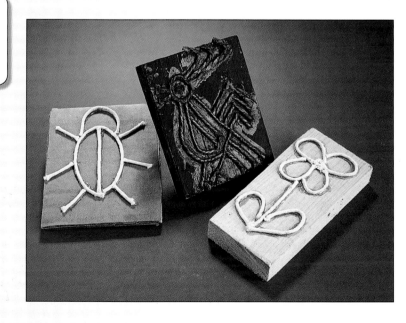

Food Tray Windows

Resources
- Polystyrene food tray
- Scenes from magazines (optional)
- Clear adhesive tape, PVA glue
- Thin card
- Scraps of fabric, braid or fringing

Approach

1. Cut the bottom out of a polystyrene food tray.

2. Draw or paint a view the same size as the bottom of the tray or cut a scene from a magazine. Glue this to thin card.

3. Tape the card into the polystyrene frame.

4. From the discarded base cut narrow strips of polystyrene and glue these onto the view to form the struts of the window frame.

5. Cut narrow strips of fabric to fit each side of the window. Sew along the top edges, gather and either sew or glue in place. Glue a scrap of braid or fringe across the top edge of the tray for a pelmet. Add curtain tie backs if desired.

Display Trays

This is a novel way of displaying collections of small objects.

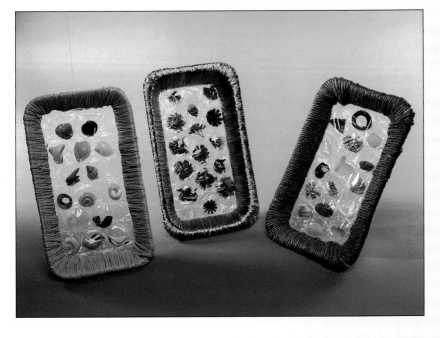

Resources
- Polystyrene food tray
- String, yarn or synthetic raffia
- Large bubble wrap
- Clear adhesive tape, PVA glue

Approach

1. Cut the bottom out of a polystyrene food tray.

2. Wrap the remaining frame using string, raffia or yarn.

3. Cut a piece of large bubble wrap to fit the frame.

4. Make a slit at the back of each bubble and insert the items to be displayed. These could be shells, pebbles, dried flower heads, seeds or even small toys. Secure the slits with clear adhesive tape.

5. Tape the bubble wrap into the frame.

Polystyrene Press Prints

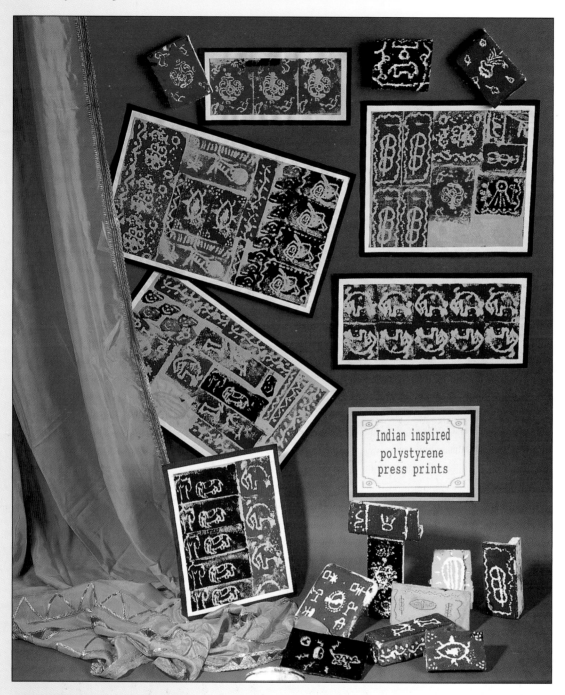

This is an effective way of making use of polystyrene packaging that comes with household appliances. The packaging will have to be cut into handy-sized blocks. Polystyrene food trays can also be used.

Approach

1. Decide upon a motif and using a ballpoint pen or blunt pencil slowly press the design into the polystyrene. Make sure that it is well indented and that the lines are sufficiently wide so that they will not clog with ink.

2. Squeeze some ink onto the tray and roller well. You should be able to hear the ink pull back from the roller. Roll the ink across the polystyrene block.

3. To print, place the block ink-side down onto the paper and press gently. Carefully lift the block off the paper. Roll more ink onto the block and place it face down, edge to edge with the first print. Continue in this way until the paper is filled.

Resources
- Polystyrene blocks or food trays
- Water-based printing ink
- Print rollers and trays

Weaving with Plastic Bags

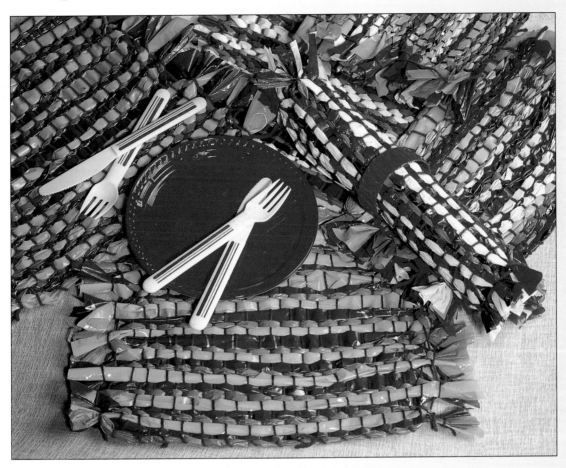

Place Mats

Approach

Resources
- Carton card
- Oddments of brightly coloured wool
- Brightly coloured plastic bags

1. Cut the card to the required size allowing an extra 2 centimetres on the width and length.

2. Mark the top and bottom edges of the card at 1–centimetre intervals. Cut slits in the card at these marks to the depth of 1 centimetre.

3. Attach brightly coloured wool to the card loom by winding several times around the first 'tooth'. Bring the wool to the front of the card through the first slit. Take it down to the bottom of the card, through the first slit, behind the 'tooth' and out through the second slit. Now take the wool up to the top of the card and into the second slit, behind the 'tooth' and out through the third slit. Continue in this way until the loom is warped. Finish by winding the wool several times around the last 'tooth'.

4. Cut the plastic bags into strips 5–6 centimetres wide and weave under and over the warp threads leaving the ends of the strips sticking out at the sides. Push the strips down well after every few rows.

5. When the card is full, secure the ends of the strips by tying them together in bunches of three or four with brightly coloured wool.

6. Slip the weaving off the card loom by bending the 'teeth' forwards and slipping the wool from behind.

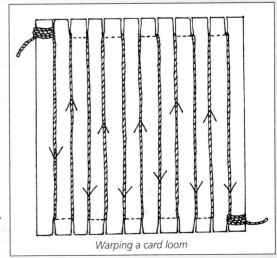

Warping a card loom

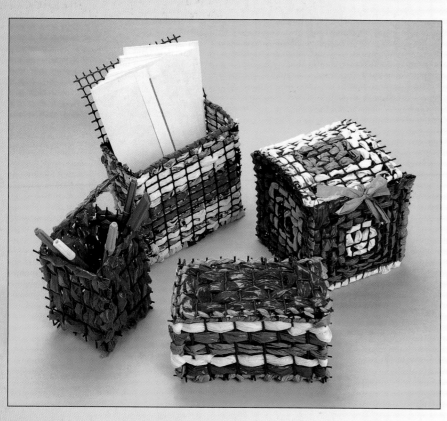

Lidded Boxes

These boxes are constructed from rigid plastic mesh used in gardens. As the mesh is 1 centimetre square the box nets can be easily worked out on 1-centimetre-squared graph paper.

Resources
- Graph paper
- Plastic mesh
- Brightly coloured plastic bags

Approach

1. Draw the box net on graph paper. Cut out each side separately.

2. Cut the pieces of box from the plastic mesh.

3. Loosely lace the sides of the box to the base using wide strips of plastic carrier bag. Bring the sides up and lace together. Lace the lid to the top of the box.

4. Using wide strips of plastic bag weave in and out of the box until all the holes are filled.

Plastic Baskets

Approach

Resources
- Plastic ice cream or margarine container
- Brightly coloured plastic bags
- Felt or fabric
- PVA glue

1. Cut down the sides of the container to the base at about 2-centimetre intervals, thus creating stakes on which to weave. Make sure you have an odd number of stakes.

2. Cut two differently coloured carrier bags into strips about 5 centimetres wide.

3. Slip one of the plastic strips behind a stake and out through the two slits. Leave the shorter end (about 6 centimetres) to the left. Slip a strip of the second coloured bag behind the next stake to the right and repeat so that you have a short end and a long end of plastic appearing through the same slit. Now take the long end of the first colour across the stake to the right, behind the next stake and out to the front again. Repeat this with the second colour. Repeat this process until the basket is woven. The strips have a tendency to ride up, so push them back down periodically. To join new strips, merely slip the new length behind the last stake used, leaving the short ends at the front to be darned in afterwards.

4. To complete the basket, cut a circle of felt or other brightly coloured fabric and glue this into the bottom of the container.

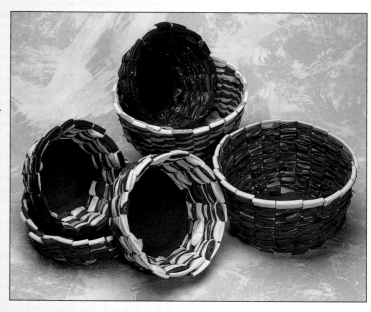

Hanging Baskets

These can be made using the plastic baskets described on page 28 or by simply painting ice cream or margarine containers.

Resources
- Plastic ice cream or margarine containers
- Plastic bags
- Chicken wire
- String or yarn
- Clear adhesive tape, PVA glue

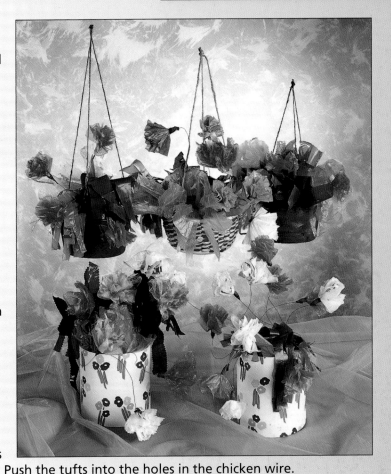

Approach

1. Paint the plastic container using paint mixed with PVA glue. Leave to dry.

2. Using a bradawl, pierce three equidistant holes under the rim of the container. Tie on lengths of string and knot together to form the hanger.

3. Crumple up a small piece of chicken wire to fit into the tub. Using different shades of green plastic bag, cut wide strips and cut into fringes. Roll or gather these up to look like plants or tufts of grass. Secure the bottoms with tape or staples. Push the tufts into the holes in the chicken wire.

4. Make smaller versions of the plastic bag carnations described below and push these into the chicken wire. Hang the baskets from the ceiling.

Variation
A simpler version of these can be made using a strip of thin card about 10 centimetres wide, instead of the plastic container. Decorate the card by painting or covering with wallpaper. Tape tufts of greenery and flowers along the top edge of the strip. Join the ends of the card together with double-sided adhesive tape or glue. Leave as a plant pot or tie on yarn to hang.

Plastic Bag Flowers

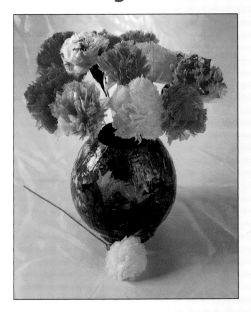

Approach

Resources
- Coloured plastic bags
- Adhesive tape or thin wire for winding
- Thicker wire for the flower stems
- Florists' tape or crêpe paper

1. Cut a plastic bag into strips about 6–7 centimetres wide (wider if the plastic is thin) and 22 centimetres long. One carrier bag makes a large flower.

2. Gather the strips into a bunch. Hold them halfway along and twist the end of the stem wire tightly around the plastic strips, thus holding them all together.

3. Bend both ends of the bunch of strips upwards and hold together by twisting tightly around with thin wire or adhesive tape.

4. Wind florists' tape or strips of crêpe paper around the base of the flower and along the stem.

5. Trim the flower to shape.

Plastic Pom-Poms

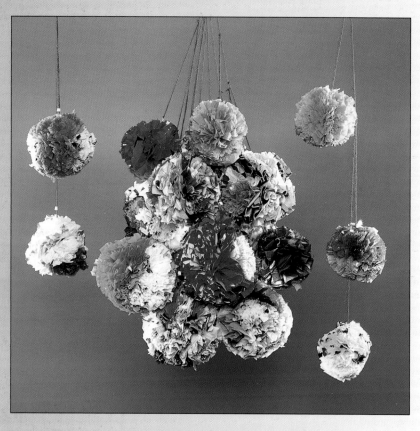

Resources
- Thin card (cereal packets)
- Coloured plastic bags
- Oddments of yarn or string

Approach

1. Draw two concentric circles on thin card. The centre circle needs to have a diameter of at least 2 centimetres. Cut around the outer circle, then cut out the inner circle. You will need two of these discs to make a pom-pom.

2. Cut plastic bags into strips about 3–4 centimetres wide.

3. Holding the two discs together, start to wind the strips through the centre and around the card. Continue winding in different colours until the hole is filled up.

4. Now cut through the plastic around the edges of the discs. Pull the discs slightly apart. Tie a length of yarn firmly around the loops between the discs and secure with a knot. Finally, pull the discs away and trim the pom-poms if necessary.

Cheer Leader Pom-Poms

1. Cut plastic bags into strips about 2–3 centimetres wide. Cut the bag across its width, cutting through the front and the back at the same time to make lots of circular strips. Cut these once to open them out.

2. Gather together about 20 strips and tape them halfway along their length. Fold them in half at the point where they have been taped. You will need at least four of these bunches to make a pom-pom.

3. Tape the folded strips around a dowel or broom handle. Make sure they are secure. If a cardboard tube is to be used as a handle, tape the folded section of the strips into the opening of the tube. Tape extra bunches of strips around the outside edge of the tube.

4. Finish by winding strips of brightly coloured fabric around the handle. Glue at the ends.

Resources
- Brightly coloured plastic bags
- Clear adhesive tape, PVA glue
- Short lengths of thick dowel, broom handle or sturdy kitchen roll tubes
- Brightly coloured fabric

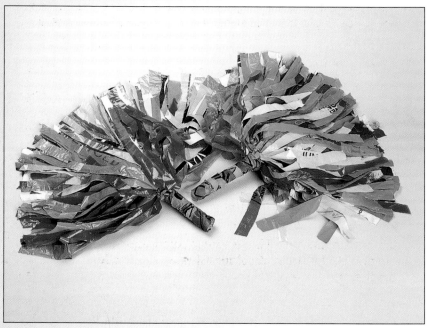

Plastic Jewellery

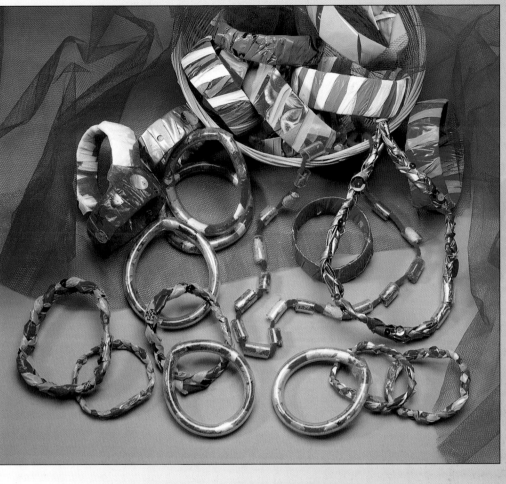

Resources
- Clear plastic tubing
- Coloured plastic bags
- Clear adhesive tape, PVA glue
- Plastic drinks bottles
- Coloured sequins

Plastic Tubing Necklaces and Bracelets

Approach

1. Cut a length of clear plastic tubing long enough to go over the head or round the wrist.

2. Use a pencil or knitting needle to push twisted scraps of coloured plastic bag into the tube. Start by filling up the middle, working from both ends. Secure the last piece of plastic bag at each end with PVA glue.

3. Hold the ends of the tubing together and tape with clear adhesive tape.

Variation

Cut the tubing into short lengths to make individual beads. Dab a spot of PVA glue onto each twist of plastic bag before squeezing it into the tube. When the glue is dry, thread the beads onto brightly coloured thread.

Plastic Drinks Bottle Bangles

Approach

1. Cut 4–5-centimetre-wide rings off a plastic drinks bottle.

2. Wind strips of plastic carrier bag around them until well padded. Tape the end.

3. For a striped effect wind another coloured strip at an angle over the first colour. Glue on sequins for further decoration.

Plaited Necklaces and Friendship Bracelets

Approach

1. Use thin, flimsy plastic bags as they plait very easily. Cut the bags into strips and plait three colours together. Try experimenting with strips of different widths.

2. Join the ends and tape together with clear adhesive tape.

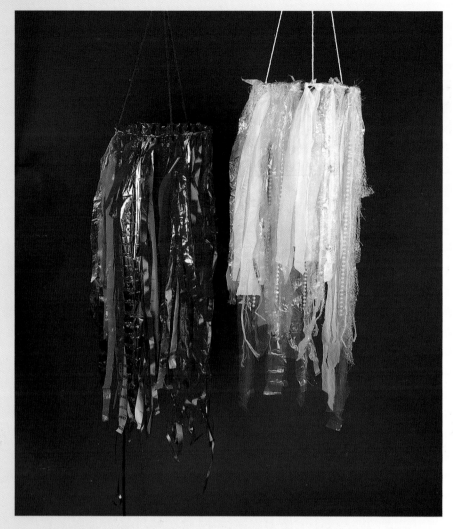

Fire and Water Hangings

Resources
- Ring or metal coat-hanger on which to hang the fabrics and plastics
- Assorted materials such as bubble wrap; clear, opaque and white plastic bags; nets, chiffons and silks; and interesting yarns

Approach

1. If using a coat-hanger pull it into a round shape. Bind the ring or hanger with wool or narrow strips of fabric.

2. Tie three or four lengths of yarn to the ring to suspend it.

3. Cut long, narrow strips of assorted materials. Fold the strips in half and attach to the ring by passing the two ends through the loop and pulling tight (see diagram).

4. Thread shiny beads onto some of the strips. Thread large sequins onto invisible thread. Continue until the ring is full. Create the fire hanging in the same way, using red, orange and gold materials.

Jellyfish

Resources
- Wire
- Clear and coloured plastic bags
- Yarn
- Clear adhesive tape
- Nylon thread

Approach

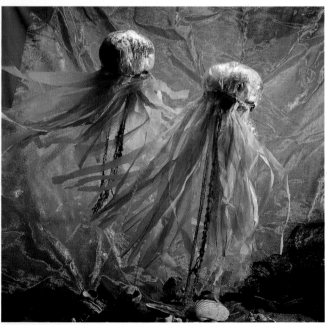

1. Bend a length of wire and tape the ends together to make a ring.

2. Make the skirt of the jellyfish as described in Fire and Water Hangings, incorporating pink, purple and blue shades of plastic.

3. To make the body, stuff a clear plastic bag with opaque plastic bags and a few strands of pink and blue yarn. Pull into shape and knot securely. Use clear adhesive tape to fasten the body to the ring.

4. Thread a nylon line through the top of the body and hang.

Waterfall Hanging

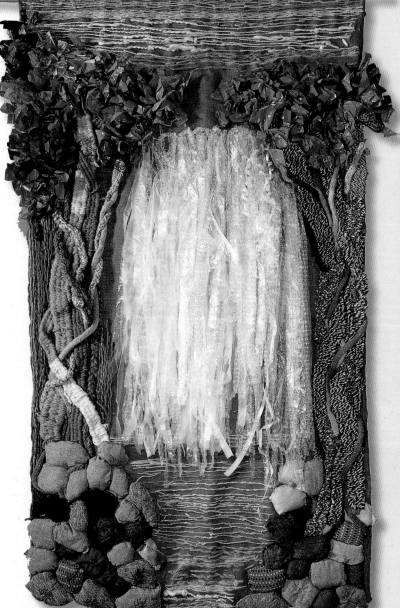

Resources
- Coloured fabrics
- Blue hessian background
- Toy filler or chopped tights
- Embroidery thread
- Latex glue
- Yarn
- Materials for stick weaving (page 43) and bobbin knitting (page 46)
- Green plastic bags
- Bubble wrap
- Clear, opaque and white plastic bags
- Nets and other matching materials

Stones

Cut out irregular shapes from 'stone' coloured fabrics. Sew around the edges, leaving a gap for stuffing. Turn right side out. Stuff with toy filler or chopped tights. Sew up the opening. Stitch the stones with green embroidery threads to represent moss. Fix to the background with latex glue.

Water and Sky

Work these areas in a variety of long and short stitches using different shades and textures of knitting yarn. By working on a blue background fabric, not all the areas have to be stitched.

Trees

Make strips of stick weaving and bobbin knitting to the required length (see pages 43 and 46). Lay on the background and twine and twist to create a suitable shaped trunk. Glue into position with latex glue.

Foliage

Cut green plastic bags into strips about 6 x 10 centimetres and, working from the back of the hanging, poke the ends of the strips through to the front (see Pegged Squares, page 52). When you have finished pegging, clip the leaves to the desired length.

Waterfall

Cut long narrow strips of bubble wrap, clear, opaque and white plastic bags, nets and other matching materials. Start near the bottom of the waterfall and working across its width sew these materials on in short lengths. Gradually work up the waterfall, increasing the length of the strips. Some materials, such as smooth plastic bag or net, will thread through a large-eyed needle and can be sewn directly into the background fabric. Others, such as bubble wrap, will need to be folded in half and tacked on at the fold.

Plastic Bottle People

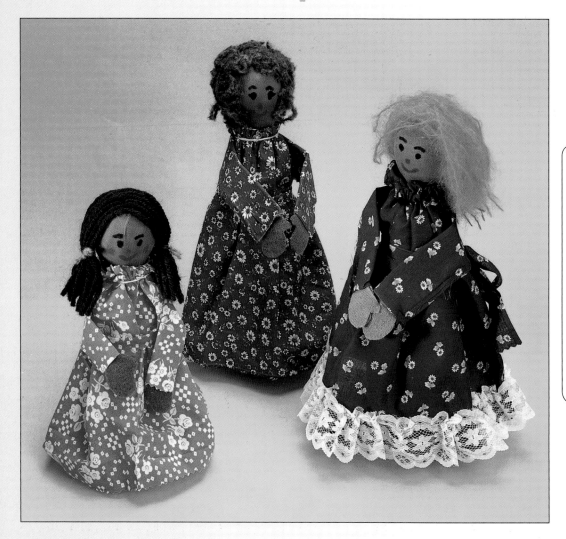

Resources
- Newspaper
- Plastic bottles of various sizes
- Flesh-coloured nylon tights and fabric
- Oddments of fabric, lace, fringing, braid, wool and beads
- Sand
- Card
- PVA glue

Approach

1. Screw up a sheet of newspaper into a tight ball. Cut a leg off a pair of tights. Push the ball into the toe. Twist the ball around several times and pull the leg of the tights back over the ball. Repeat until you cannot see the newsprint through the tights.

2. Trim off any excess fabric and glue or stitch the ends down.

3. Partly fill a plastic bottle with sand to make it stable.

4. Push the head into the second leg of the tights. Twist and pull through as before. Place the head on top of the bottle, pulling the tights down over the bottle to the base.

5. Twist the tights at the side of the bottle near the bottom and pull back over the bottle and over the head. Repeat this process until the leg has been used up. Finish at the base and stitch or glue the ends underneath. Bind with tape or thread around the neck to keep the head in place.

6. Cut a length of fabric long enough to gather around the bottle for the dress. Trim with lace or braid as required. Gather the fabric around the neck and tie tightly.

7. Cut a length of card for the arms. Cut out hands from the card and cover with flesh-coloured fabric. Glue these to the arms. Cover the arms with fabric and glue or sew to the back of the doll. Bend the arms around and attach them to the sides of the doll.

8. Add wool for hair, felt pieces for features and jewellery if desired.

Plastic Bottle Fish

Resources
- Thin plastic drinks bottles
- White paper
- Fine permanent felt-tipped pens
- Masking tape
- PVA glue
- Curtain ring
- Thin white paper or tissue
- White paper reinforcement rings
- Coloured drawing pins
- Nylon fishing line
- Ready-mixed paint or powder paint

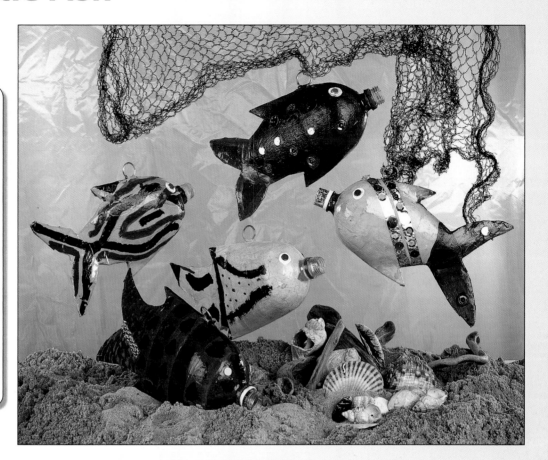

Approach

1. Cut away the base of a plastic bottle. Flatten the bottle from the cut edge to the shoulder, making sure that the creases are squeezed out as flat as possible.

2. To make a pattern for cutting out the fish, lay the partly flattened bottle on a sheet of white paper and draw around it. The tail and fins of the fish can now be drawn to fit within this outline. Cut out the fish-shaped pattern.

3. Place the pattern on the flattened bottle and draw around it onto the bottle with a permanent marker. Hold the edges of the bottle tightly together and cut away the unwanted pieces. Still holding the cut edges together, secure with overlapping strips of masking tape.

4. Attach the curtain ring to the top of the fish with masking tape. The children will need to experiment to find the point of balance.

5. Use diluted PVA glue to cover the fish with small pieces of thin white paper or tissue paper. Put a stick or long-handled paintbrush into the mouth of the fish, prop it up in a jar and leave to dry.

6. When the fish is dry apply a base coat of ready-mixed or powder paint mixed with a little PVA glue. Two coats may be needed to cover the bottle thoroughly. When this is dry paint on spots, stripes or other patterns. Use white paper reinforcement rings or coloured drawing pins to create the eyes. Thread nylon fishing line through the ring and hang.

Variations

Larger fins can be cut out of card and foil scales can be added. Use buttons, beads and glitter for further decoration. Feathery tails can be made from strands of tissue paper, plastic bags or wool.

CARDIFF
CAERDYDD

35

Plastic Bottle Vases

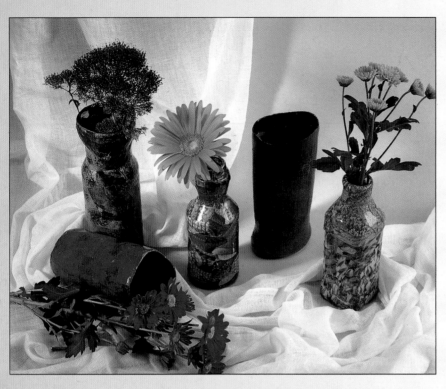

Resources
- Selection of interestingly shaped plastic bottles
- Newspapers and colour supplements
- Cellulose adhesive
- Paints and sponges
- PVA glue or clear varnish

Approach

1. Cut the neck and shoulders off a plastic bottle.

2. Tear colour supplement pages into smaller pieces and glue them, colour side down, to the bottle. Make sure they overlap the cut rim of the bottle. When the bottle is covered add two layers of newsprint. Let this dry before adding a final layer of colour supplement paper. Allow to dry thoroughly.

3. Mix some paint to match the colour of the bottle's covering. Use a dry sponge to dab the paint sparingly over the bottle, blending all the colours together.

4. When thoroughly dry, coat with clear varnish or PVA glue making sure that it is well sealed on the inside rim. Apply a second coat when dry. The vase should now be watertight and ready for fresh flowers.

Lilies or Bottle Neck Flowers

Resources
- Plastic bottles
- Pipe-cleaners
- PVA glue
- Green paper
- Flexible straws
- Green garden sticks or thin dowel
- Clear adhesive tape
- Acrylic paint or emulsion paint
- Green florists' tape

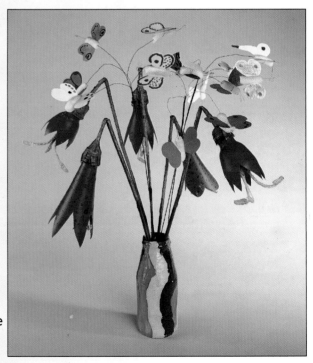

Approach

1. Cut the neck and shoulder off a bottle. Snip the lower edge into spiky petal shapes.

2. Bend the ends of three pipe-cleaners to form stamens. Glue and roll the other ends of these in a strip of green paper to form a plug for the neck of the bottle. Push into position.

3. Tape the flexible end of the straw to the back of the flower shape so that it stands out from the flower. Use small strips of tape and build up the back of the flower slightly. Bend the straw so that the flower head hangs down.

4. Slip the straw over a garden stick.

5. Paint the flowers using acrylic paint or household emulsion. Paint the tape at the back of the flower green and paint the straw or bind it with green florists' tape.

Plastic Bottle Flyers

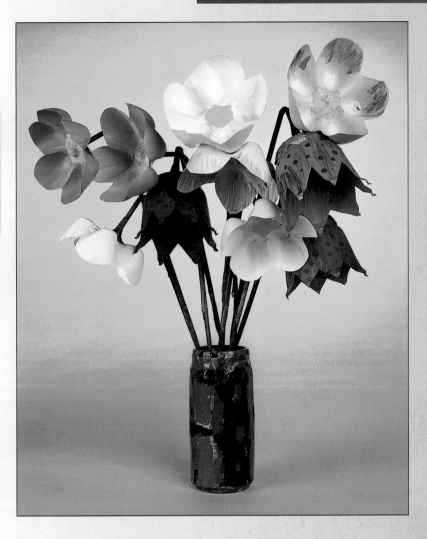

Resources
- Plastic drinks bottles with fluted bottoms
- Flexible straws
- Green garden sticks or thin dowel
- Clear adhesive tape
- Acrylic paint or emulsion paint
- Green florists' tape

Approach

1. Cut the bottoms off the bottles and shape them to resemble petals.

2. Continue to make the stems as described for Lilies or Bottle Neck Flowers (page 36).

3. Slip the straw over a garden stick. If the stick is too thick, slit the straw to ease the stick in. Secure with tape.

4. Paint the flowers using acrylic paint or household emulsion. Paint the tape at the back of the flower green and paint the straw or bind it with green florists' tape.

Variation

Choose bell-shaped yoghurt pots and snip v-shaped pieces out of the rim. Proceed as above.

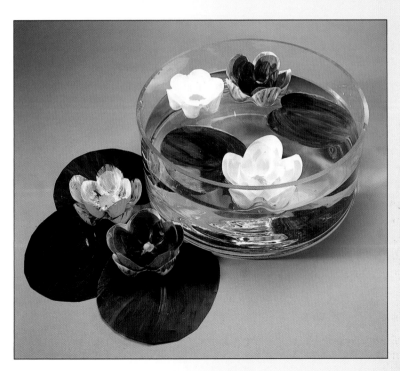

Monet's Water Lilies

Resources
- Plastic bottles with fluted bottoms of various sizes
- Acrylic or vinyl paint
- PVA glue
- Green paper or card
- Clear plastic packaging (optional)

Approach

1. Cut the bottoms off various sizes of bottles and shape into flowers. Three different sizes work very effectively together.

2. Using acrylic or vinyl paint colour the sections of the flower. When dry, use PVA to glue the three sections inside each other.

3. If you want to float the flowers on water cut the leaves from clear plastic packaging and paint with vinyl paint, otherwise use green paper or card.

Painted Plastic Containers

Resources
- Clear, rigid, plastic containers
- Water-based glass paints and outliner paste
- Fine brushes
- White paper
- Adhesive putty

Approach

1. Cut pieces of paper the same size as the faces of the box to be painted. If the container is cylindrical simply measure its circumference and cut paper to fit. Draw the design on the paper and fix to the inside of the container with adhesive putty.

2. Using the outliner paste, follow the lines of the design. Leave to dry.

3. Colour in the design with glass paints.

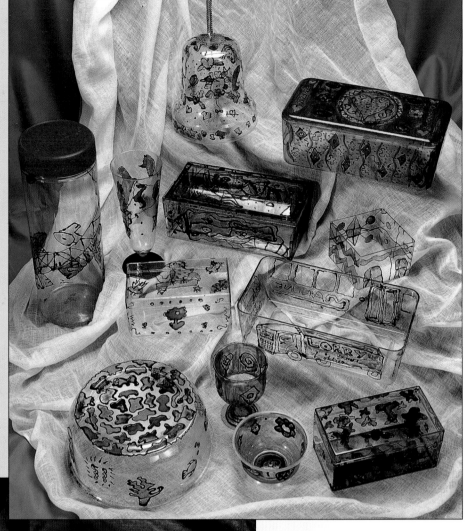

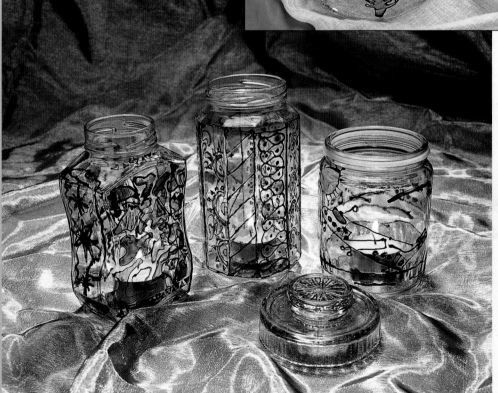

Painted Glass Jars and Bottles

These make attractive storage jars or nightlight holders. Bottles may be painted and used as candleholders. (See also Acknowledgements, page 2.)

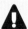 **Never leave children unsupervised with burning candles.**

Sand Jars

Resources
- Glass jar
- Sand
- Powder paint
- Acrylic paint
- PVA glue

Approach

1. Colour the sand by simply mixing with powder paint. Mix up a dessertspoonful of powder paint with several tablespoonfuls of sand.

2. Fill a jar with the layers of coloured sand using a funnel.

3. Tilt the jar to create slopes and different levels. Move the jar gently to avoid mixing the layers of sand.

4. Fill the jar right up to the top so there is no space between the sand and the lid. If any space is left the sand will move when the jar is handled.

5. Using a fine brush and acrylic paint or powder paint mixed with PVA glue; paint a picture on the jar to complement the layers of sand.

6. Decorate the lid of the jar with coloured card or felt.

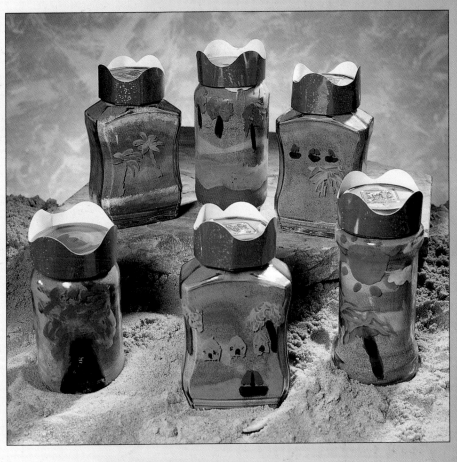

Snowstorms

Resources
- Small screw-topped jar
- Plastic modelling clay
- Latex (waterproof) adhesive
- Glitter
- Felt

Approach

1. Decide upon a scene and model the pieces out of plastic modelling clay. Dry as instructed on the packet.

2. Draw round the lid of the jar onto a piece of felt. Cut out the circle of felt and glue it to the outside of the lid.

3. Coat the inside of the lid with waterproof adhesive and arrange the models to create a scene. Leave to dry.

4. Fill the jar about three-quarters full with water (do not fill the jar completely as the model will displace some of the water). Sprinkle in some glitter and mix well. Top up with water so that the jar is almost full.

5. Coat the outside rim of the jar with adhesive and screw the lid on tightly. Leave to dry overnight.

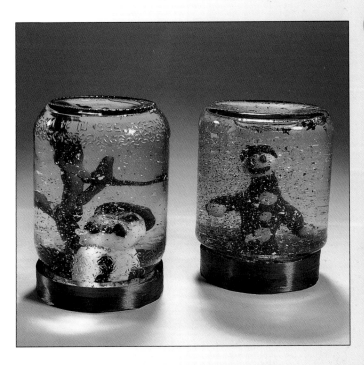

Decorated Glass Jars

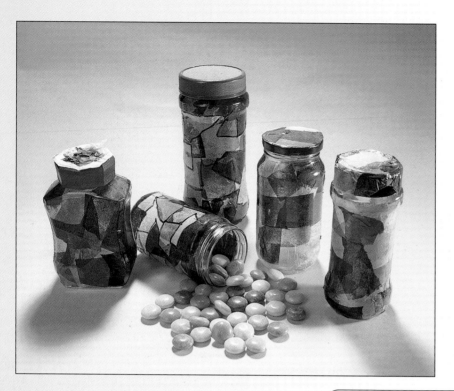

Resources

- Glass jars
- Coloured tissue paper
- PVA glue or cellulose paste
- Black marker pens
- Clear varnish (optional)

Approach

1. Cut coloured tissue paper into small straight-sided shapes. Use either dilute PVA glue or cellulose paste to glue them to the jar.

2. When the jar is dry use a black marker pen to outline the shapes.

3. Coat with PVA glue or clear varnish.

Foil-Covered Jars

Approach

Resources

- Glass jars
- Thin card
- Kitchen foil
- Double-sided adhesive tape
- PVA glue
- Shoe polish or paint

1. Cut a motif out of thin card and attach it to a jar with double-sided tape.

2. Cut a piece of foil to fit all the way around the jar. Crumple the foil lightly and then very carefully straighten it out.

3. Spread glue across the motif and around that section of the jar. Press the foil onto the motif and rub gently, working the foil well in around the edges of the card.

4. Glue the foil all the way around the jar.

5. Cut out a motif for the lid and cover this in the same way.

6. Rub the motifs with a little shoe polish on the tip of a finger or use a dab of paint.

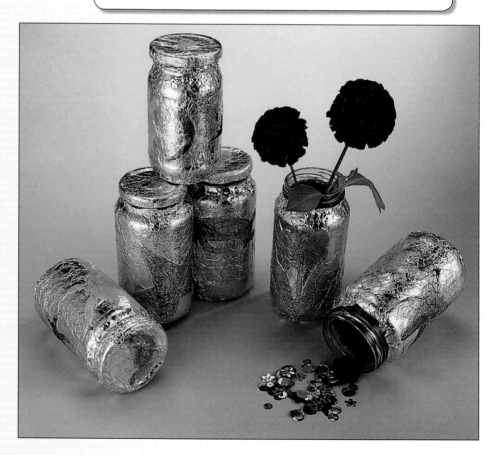

Sequinned Jars

Resources
- Glass jars
- Assortment of sequins and seed beads
- Glitter
- PVA glue
- Shiny card or paper

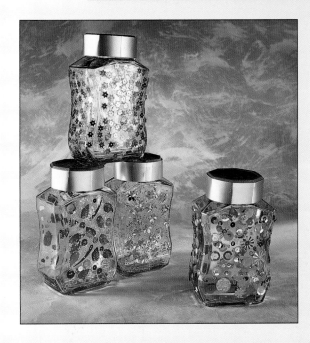

Approach

1. Coat the jar with a thin layer of PVA glue and cover with sequins, seed beads and glitter.

2. To decorate the lid cut strips of shiny card or paper and use PVA glue to glue them around the sides of the lid.

Victorian Dome Jars

Victorian Dome Jars are an attractive way of reusing large screw-topped jars. They are best made when there is a plentiful supply of dried grasses and seed-heads to be found in gardens and hedgerows. However, with a little forward planning, flowers such as statice, helichrysums and poppies can be grown in the school garden or in containers, and cut and dried for use later in the year.

Resources
- Large screw-topped jar
- Assortment of dried flowers and grasses
- Oasis
- PVA glue
- Adhesive tape
- Oddments of braid or fringing

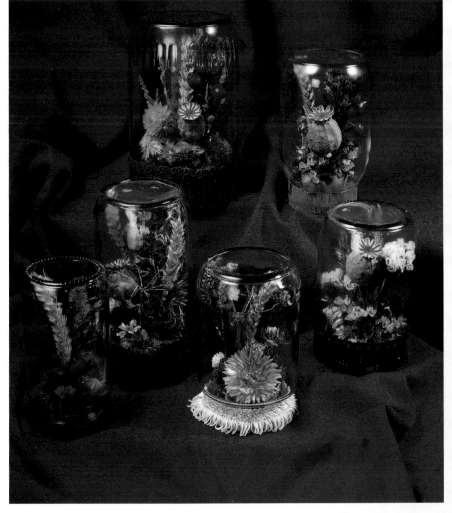

Approach

1. Cut a piece of oasis to fit in the lid of the jar. Glue this in position with PVA glue.

2. Cut the flowers to an appropriate length, remembering to measure them against the jar. Start in the centre of the oasis with the tallest flower and work around. The jar will probably be viewed from all sides. Cover as much oasis as possible. Helichrysums can be nipped off their stalks and pins pushed through the heads to anchor them. Occasionally place the jar over the arrangement to make sure that it is not getting too wide.

3. When the arrangement is complete screw the jar into the lid. Seal with adhesive tape. Glue fringing around the jar to hide the lid.

Peg Loom Weaving

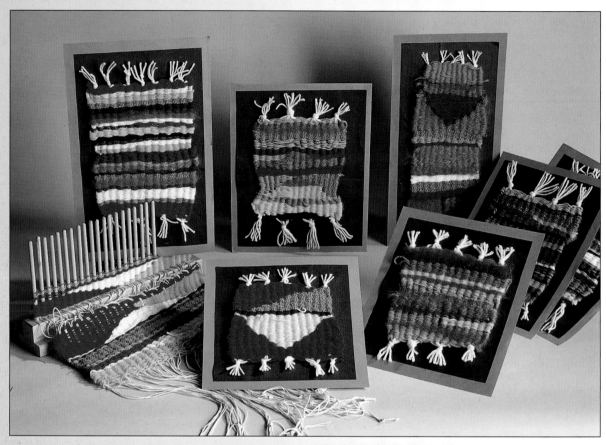

Weaving is just one of the ways of using up an accumulation of odd scraps of wool. These brightly coloured weavings were inspired by the textiles of Mexico and were worked on a peg loom.

Resources
- Peg loom
- Strong yarn or smooth parcel string
- Oddments of brightly coloured wool

Approach

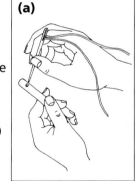

(a)

1. To warp up the loom, use strong yarn or smooth parcel string. For each warp, measure off a length of yarn twice the length of the finished weaving plus 10 centimetres at each end for the fringe or finishing off. For example, for a finished weaving 30 centimetres in length cut a length of yarn 80 centimetres in length for each peg (60 cm plus 10 cm for each end). Thread each peg with the length of yarn, knotting the two ends together (see diagram a). Place the pegs in the holes in the base. Bring all the warp threads to the front.

2. To weave, wind in and out of the pegs from one side to the other (diagram b). When the pegs are nearly full lift the first peg out of the base and pull the warp thread up through the weaving until it is visible at the top of the weaving (diagram c). Put the peg back in the hole (diagram d). Repeat with each peg. The weaving will now be on the warp threads at the front of the loom. Continue and repeat the process until the warp threads are full.

3. To finish off, remove all the pegs and lay the weaving flat. Gently pull the warp threads through the weaving until there is enough thread at each end to fasten off. Make sure that the weaving is smoothed out and even. Knot the protruding warp threads in threes or fours.

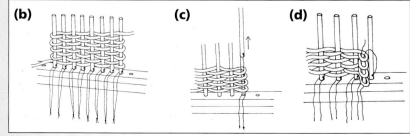

(b)　　　　(c)　　　　(d)

Stick Weaving

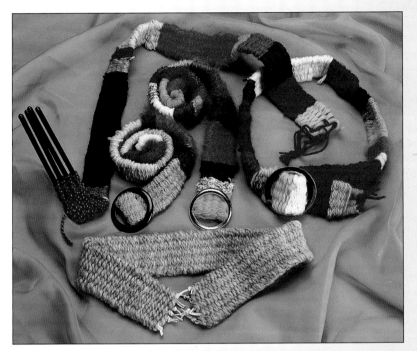

Resources
- Peg loom sticks, or thin sticks such as wooden dowel and adhesive tape
- Yarn
- Oddments of brightly coloured wool

Approach

1. If peg loom sticks are available use three or four sticks. Thread the sticks in the same way as for the peg loom (see page 42). If you do not have peg loom sticks improvise by taping single strands of yarn to the bottoms of thin sticks such as wooden dowel. Use the tape sparingly.

2. To weave, hold the sticks about halfway up and fan them out slightly. Hold the end of the weft thread in the same hand until you have got started. Weave in and out of the sticks, working from one side to the other.

3. When they are full, draw the warp thread up through the weaving. Continue in this way until the warp threads are full. Finish as for peg loom weaving. If making a belt sew the ends in for a neat finish and attach a buckle.

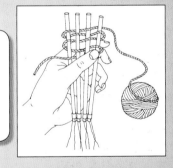

Drinking Straw People

This is a variation on the Stick Weaving idea above.

Resources
- Six long chenille pipe-cleaners
- Four fat plastic drinking straws
- Scraps of felt and oddments of wool
- Tapestry needle

Approach

1. Thread a pipe-cleaner through each of the four straws, making sure that they stick out at each end. At one end the pipe-cleaners need to stick out enough to form the legs.

2. Twist all the pipe-cleaners together at the other end, where the head will be. Push the straws up to this end. Spread the straws out in a fan shape but not too widely.

3. Thread the needle with wool suitable for hair or a hat and begin to weave under and over the straws at the head end. Change colour for the face and the clothes.

4. Do not weave right to the bottom end of the straw as you will need to grip the end to pull the straw off the pipe-cleaner. Slide the straws off the pipe-cleaners leaving the weaving in place. Twist the pipe-cleaners together in pairs to form the legs. Wrap the ends with wool to form the feet. Bend up.

5. To make the arms push a pipe-cleaner through each side of the figure. Fold each pipe-cleaner in half and twist. Turn the ends over for hands. Draw on the eyes, nose and mouth with felt-tipped pen or glue on tiny scraps of felt.

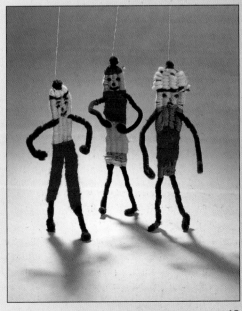

Weaving on Rings

Resources
- Suitable ring (hoop, bike wheel, lampshade ring)
- Masking tape
- Oddments of coloured wool

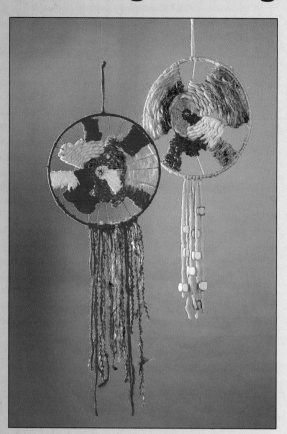

Approach

1. Wind wool all the way round the ring and knot or glue the end.

2. Warp up the ring to resemble the spokes of a wheel. The threads do not have to cross each other in the centre. It can be more effective if they cross off-centre. You will need to create an odd number of warp threads. To do this, instead of taking the last thread all the way across the circle, fasten it to where all the 'spokes' cross.

3. Start weaving at the centre of the ring where all the threads cross. Work around this bunch of threads until the centre of the weaving is quite firm. Weave out from the centre, working on two, three or five threads at a time. Leave gaps in the weaving.

4. Wind wool around some of the warp threads. Incorporate a wide variety of yarns and experiment using several yarns together. Stitch or tie on long threads and let them dangle. Create fringes and add beads.

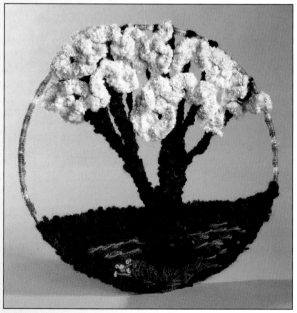

Tree Rings

Resources
- Suitably sized ring
- Oddments of wool and a needle

Approach

1. Wind sky-coloured wool around the ring, covering about half the circumference. Knot or glue the end. Wind the bottom half with green or brown wool.

2. To create the warp threads, tie a length of wool to the ring where the sky and land colours meet. Keeping the wool taut, take it across the circle to the other side; wind it two or three times around the ring and return. Repeat until the area of land is warped.

3. To weave, turn the hoop so that the warp threads are vertical. Weave under and over them with land colours until the area is complete.

4. Turn the ring so that the land is at the bottom. Add the warp threads for the tree in a fan shape, stitching through the weaving and around the ring at the bottom and fanning out at the top. You will need about 12 warp threads. When weaving the trunk pull the warp threads in to keep the sides of the trunk fairly parallel. Create thicker or thinner branches by weaving along four, three or two threads.

5. Foliage or blossom can be knitted by casting on a lot of stitches and knitting three or four rows. Break off the wool leaving a long end. Pass the end back through all the stitches and draw up the knitting. Sew the gathered knitting to the tree. Another method is to use finger knitting (see page 56).

Hole-in-Card Looms

Resources

- Assortment of coloured wool
- Needle and thread
- Strong carton card
- Coloured hessian or woven cloth
- Felt fabric
- PVA glue
- Shells, beads, twigs, etc.

Approach

1. Cut a circle out of strong card.

2. Glue hessian across the card covering the hole. Cut out the middle section leaving enough fabric to turn to the back. Snip all the way round to ease the fabric. Turn it to the back and glue.

3. Working from top to bottom across the hole, create the warp threads by stitching into the hessian at the edge of the circle. Space the threads about 1 centimetre apart.

4. Weave a landscape scene and add detail to the scene by cutting out and gluing on fabric shapes.

5. Add detail in the foreground by stitching items such as shells and beads into the hessian.

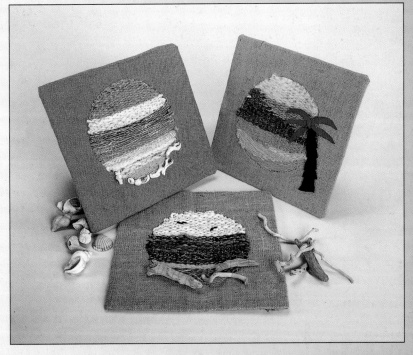

cut out the middle section

fold to back

Hot and Cold Planets

Resources
- Carton card
- Assortment of hot and cold coloured wool

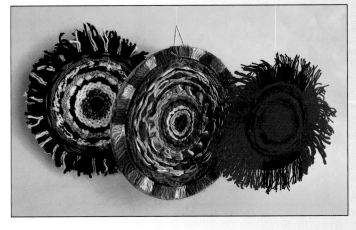

Approach

1. Cut out a circle from card. Cut slits around the edge of the card at regular intervals, about 1 centimetre in length, making sure there are an odd number.

2. Bring the warping thread to the front of the card through one of the slits. Cross the circle to the opposite slit. Go into this, behind the 'tooth' and out through the next slit. Cross the circle again through the centre and into the next slit. Repeat this process until the circle is warped.

3. To create an odd number of threads do not take the last thread all the way across the circle but stop at the centre where the threads cross. Stitch or tie the end of the thread in here.

4. Start weaving around the point where all the threads cross and work out in a spiral.

5. When the card is full to the base of the slits knot a fringe to the edge of the weaving. This hides the carton card. Leave the weaving on the card to display.

French Knitting

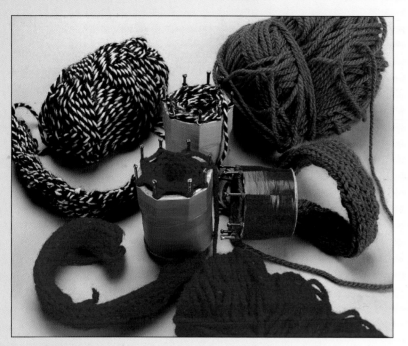

To Make a Bobbin

Resources
- Short length of strong cardboard tube
- 4-cm long rust-resistant nails
- Masking tape, coloured plastic tape

Approach

1. Using a separate piece of masking tape for each nail, tape four, six or eight nails around the rim of the tube depending on the size of the tube. Make sure that at least 2 centimetres of nail is taped to the side of the tube. Push the tape tight against the nail.

2. Wrap a length of tape all the way around at the top of the tube. Wind coloured tape around the whole tube.

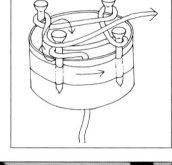

To Knit

Resources
- Bobbin
- Coloured wool and needle

Approach

1. To cast on drop the end of the wool down the tube and hold with the little finger of the hand that is holding the tube. Put the wool to the right of the nearest nail (left if left-handed), loop the wool around the nail and take it to the next nail right (or left). Loop the wool around this nail. Repeat this process until you are back to the beginning.

2. Hold the wool across the first nail, maintaining tension by using the index finger of the left hand to hold the wool to the side of the bobbin. Using finger nails or a blunt needle lift the bottom loop over the wool.

3. Turn the bobbin clockwise if right-handed (anticlockwise if left-handed), continually lifting the lower loop up over the wool. Hold the little tail of wool firmly with the little finger. Tug on it to pull the knitting through the tube.

4. To finish, break off the ball of wool. Thread the remaining length of wool onto a needle, pick up all the stitches from the nails and pull the wool through and fasten off.

Lengths of French knitting can be stuffed to make snakes and caterpillars. They can be used to make trees and branches. Long creepers can be made by sewing on felt leaves or leaves made from wire and old tights.

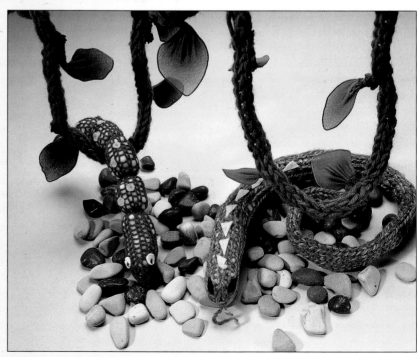

Pom-Pom Mice

Resources

- Thin card (cereal packets)
- Assortment of white, grey and brown wool
- Coloured felt
- Latex glue
- Needle and thread

Approach

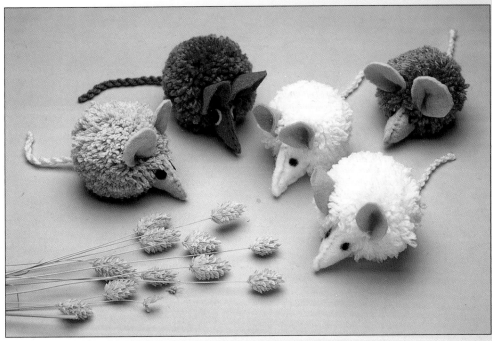

1. Cut out two circles, 6 centimetres in diameter, from thin card. Make these into rings by cutting out central circles 2 centimetres in diameter.

2. Hold the two card rings together and wind wool evenly all the way round, passing it through the central hole each time.

3. When the central hole is full cut through the threads around the edges of the card rings.

4. Pull the card rings slightly apart. Tie a length of wool firmly around the wool between the card rings and knot securely. Tear the card away.

5. Cut out two head pieces from felt and sew around the curved sides. Stuff firmly. Using latex glue, stick the head to the pom-pom, pressing it well into the cut threads.

6. Cut out two ears, fold and either glue or stitch them to the head. Glue on the eyes. Twist strands of wool together for a tail and glue into position.

Hedgehog Family

Follow the same procedure as for the mice but make a 10-centimetre pom-pom for the mother hedgehog and a 6-centimetre pom-pom for each baby. Use several strands of beige and brown wool together when winding the pom-pom. Use brown felt for the face.

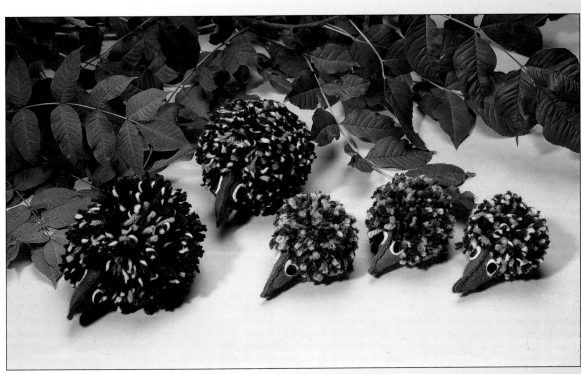

Wrapped Landscapes

Create landscapes around card. Portrait-shaped card will give depth to the scene.

Resources
- Thick carton card
- Double-sided adhesive tape
- Wool in landscape colours
- Felt scraps
- Glue

Approach

1. Stick a strip of double-sided tape down the middle of each side of the card.

2. Starting from the bottom wind wool around the card, pressing it to the tape. Use interesting textures as well as a range of shades. Wrap two shades of a colour together. Alter the angle of wrapping to create hills.

3. When the card is covered, cut out shapes from scraps of felt and glue them to the scene.

Stitched Cards

Resources
- Old greetings cards, postcards or magazine pictures glued to thin card
- Glue stick
- Embroidery cotton, thin needles

Approach

1. Using a straight stitch sew into the picture, embroidering the most important parts. Use larger stitches in the foreground and smaller stitches in the distance. Younger children will be happier using large images from magazines. They can then use thicker needles and yarn.

2. The finished pictures can be mounted in clip frames and given as presents or can be remounted on card to make greetings cards.

Fabric Collage Landscapes

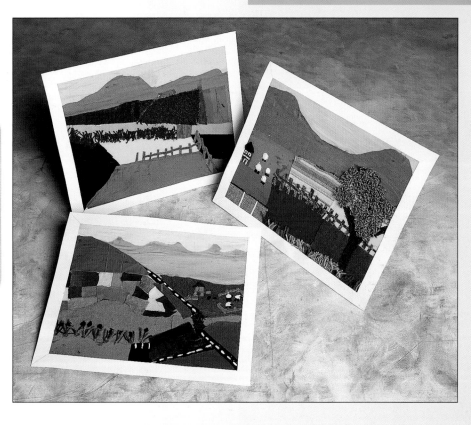

Resources
- Thin card on which to glue the fabric
- Wide variety of natural coloured fabrics in interesting textures, for example corduroy, towelling and velvet
- Wool, braids
- PVA glue

Approach

1. Begin by gluing a strip of sky-coloured fabric at the top of the card.

2. Work down from the sky in layers, adding distant hills and fields in cool colours. Work brighter colours into the foreground. Make sure that the whole card is covered.

3. Add detail such as fences, trees, animals and buildings. Clip short pieces of green wool and glue along the bottom edge of the picture or along river banks and road sides.

Fabric Collage Portraits

Resources
- Thin card
- White paper the same size as the card
- Small patterned wallpaper
- Variety of fabrics, wool and beads
- PVA glue

Approach

1. Cut a piece of patterned wallpaper the same size as the card and glue it on.

2. On the white paper draw the head and shoulders of a celebrity. Draw in the features and the clothes. This is going to be used as a paper pattern.

3. Cut out the head and neck. Pin this to some flesh-coloured fabric and cut out. Glue this to the card.

4. Piece by piece, cut up the drawing and use as a paper pattern to assemble the portrait. Add wool for hair and beads for earrings and jewellery.

Flowers from Tights

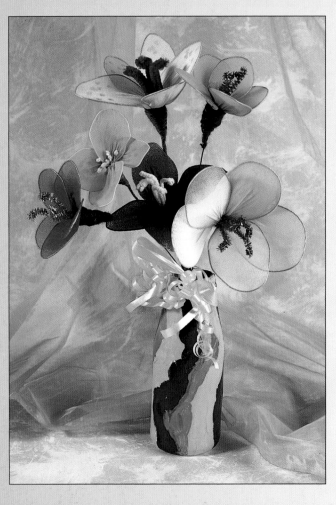

These flowers can be made from coloured tights, or flesh-coloured tights can be treated with a pre-dye and then dyed the required colour.

Resources
- Coloured tights
- Thick and thin flexible wire
- Green wool or thread
- Pipe-cleaners
- Felt-tipped pens

Approach

1. Make a petal shape out of thin flexible wire. Twist the ends together.

2. Cut a piece of tights fabric twice as long as the petal and wider. Stretch the fabric over the wire and hold all the edges together at the bottom of the petal. Wind and tie tightly with strong thread or wool. Trim off any excess fabric. Make enough petals for a flower.

3. Cut some pipe-cleaners to make stamens. Cut a length of thick wire for the stem. Using green wool, bind the stamens to a petal and bind each petal to the stem. Continue winding the wool around the ends of the petals until all the tights fabric is covered and the back of the flower is built up. Wind along the stem and finish by tying the wool to the stem wire.

4. Flowers made from light-coloured tights can be drawn on with felt-tipped pens.

5. Leaves can be made in the same way as the petals and added to the stem.

Snakes and Caterpillars

These colourful creatures are simply stuffed tights decorated with scraps of felt.

Resources
- Coloured tights
- Toy filler or chopped tights
- Scraps of felt
- Glue
- Needle and thread

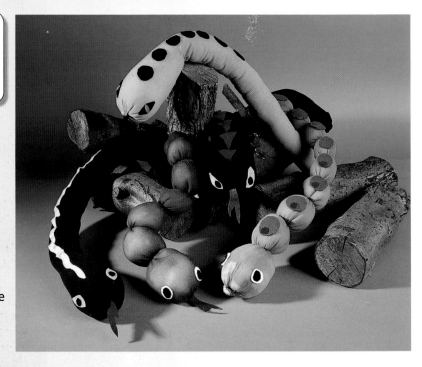

Approach

1. Cut both legs off a pair of tights. Pull one leg onto your arm then pull the other leg over the top. Remove the tights from your arm and give them a good stretch.

2. Stuff with toy filler or chopped tights and stitch up the end. For the caterpillar tie the 'sausage' into segments.

3. Add a forked tongue for the snake and glue on felt eyes and pattern detail to the body. Decorate with scraps of felt, tufts of wool, buttons and sequins.

Stuffed Faces

Resources
- Old tights
- Toy filler or chopped-up tights
- Buttons, wool, sewing thread and needle

Approach

1. Cut a leg off a pair of tights and stuff the toe end with toy filler to make a head shape. Twist the head around several times and pull the remaining length of tights back over the head. This makes a double layer of tights fabric. Fold the remaining end to the back and stitch down.

2. Either sew on buttons for eyes or cut them out of felt. To make the nose, pinch up a fold of fabric and stuffing and stitch through from side to side. Cut the mouth out of felt or stitch with red or pink wool. Add ears by stitching on little pads of stuffed tights. Stitch through the pads to create the folds in the ear.

3. Sew on strands of wool for hair. Add beads for earrings or bows in the hair. Make hats or add spectacles. The faces can be mounted on sticks for puppets or grouped together to make a class portrait!

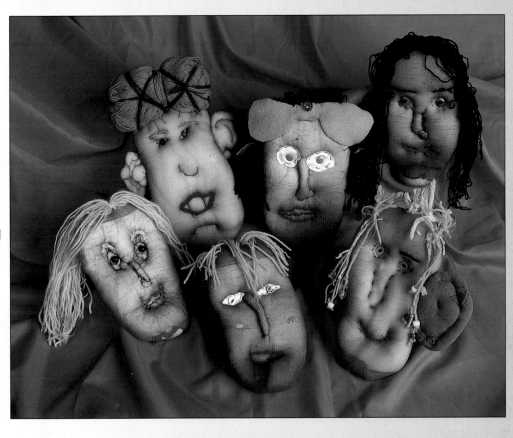

Coat-Hanger Faces

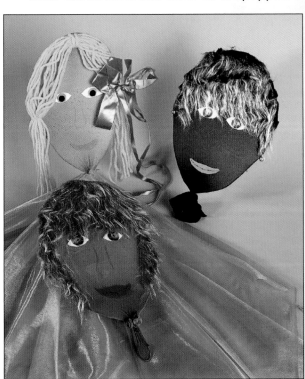

Resources
- Wire coat-hanger
- Old tights in flesh tones
- Fur fabric or wool
- Felt
- Glue

Approach

1. Pull the wire coat-hanger into a face shape with the handle at the bottom. Bend the hook in to make a holding loop.

2. Cut a leg off a pair of tights. Put the loop into the toe and pull the tights up over the wire. Twist the head around several times and pull the tights back down over the head. Tie at the chin.

3. Stitch or glue features onto the head. Scraps of fur, fabric or wool can be used for the hair. Eyes and mouth can be cut out of felt and glued on.

Pegged Squares

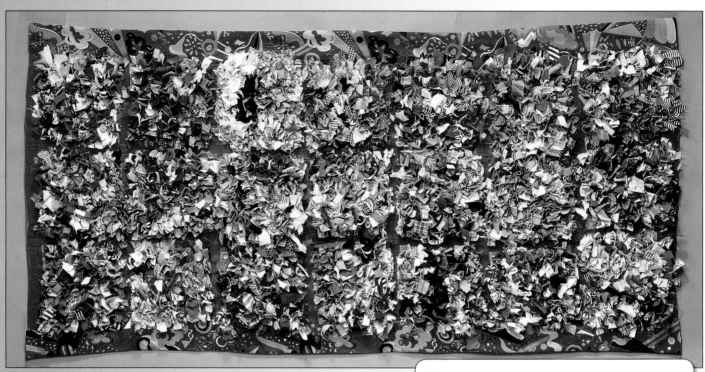

Approach

1. Zigzag the edges of the hessian on a sewing machine, or bind with masking tape to prevent fraying.

2. To make the prodding tool, break one of the legs off a dolly peg. Sand the other leg to a tapering point.

3. Using a felt-tipped pen, draw a margin the width of a ruler all the way around the hessian square.

4. Cut the fabric to be pegged into pieces about 3 centimetres wide and 10 centimetres long.

5. Make a fold in the hessian just below the pen line. Crease it well and keep the fold uppermost. Poke the peg through both layers of hessian just below the fold to make a hole. Now poke one end of the short strip of fabric through the hole. Pull it halfway through. Check that it is of equal length each side of the fold. Repeat all the way along the fold to the pen line. Do not work in the margins. (See diagram above.)

6. Hold the fabric each side of the fold and pull so that the fold opens and the strips of cloth lie each side. At this point they look like bows but they will stand up as you work each successive row. Make another fold just below the first row and start again. Repeat until the square is complete. If desired, the pile can be neatened by clipping.

Pegged Squares Rug

When all the squares are completed they can be mounted individually, turned into cushions or joined together to make a class wall hanging or rug.

Resources
- 30-centimetre square pieces of hessian
- Dolly pegs
- Sandpaper
- Felt-tipped pens
- Large supply of material scraps

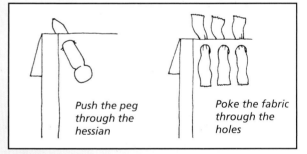

Push the peg through the hessian

Poke the fabric through the holes

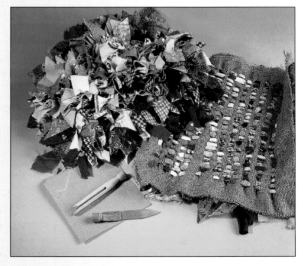

Class Rug

Resources
- Frame
- Hessian
- Felt-tipped pens
- Masking tape
- Drawing pins
- Dolly pegs
- Sandpaper
- Large supply of scraps of material

1. Mark the design on a large piece of hessian using felt-tipped pens. Zigzag the edges or bind with masking tape to prevent fraying.

2. Attach the hessian to a frame with drawing pins, stretching it well. Balance the frame between two tables so that the children can sit with their knees under the frame. The pieces of fabric should be cut the same size as for Pegged Squares (page 52) but the method varies slightly.

3. Using a modified dolly peg (see page 52), poke a hole in the hessian. Take a short strip of fabric and use the peg to poke one end of the strip through the hole. With the other hand under the frame pull the strip halfway through. Now make another hole very close to the first and poke the other end of the strip through. With the hand under the frame pull both ends even. All that should be seen on the top of the hessian is a small stitch. The two ends are hanging down below. Now poke the peg into the last hole that was made and poke another strip of cloth into this hole. You now have two pieces of fabric in the same hole. Make a new hole next to this one and poke the other end of the strip through. Continue in this manner until the rug is completed.

4. Take the rug off the frame. Turn the hems to the back and either glue with latex adhesive or sew.

To Make a Frame

Frames are very easily made. They are simply four lengths of wood held together with bolts and wing nuts. Decide upon the dimension of the rug. Cut the wood to size, drill holes and bolt the lengths of wood together. A metre in length is quite ample and 60 centimetres is sufficient for the width.

Rainbow Squares

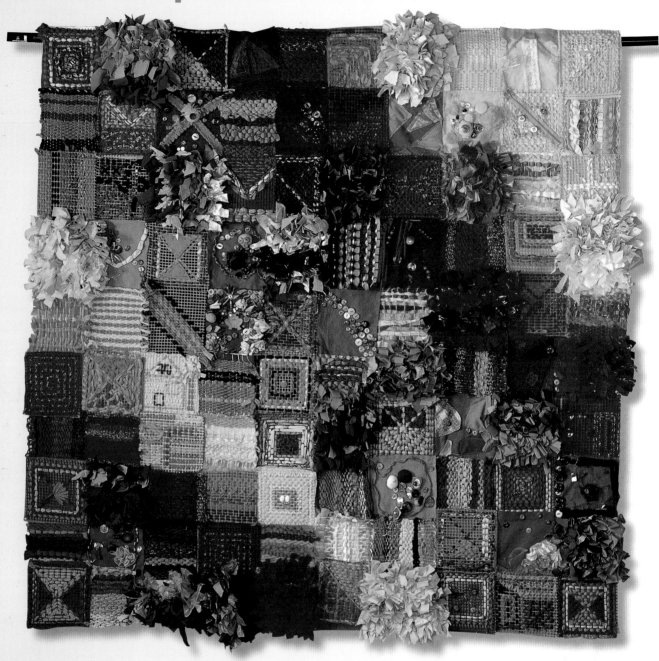

This is an opportunity to explore both colour and texture. It is ideal for a large group activity with each child contributing an individual piece to the final hanging.

Let each child choose the colour in which he or she wants to work. Ask them to start collecting things in shades of their own colour, such as beads, buttons, buckles, oddments of wool, coloured plastic bags, threads, parcel bows, florists' ribbon and artificial flowers.

Resources
- Children's collections (examples listed above)
- Carton card for looms
- Hessian
- Rug canvas
- Plain materials in various colours to use as a base on which to sew buttons, beads, etc.
- Embroidery needles, tapestry or large-eyed needles to take wool, weaving needles
- Latex glue
- Ready-mixed paint or powder paint

Canvas Squares

Paint a 16-centimetre square of rug canvas on one side with ready-mixed or powder paint in your chosen colour. Leave to dry. Using a wide variety of threads and materials stitch up and down through all the holes in the canvas. Vary the size, direction and type of stitch, (for example, running stitch, cross stitch and half cross stitch). Vary the texture by sewing with narrow strips of fabric, strips of plastic bag and different thicknesses of wool. Try using several strands of various shades together. Create further texture with the addition of buttons and beads.

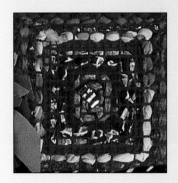

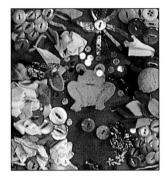

Button and Bead Squares

Create an interestingly textured square by sewing on numerous buttons, beads and sequins of various sizes. Cover buttons with material by cutting a circle a little larger than the button. Sew around this in running stitch until you are back at the beginning. Pull the thread so that the circle draws up into a little bag. Slip in the button. Pull up the thread firmly and stitch. Soft padded bobbles can also be made in this way.

Woven Squares

Cut an 18-centimetre square piece of carton card and make the loom as described for Place Mats (page 27). Keeping to shades of one colour, weave the square using wool, strips of fabric, plastic bags, florists' ribbon and so on. Do not leave the ends sticking out at the edges of the work. When the end of a row has been reached, weave back in the opposite direction, taking care not to pull against the end warp thread. When the end of a strip has been reached join a new one by overlapping the old for several centimetres and complete the row. Push the weaving down periodically to keep it firm. When the card is full, slip the weaving off by bending the 'teeth' forwards.

Fabric Collage

Make a collection of interestingly textured fabrics. Combine smooth, shiny surfaces of satin and taffeta with velvets and fur fabrics. A few small scraps of glittery fabrics would add highlights to the finished hanging. Small pieces of fabric may be sewn down randomly or a design may be developed using geometric shapes. Embellish with buttons, beads or even parcel bows.

Pegged Squares

Cut a hessian square 20 centimetres in size. Draw a 2-centimetre margin all the way around. Do not work in the margin. Neaten the edges to prevent fraying. Proceed as described for Pegged Squares (page 52), but work in shades of one colour. Combine plastic bags and fabrics. If desired, neaten the finished squares by clipping.

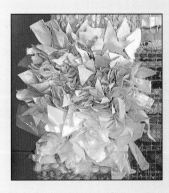

Assembling the Wall Hanging

An old dust sheet will make an excellent backing on which to glue the squares. Mark out the required area in 15-centimetre squares. This allows for the overlapping of squares so that none of the backing materials shows. Sort out the squares into colours and begin to lay them on the backing, working diagonally across the area. When satisfied with the arrangement stick down with latex adhesive as this remains flexible when dry.

The School Pond – A Textile Picture

This can be a whole school project with the children working on the picture a group at a time. Much of the picture can be worked separately and assembled later.

Approach

Resources
- Hessian
- Wooden frame on which to stretch the hessian (see Class Rug, page 53)
- Wide selection of knitting wool and fabrics in natural colours
- Green plastic bags in different shades
- Felt-tipped pens
- Drawing pins
- Latex glue
- Needles

1. Draw and photograph a pond scene, perhaps in the school environmental area.

2. Cut a piece of hessian the size of the finished hanging plus an allowance for turnings and a slot at the top for hanging. Neaten the edges to prevent fraying.

3. Using felt-tipped pens, draw the design on the back of the hessian, remembering that it will appear reversed on the front.

4. Mark in the areas to be pegged, such as the rough grass, bush and area between the pond and path. Use drawing pins to attach the hessian to the frame.

5. Use the following methods for each area of the design.

Background Bushes and Foliage

Make lengths of finger knitting for bushes and foliage. To finger knit tie a loop in the end of the wool several centimetres from the end. Put the loop on the index finger. Hold the short end of wool just below the knot with the thumb and second finger. With the other hand pass the long length of wool over the index finger towards the front. Hold this with the finger and thumb whilst passing the first loop over the second (see diagram). Pull on the long end to reduce the size of the stitch. Thicker strands can be made by finger knitting the lengths of finger knitting.

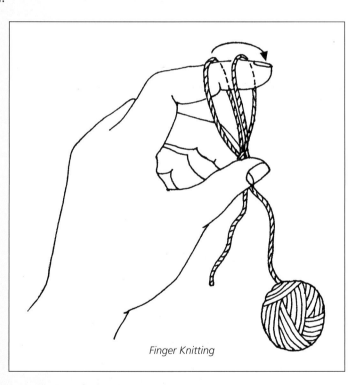

Finger Knitting

Grass and Leaves

Using a variety of green fabrics, peg the grassy areas as described on page 52. Peg the leaves of the bush with green plastic carrier bags. Cut double leaf shapes from the bag and peg as for the grass.

Stone Wall

Cut stone shapes from grey fabric. Sew around the shape leaving a small opening for stuffing. Stuff the stone and sew up the opening. (See Waterfall Hanging, page 33.)

Trees

Using shades of brown wool make strips of French knitting (see page 46) and ordinary knitting sewn into tubes for the trunks of trees. Alternatively, strips of weaving can be made on weaving sticks (See Stick Weaving, page 43).

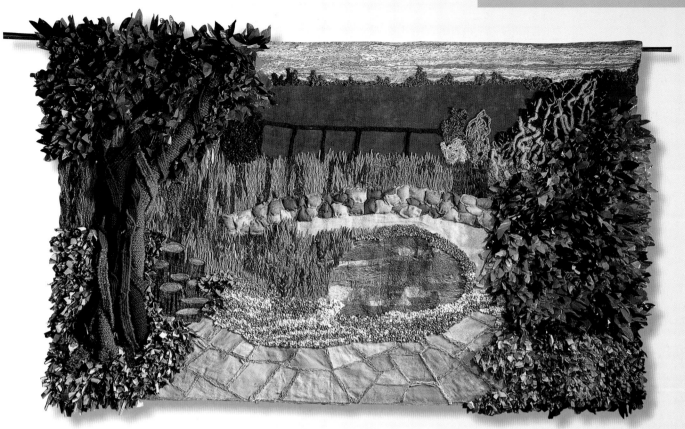

Pond

Cut a piece of fabric the size of the pond. Cut scraps of fabrics in blues, browns and greens and sew these to the pond background, or glue on for a quicker result.

Logs

Cut the logs out of textured brown fabric and stitch into them to add more texture.

Assembling the Parts

1. When the pegging is finished spread latex glue on the back of these areas to prevent pieces working loose. Leave to dry. Take the picture off the frame and turn it right side up.

2. Clip the grassy area by the pond very short.

3. Cut paving stones out of fabric and glue into position leaving small gaps between. Sew into these gaps with stone-coloured wool.

4. Glue the pond and the stone wall into position.

5. Twist up lengths of French knitting, stick weaving and knitting into a tree. Glue into position.

6. Cut a piece of plain green fabric such as velvet to the right size for the field. Glue into position. Only glue lightly around the edges because this will be stitched into.

7. Cut more double leaf shapes for the foliage of the tree. Poke these through the hessian from the back.

8. Using several shades of blue knitting wool, embroider the sky in a long surface stitch. (See Waterfall Hanging, page 33.)

9. Stitch on the finger knitting to form bushes on the skyline and behind the plastic bag bush. Glue or stitch on lengths of French knitting for the fence. Glue on the logs.

10. Cover any hessian that is showing with layers of stitching in wool of various shades of green. Stitch into the pond and give the impression of reeds.

11. When the picture is complete, turn back the hems and make a slot for a pole for hanging.

Textile Flowers – A Group Wall Hanging

The following textile work was inspired by a study of Van Gogh's *Sunflowers*.

Resources

- Assortment of fabrics
- Hessian
- Brown buttons and beads
- Brown thread, needle
- Toy filler or wadding
- Latex glue

Approach

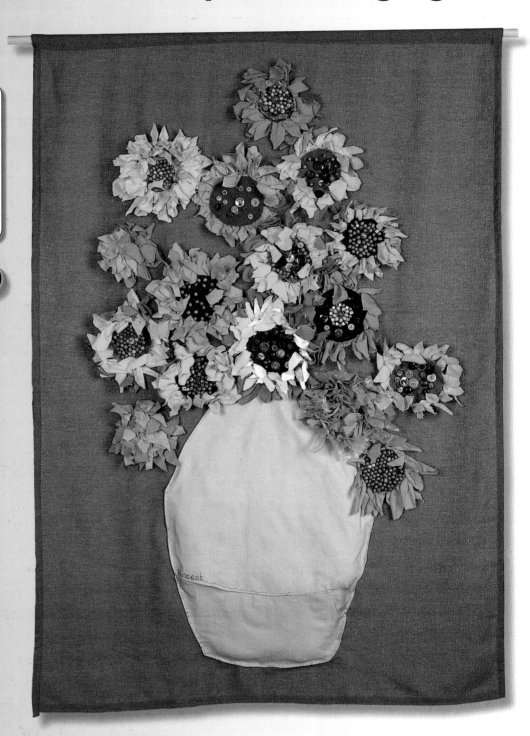

1. Choose a fabric for the centre of the flower. Cut out a circle 8 to 10 centimetres in diameter.

2. Stitch the circle centrally to a 25-centimetre-square piece of hessian. Stitch on buttons and beads to cover the circle.

3. Cut strips of yellow material about 4 centimetres wide by 12 centimetres long. Fold in half and trim the ends to a petal shape. Working from the back, poke the petals through the hessian (for the method see Class Rug, page 53). Some children could work one row, others two, in order to create different flowers. A row of green strips may be worked around some of the flowers.

4. Cut around the flower heads leaving a 4-centimetre border of hessian. Snip this at intervals. Fold over and glue to the back of the flower.

5. Cut out the vase shape and sew to the background leaving the top edge of the vase open. Stuff the vase lightly with toy filler. Sew down the opening.

6. Glue the flower heads in position with latex glue.

Individual Wall Hanging

Resources
- Rectangle of blue hessian
- Assortment of fabrics
- Buttons and beads
- Thread in various colours
- Toy filler or wadding
- Latex glue
- Cane or pole for hanging

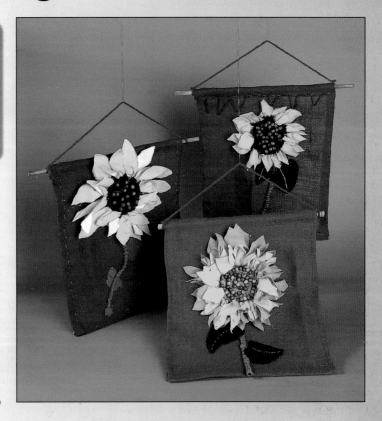

Approach

1. Pin and sew a rectangle of blue hessian, making a slot at the top to accommodate a pole or cane.

2. Sew the sunflower centre directly onto the blue hessian. Embellish with buttons and beads. Make the petals and poke through the blue hessian.

3. To make the stalk, roll up a rectangle of green fabric and bind with green thread all along its length. Couch this in position by sewing up on one side of the stalk and sewing down on the other.

4. Cut leaves out of thick green fabric. Sew these into position, padding them slightly with toy filler.

5. Slip a cane into the top and hang.

3-Dimensional Sunflowers and Vase

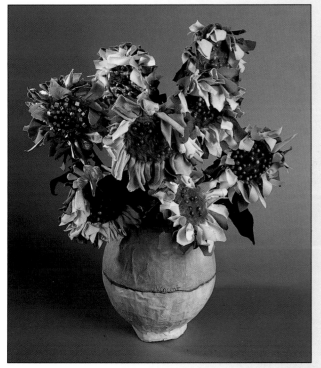

Resources
- Materials used for Group Wall Hanging (page 58)
- Materials used for Papier Mâché Balloon Vases (page 10)
- Stiff wire or thin cane
- Green fabric and thread, needle

Approach

1. To make the sunflower heads, follow steps 1–4 of the Group Wall Hanging.

2. Roll a length of stiff wire or thin cane in green fabric. Bind all along its length with green thread.

3. Cut a circle of green fabric the same size as the back of the sunflower head. Make a snip in the centre of this. Sew the green circle to the back of the sunflower neatly around the edges leaving a small section unsewn. Stuff the back of the flower with toy filler. Sew up the opening.

4. Push the end of the stalk through the hole in the centre of the green circle and either sew or glue with latex adhesive. If the stalk of the flower is made from wire, bend the top slightly. If the head wobbles about too much stick the bottom edge of the flower to the stalk.

5. To make the vase, see Papier Mâché Balloon Vases, page 10.

Flower Cushion

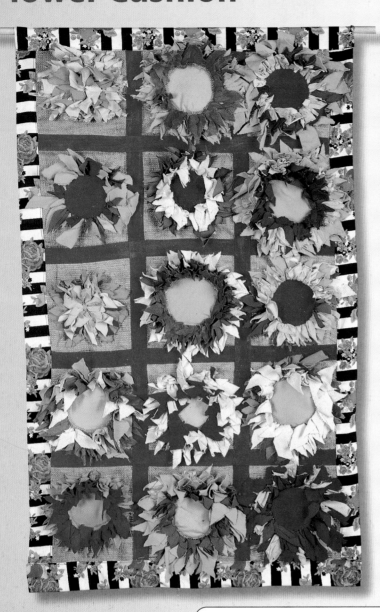

Approach

1. Cut out a circle of material for the centre of the flower. Either stitch this onto the square of hessian or use latex glue.

2. For the petals, cut strips of fabric about 4 centimetres wide and 10 centimetres long. Cut the ends diagonally to form petal shapes.

3. Working from the back, use a sharpened clothes peg to poke the petals through the hessian to the front. Work around the flower centre, making two rows of petals. Cut the leaves in the same way and work one row of leaves.

4. Cut out a square of coloured fabric for the back of the cushion. With the wrong sides of the fabric facing you, sew the front piece to the back of the cushion using back stitch. Leave an opening for stuffing. Turn right sides out, stuff the cushion and sew up the opening.

Flower Hanging

This could be a group or class project.

Approach

1. Let each child work on a 30-centimetre square of hessian to produce a cushion front as above. Use as many colour combinations as possible.

2. Sew the squares of hessian together in strips by overlapping the edges. Sew the strips together.

3. Sew braid over the joins and bind the edges with brightly coloured fabric. Make a slot at the top for a pole for hanging.

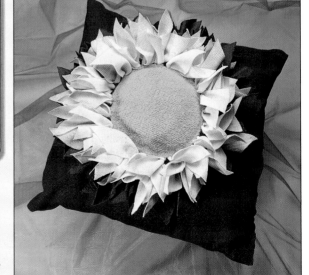

Button Mirror Frame

This is a way of giving new life to old vanity mirrors.

Resources
- Old vanity mirror
- Carton card
- Latex glue (optional)
- Double-sided adhesive tape
- Closely woven fabric or hessian
- PVA glue
- Buttons
- Curtain ring

Approach

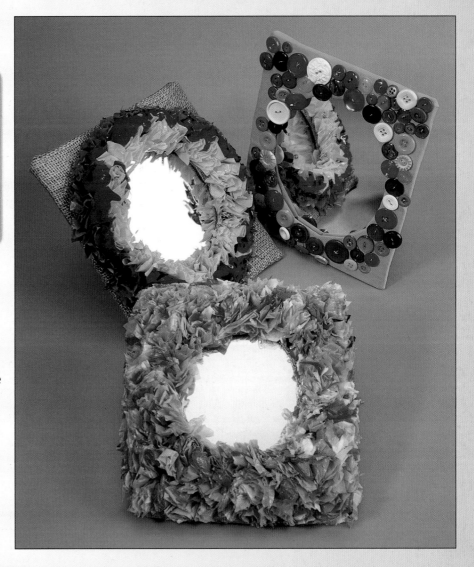

1. Draw around the mirror on a piece of carton card. Trim the card to the required frame size.

2. Cut a second piece of card the same size. Fix the mirror to the card with glue.

3. Cut out the mirror shape from the first piece of card, making the hole slightly smaller than the mirror.

4. Cut a piece of closely woven fabric slightly larger than the card. Place the card with the hole in it on the fabric and draw around the hole. Remove the card and sew buttons onto the fabric around the mirror shape.

5. When complete, fix the fabric to the card frame with double-sided tape. Cut out the middle section of fabric covering the hole but leave enough fabric to turn to the back. Snip all the way round to ease the fabric. Turn it to the back and glue.

6. Using the PVA glue, attach the frame to the card holding the mirror. Fold the edges of fabric back over both pieces of card and glue at the back. Cut a piece of felt and glue over the raw edges at the back.

7. Sew on a curtain ring for hanging.

Flower Mirror Frame

For Flower Frames use hessian rather than a closely woven fabric. Cut strips of brightly coloured fabric or plastic bag about 6 centimetres wide and 10 centimetres long. Prod these through the hessian following the mirror line. Work three circles of plastic bag or fabric strips. Trim the pegged strips as short as you wish. Complete as above for Button Mirror Frame.

Variation

Instead of working three circles of prodded strips, cover the whole front of the mirror frame with prodded strips of plastic in different colours. Clip very short to give a fluffy pile.

Button Pictures

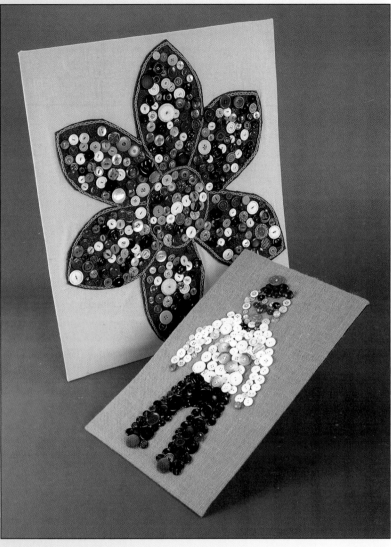

Resources
- Coloured fabric
- Needles and embroidery thread
- Buttons
- Carton card
- Double-sided adhesive tape
- PVA glue
- Curtain ring

Approach

1. Draw a picture onto a piece of coloured fabric, keeping the design very simple.

2. Sew around the outline of the picture using running stitch, back stitch or chain stitch depending upon the ability of the children.

3. Fill in the design by sewing on buttons. Use a thick embroidery thread as this will hold the buttons securely with fewer stitches.

4. When finished, attach the sewing to a piece of carton card using double-sided adhesive tape. Turn the edges to the back and glue.

5. Cut a piece of felt or other fabric and glue to the back. Sew on a curtain ring as a hanger.

Button Tubs

Resources
- Small lidded containers
- Coloured fabric
- Buttons
- Needle and thread
- Double-sided adhesive tape
- PVA glue

Approach

1. Measure the height and the circumference of the tub. Cut a piece of fabric this size plus a small allowance for overlap.

2. Sew buttons all over the fabric.

3. Glue the fabric to the container with PVA glue or use double-sided adhesive tape.

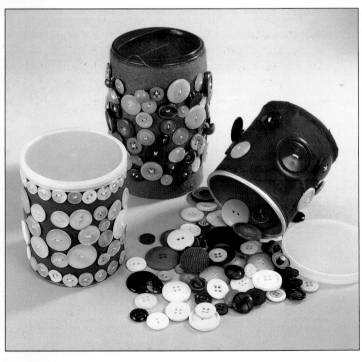

Beaded Sun-Catchers

These sun-catchers were inspired by the dreamwebs of the native North American peoples. You will need plenty of beads for a whole class project so start collecting broken necklaces well in advance.

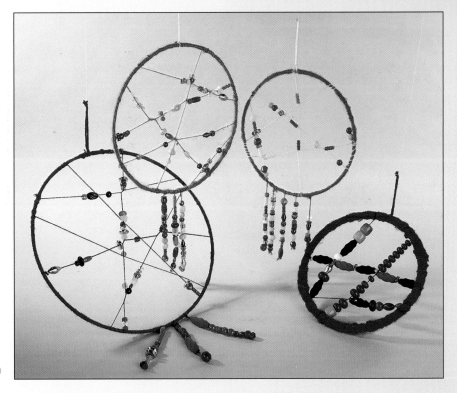

Resources
- Wire ring or thick card ring
- Coloured yarns
- Beads

Approach

1. Make a wire ring by bending a length of wire into a circle and securely taping the ends together.

2. Wrap a brightly coloured yarn around the ring. Secure the end.

3. Tie a length of yarn to the ring and thread on some beads. Secure the yarn at the other side of the circle by turning it around the ring several times. Remember to keep the yarn as taut as possible.

4. Thread on some more beads and re-cross the circle. Where two lengths of yarn cross wrap the second around the first to prevent the beads from sliding backwards and forwards across the whole width of the ring. Continue in this way until the space seems evenly divided.

5. Thread short lengths of beads and tie to the bottom of the ring.

Bubble Wrap Sun-Catchers

Resources
- Wire or thick card ring
- Large bubble wrap
- Marker pen

- Necklace beads, buttons, marbles, large sequins, glass nuggets, shiny sweet wrappers

- Coloured yarns
- Clear adhesive tape
- Needle and thread

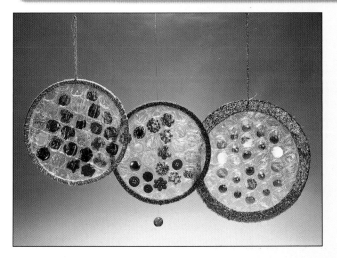

Approach

1. Place the ring onto the bubble wrap and draw around it with a marker pan. Cut out on the inside of the line so that no ink shows.

2. Make a slit in each bubble and insert the button, bead or other shiny object. Work along one row at a time. Seal the slits with clear adhesive tape.

3. Wrap the ring with yarn or thin strips of fabric. Place the bubble wrap into the ring and sew into position with thin thread.

4. Hang beads from the bottom of the ring if desired.

63

Embossed Foil Plates

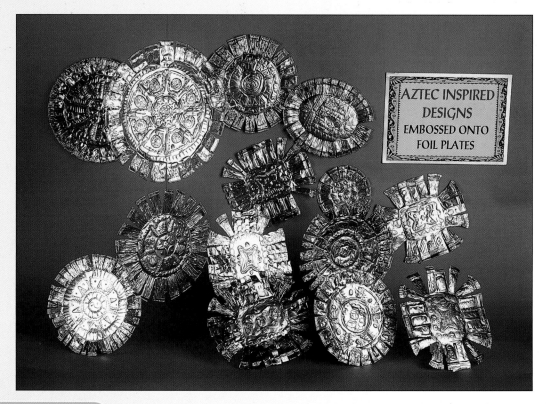

AZTEC INSPIRED
DESIGNS
EMBOSSED ONTO
FOIL PLATES

Approach

1. Cut slits into the sides of a foil dish or plate at regular intervals and flatten the sides down. Place it on a padded surface, such as a thick magazine or newspaper.

2. Using a blunt pencil draw the design onto the foil dish. Go over the lines several times to make them wider. Try filling in spots to create the impression of studs on the reverse side. Take care not to press too hard or the dish will tear.

3. If desired, the finished plates can be sprayed with gold or bronze paint.

Resources
- Large foil dish or plate
- Magazine or newspaper
- Pencil
- Gold or bronze paint (optional)

Foil Pendants

Resources
- Small foil dishes
- Carton card
- Pencil
- PVA glue
- Gold or silver knitting yarn

Approach

1. Cut slits into the sides of the dish at regular intervals, stopping just short of the base of the dish. Flatten the dish out.

2. Place the flattened dish onto a piece of carton card and use a blunt pencil to outline the base of the dish, pressing down firmly. Emboss the design onto the base.

3. Remove the dish from the card and you should see a clear outline of the bottom of the dish imprinted on the card. Cut out the card around the imprint.

4. Glue the foil (raised side uppermost) to the card shape. Bend the sides of the dish to the back of the pendant and glue. Roll the edges on a hard surface.

5. Pierce a hole through the pendant and thread with gold or silver knitting yarn.

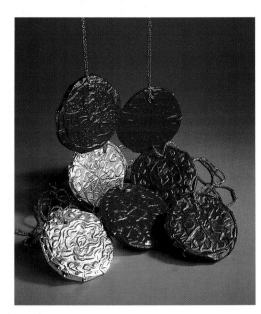

Carnival Shakers

Resources
- Coloured plastic bags
- Foil dishes
- Thin coloured card
- Rice or split peas
- Stick (garden cane or thin dowel)
- Brightly coloured fabric
- Clear adhesive tape
- Mini stapler

Approach

1. Cut narrow strips of plastic bag. Gather into two bunches and secure the ends with tape. Staple these to either side of a foil dish.

2. If desired, cut card shapes and staple these to the rim of the dish or thread wooden beads onto strong yarn and staple these so that they hit the dish when the shaker is twisted.

3. Put a little rice into one of the dishes. Put the other dish on top to form a lid. Staple the rims of the dishes together, leaving a space through which to push a stick.

4. Tape the stick securely to the dishes. Bind the stick with strips of brightly coloured fabric.

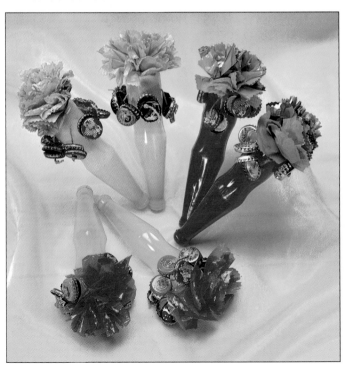

Bottle Top Rattles

Resources
- Thin, soft plastic bottles (preferably coloured)
- Metal bottle tops
- Coloured plastic bags
- Needle and strong yarn
- Hammer and nail
- Double-sided adhesive tape

Approach

1. Using a hammer and a nail, make holes in the centres of 20 bottle tops.

2. Thread a long needle with strong yarn. Tie a large knot at the end. Thread on two bottle tops. Stitch through the bottle to the opposite side and thread on two more bottle tops. Sew a large knot in the thread and cut off the end. Repeat this process until all the tops are sewn to the bottle. Dab a spot of PVA glue onto each knot to secure the top.

3. Decorate the top of the bottle by cutting small strips of plastic bag and tying together in the middle to form a flower or bow. Attach this to the top of the rattle with double-sided adhesive tape.

Bottle Top Figures

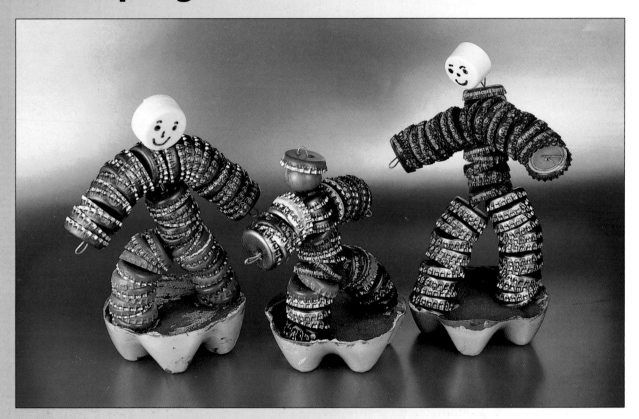

Resources
- Metal bottle tops
- Plastic bottle tops
- Thin flexible wire
- Hammer and nail
- Wire cutters

Approach

1. Using the hammer and nail, punch a hole in each bottle top. You will need about 70 tops for a figure. It is probably easier to punch a few tops at a time and build the figure up in stages.

2. Punch or drill a hole in the side of a plastic bottle top – this will be used for the head. Thread a length of wire through the hole bringing the two ends together. Twist the wire two or three times and open the two ends of the wire out to form the arms of the figure (see diagram a).

3. Slot another length of wire, twice the length of the intended body and legs, through the loop just under the head. Bring the ends together and twist tightly below the arm wire (diagram b).

4. Thread the bottle tops onto one arm to the required length. Snip the wire and bend the end over into a loop to form a hand and to hold the bottle tops in place. Repeat for the other arm.

5. Thread the remaining two wires together through the bottle tops to form the body (diagram c). When this is long enough, twist and separate the wires to form the legs. Thread tops onto each leg wire and bend the ends up into loops to form feet and to hold the bottle tops in place (diagram d).

6. The figures could be suspended on nylon line or set into tubs of plaster.

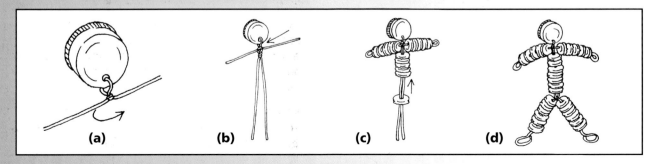

(a) (b) (c) (d)

Wire and Wool Figures

Resources
- Flexible wire
- Wire cutters
- Oddments of wool
- Tin lids
- Sawdust
- Double-sided adhesive tape
- PVA glue

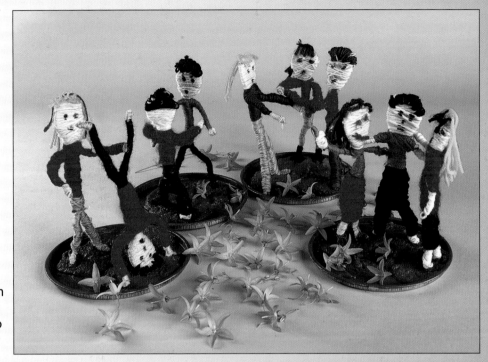

Approach

1. Cut a length of wire long enough to form the arms and head. Bend the wire to form the head. Twist the wire to form the neck and open out to make the arms. Bend the ends up into loops for the hands.

2. Make the body and legs as for Bottle Top Figures, page 66.

3. Wind wool around the wire figure, building up layers until the figure is sufficiently large. Sew in the ends of wool with a needle or simply glue them down. Put a strip of double-sided adhesive tape around the head before winding with wool. Add hair and facial features.

4. The figures can be mounted on tin lids using a mixture of sawdust and thick PVA glue. Paint when dry.

Bits and Bobs People

Approach

1. Hammer a hole in each bottle top. Hammer two holes if it is going to be used as a hat.

Resources
- Plastic and metal bottle tops of all shapes and sizes, corks, pen tops, film canisters, beads, buttons, the plastic casings from old felt-tipped pens, ring pulls from cans, small objects that can be threaded on wire
- Pipe-cleaners
- Flexible wire
- Wire cutters
- Hammer and nail
- Plaster and tin lids or thin thread

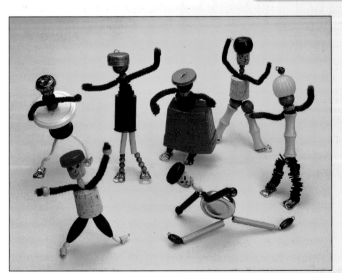

2. Cut a length of wire long enough to form the body and the legs when folded in half.

3. Fold the wire in half. Thread the ends of the wires through the holes in the bottle-top hat. Twist the two ends of wire together and thread on a bead or cork for a head. Add something small for a neck.

4. Cut a length of wire or pipe-cleaner for the arms. Felt-tipped pen casings can be cut to size and threaded onto wire for arms and legs. Thread the wire or pipe-cleaner through the two body wires and twist it around them to form the arms.

5. Punch holes in the rim of a lid for a body or thread on buttons or a cork. Larger bottle tops can be used as skirts. Ring pulls can be added as feet.

67

Wire Jewellery

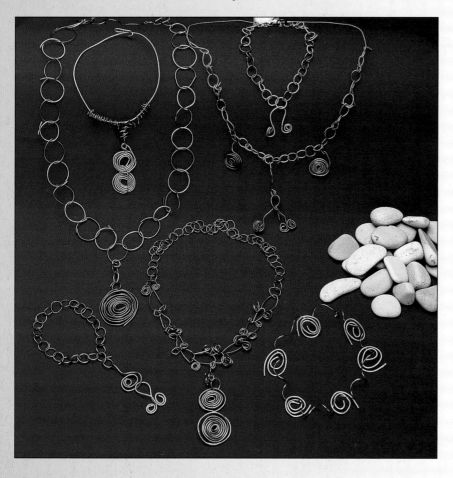

Resources
- Flexible wire (stripped electrical flex, oddments of garden wire or plastic-coated wire)
- Wire cutters
- Mini, long-nosed pliers

Let the children have a period of experimentation to get used to the tools and the wire.

To Make a Coil or Spring

Wind a length of wire around a pencil or length of dowel. Remove the coil and either squeeze the links closer together or leave them open. Snip the coils of the spring to make jump rings. Make plenty of jump rings. When joining them squeeze together well.

To Make a Flat Spiral

Grip the end of the wire with the long-nosed pliers and wind the wire part way round the tip of the pliers. Remove the pliers. Grip the coil flat between the pliers and keep turning it, gradually winding on more wire. Once a coil has been started it can be turned in the fingers. Several coils can be joined together with jump rings to form a necklace.

To Make a Shaped Spring

Make a spiral at each end of a piece of wire. Coil them up until they meet. Bring the spirals together by closing like a book. Using long-nosed pliers, pull the ends of the wire out to open up each spiral. These long spirals can now be hung from a chain.

To Make a Chain

Bend a length of wire into a U-shape. Make a tiny flat spiral at each end of the wire. Squeeze the U-shape together just above the spirals. Make several of these. To make a chain, hold one link by the spirals, slip the bend of another link into this and pull up. Bend the spirals of the second link upwards and flatten.

Variation

Introduce stones, sticks and shells into the jewellery making. Coil stones or sticks with copper wire. Look for shells with holes that can be threaded onto wire or linked with jump rings. (See also Acknowledgements, page 2.)

Ballerinas

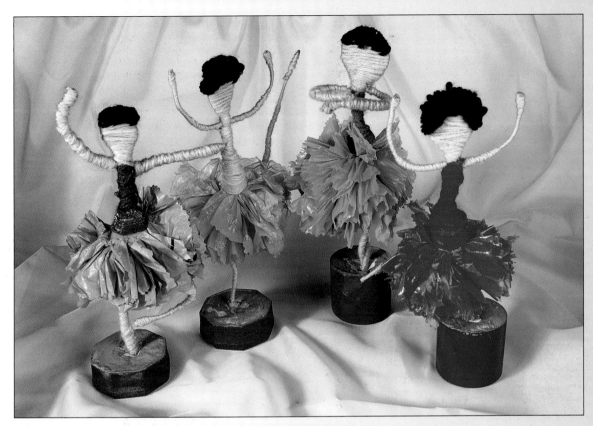

These little figures might develop from a study of movement and dance. Reference could also be made to the work of Degas.

Approach

Resources
- Wire
- Coloured plastic bags
- Clear adhesive tape
- Wool
- Lid
- Plaster

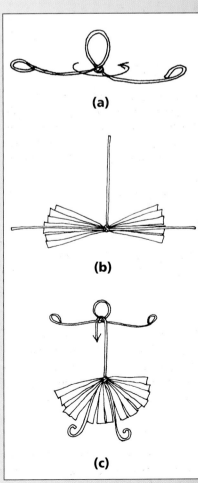

1. Cut three 30-centimetre lengths of wire. Make a loop in the centre of one length by coiling the wire around a small pot or thick dowel to form a head. Twist the wire together two or three times to form a neck and then open the wire out to form arms. Bend the ends up into loops (see diagram a).

2. Cut a coloured plastic bag into strips about 6 centimetres wide and 15 centimetres long. Gather the strips up and hold in the centre with a second length of wire. This wire will make the legs (see diagram b). Use the last length of wire to bind the plastic strips and leg wire together. Bend the plastic strips and leg wire downwards. Bind round the fold with clear tape to hold in position. Bend the ends of the leg wires up into loops to form feet.

3. Pass the end of the body wire through the head until the desired body length is reached, then bend the wire over and twist around the body (diagram c). Clip off any excess wire. At this stage the head and arms will flop around a little but will become firm when wound with wool.

4. Bind a little double-sided adhesive tape around the hips and head of the figure before winding with wool. Trim the skirt and bend the arms and legs into position. Set the dancer into a small lid filled with plaster.

(a)

(b)

(c)

Outdoor Nightlight Holders

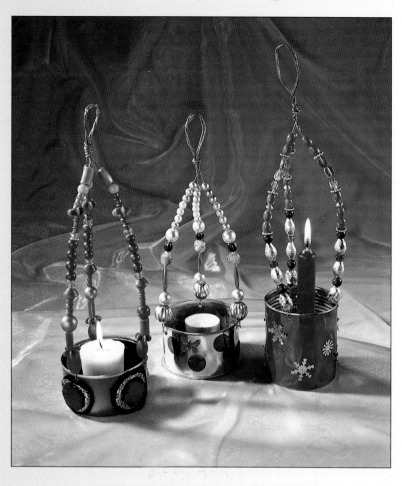

Recycle old tin cans into decorative lanterns.

Resources
- Shallow tin cans
- Wire
- Glass beads
- Hammer and nail

Approach

Make sure that the tops of the cans have been removed smoothly and there are no sharp edges.

1. Punch three evenly spaced holes near the rim of the can with a hammer and nail.

2. Cut three lengths of wire and thread them into the holes, twisting the ends down into the inside of the can.

3. Thread each length of wire with beads, leaving enough wire at the top to bend the ends over into a loop.

4. Decorate the can with sequins, shiny items or fabric.

5. Put small nightlights or candles in the cans.

⚠ **Never leave children unsupervised with burning candles.**

Wrapped Tin Cans

Resources
- Tins
- Oddments of wool, felt or fabric
- Double-sided adhesive tape
- PVA glue

Approach

1. Put several strips of double-sided adhesive tape down the sides of the can (three or four if using a large can, two for a small one).

2. Decide upon a scene and start wrapping wool from the bottom of the can upwards.

3. When the can is covered, cut out felt motifs and glue in position.

4. Cut out a circle of fabric and glue onto the lid.

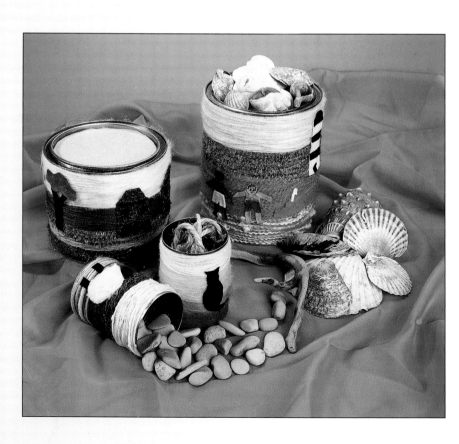

Beaded Plaques

These attractive plaques are made from broken or discarded jewellery.

Resources
- Tin lids
- Beads
- String or wire
- Hammer and nail
- PVA glue

Approach

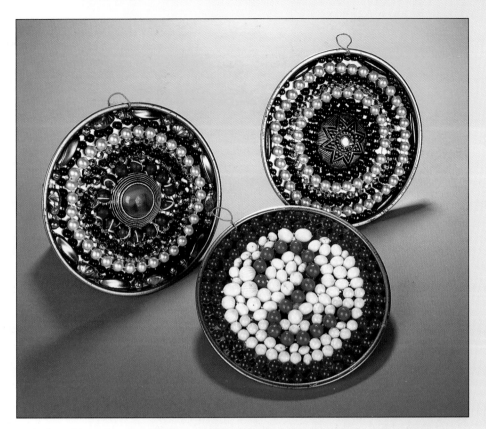

1. Using a hammer and nail punch a hole at the top of a tin lid and thread with string or wire to form a hanger.

2. Spread thick PVA glue into the lid. To make the shields, start in the centre with an earring or pendant. Then add circles of beads around this until the lid is full.

3. To make the number plaques, place a circle of beads around the outside edge of the lid. Make the number shape and fill in all the spaces.

4. Leave the plaques for several days to dry thoroughly.

Broken Crockery Mosaics

These mosaic plaques would be fun to make as part of a Greek or Roman topic.

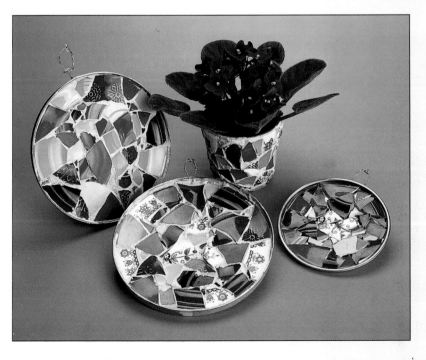

Resources
- Broken crockery
- Hammer
- Polythene bag
- PVA glue or plaster of Paris
- Tin lids
- Protective goggles

Approach

1. Make a collection of chipped or broken crockery and old plates.

2. Break these into mosaic-sized pieces by placing them a few at a time in a strong polythene bag and tapping sharply with a hammer. Ensure the bag is tied securely to prevent flying chips. Wear protective goggles and wear gloves when handling the broken crockery.

3. Make a hanger as above and spread plaster of Paris or PVA glue on the tin lid. Arrange the broken pieces of crockery to suit. Small rigid containers such as plant pots can also be covered.

71

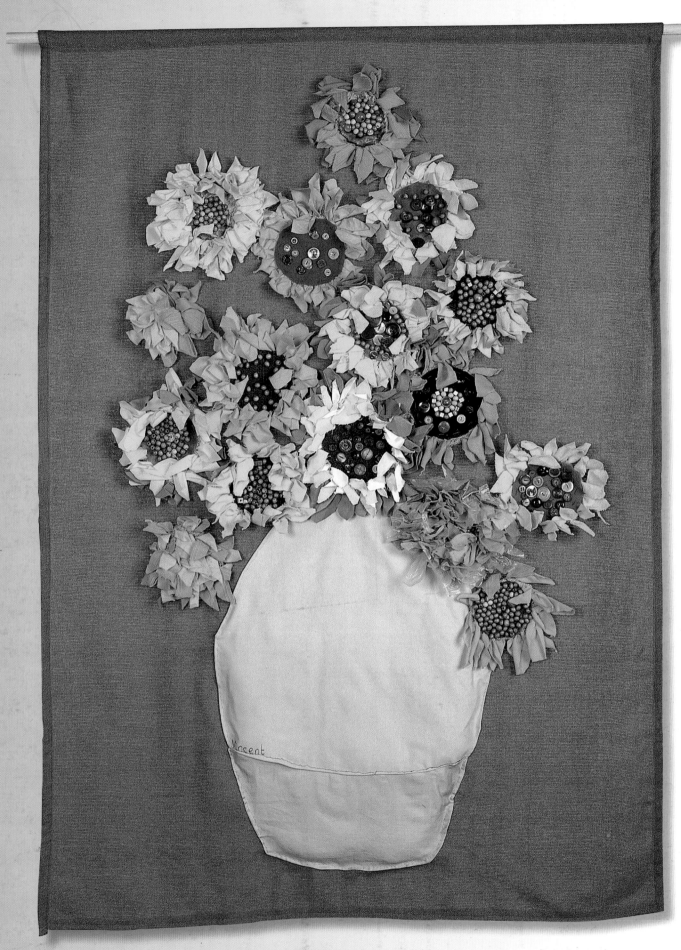

Textile Flowers – A Group Wall Hanging (page 58)

MEET THE IMPATIENT BEADER

Here's what Margot's friends have to say about her! Margot Potter is...

*loyal * sonic * luminescent * luminous * superstar * multifarious * innovative * eccentric * odd * different * incandescent * efficacious * unstinting * ebullient * witty * intelligent * entertaining * hilarious * vibrant * lovely * sweet * extraordinary * vivacious * fantabulous * heroic * indomitable * effervescent * sparkly * sparkling * multifaceted * scintillating * moxie * genuine * alluring * perspicacious * alive * spaz * superlative * bubbling * enthusiastic * dynamic * eclectic * fearless * creative * fabulous * glittery * sassy * cheeky monkey * wise * crabby * honest * real * kind * open-minded * generous * adorable * endearing * Renaissance-ish * smart * proactive * survivor * manifestor * spiritual * transformative * catalyst * fun * lively * pensive * determined * joyful * quirky * spontaneous * sagacious * loquacious * crafty * muse * free-spirit * therapeutic * loving * wonderful * talented * giving * friendly * energetic * sisterly * spunky * super * darling * special * pizzazy * sizzling * bead-sistah * promethean * goddess * ferocious * indescribable * resilient * splendiferous * avant-garde * vibrant * supercalifragilisticexpialidocious*

The self-appointed Bead Queen of the Universe and Mistress of the Bead, Margot Potter is a force of nature, a creative whirlwind, a dazzling diva (in the best sense of the word) and a woman of substance whose mission is to spread Super Girlie Good Power™ throughout the galaxy. Her irreverent approach to jewelry and craft design, her gift for color, her wicked sense of humor, her sensational sense of style on a budget and her ability to turn a phrase with panache are unparalleled. She inspires her readers to color outside of the lines and get their creative juices flowing. She doesn't merely think outside of the box, she thinks you should tear the box apart and turn it into something fabulous…then stand on it and reach for the stars. A woman of considerable talents and interests, she likes to say she has packed a lot of lifetimes into this one…because she has! Much like a crow, she is endlessly fascinated by sparkly things. Thus, she simply had to make this book.

If you'd like to know more about Ms. Potter, you are most cordially invited to visit Margot's world and her irreverently inspirational blog via www.margotpotter.com.

3

the impatient BEADER

presents

Sparkletastic

Dazzling Jewelry and Fashion
Projects for the Discriminating Diva

margot
potter

NORTH LIGHT BOOKS
CINCINNATI, OHIO
www.artistsnetwork.com

11 10 09 08 07 5 4 3 2 1

Distributed in Canada by Fraser Direct
100 Armstrong Avenue
Georgetown, ON, Canada L7G 5S4
Tel: (905) 877-4411

Distributed in the U.K. and
Europe by David & Charles
Brunel House, Newton Abbot,
Devon, TQ12 4PU, England
Tel: (+44) 1626 323200,
Fax: (+44) 1626 323319
Email: postmaster@davidandcharles.co.uk

Distributed in Australia by Capricorn Link
P.O. Box 704, S. Windsor,
NSW 2756 Australia
Tel: (02) 4577-3555

Library of Congress
Cataloging-in-Publication Data
Potter, Margot.
 Sparkletastic / Margot Potter. -- 1st ed.
 p. cm.
 Includes index.
 ISBN-13: 978-1-58180-973-2
 ISBN-10: 1-58180-973-5
 1. Beadwork. I. Title.
 TT860.P6835 2007
 745.594'2--dc22

2006036236

F+W PUBLICATIONS, INC.

This one's for the girls...

To every girl who ever sat on the sidelines wishing she could shine, this book is for you. Let me share a little secret with you, my love. Beauty is an attitude, and you are a superstar. Don't let anyone tell you differently. With a dash of glitter, a 100-watt smile, a great big dose of self-confidence and a fierce pair of shoes, you can light up any room. So break out your *Super Girlie Good Power*™ and let it shine!

Editor: Jessica Gordon
Art Direction and Design: Amanda Dalton
Production Coordinator: Greg Nock
Photographers: Christine Polomsky and Tim Grondin
Stylist: Jan Nickum
Illustrator: Vladimir Alvarez

Without you, I'm nothing

To my daughter, I am so sorry you had to give up your summer so Mommy could have four jobs, and I love you more than life itself. To Drew, thank you for taking care of our menagerie and keeping me sane while I worked like a madwoman. To Jessica, my favorite editor, you little minx, I adore you. To Christine Polomsky, your photos kick bootay. To Christine Doyle, thanks for another tremendous opportunity. To Amanda Dalton, thank you for the fantabulous book design. To Tim Grondin, thanks for the romantic romance photos. To Swarovski and Miss Kim P., there is no sparkle on the planet that compares. To Bob Mackie (the sparkle master), I bow down to your sparkly goodness. To Mistress Jean Yates, you rock...hard. To Laura at Sacred Kitsch Studio, you have the coolest stuff to play with on the planet. Finally, to the many fabulous drag queen friends I have known throughout the years...I cannot thank you enough for showing me what a freaking gas it is to be a girl! Yay!

Sparklies

Introduction 6

Girlie Girl 16

Rhinestone Cowgirl 30

Fashionista 46

Screen Queen 60

Diva in Training 74

Disco Dancer 88

Rock Star 108

Resources 124

Patterns 126

Index 127

INTRODUCTION

Some people sparkle. Even in a burlap sack, somehow they manage to shine like a finely faceted gemstone. They are the kind of people others describe as effervescent, scintillating, dynamic—people who light up a room just by being in it, who love to stand out in the crowd, who have a deep affinity for all things glamorous, girly and good. Don't they look like they're having the time of their lives? Wanna join in the fun? Maybe you're a closet sparkle freak longing to wear a tiara to the grocery store or a sequined tank top to the gym, or maybe you secretly dream of Liberace's piano and Bob Mackie's Oscar gowns… Well, my little diamond in the rough, the time has come for you to break out the glitter and release your inner diva!

I can't seem to help adding a dash of sparkle to most every design. Am I tacky or fabulous?! Who cares! I am sparkly, and it works for me. Life is too short to sit on the sidelines in a frumpy old pair of torn jeans. So what if you don't have a ticket to the dance—make your own dance, honey. Add a dash of glitter and sequins, and see what it does for your mood. It is pretty tough to be grumpy in a fantastically sparkled ensemble. Even if other people laugh at you, let them…you are a sparklicious diva, and they are missing out on all of the fun!

Diamonds might be a girl's best friend, but let's face facts, dahling: Crystal is a girl on a budget's better friend. Why should your ring finger have all the fun? Join me as we break out the crystal wand, the glitter and the sparklies, and bedeck, bejewel and bedazzle our world into sparkletastic goodness! You can opt for a tasteful accent of subtle shimmer or go for over-the-top glitz—it is entirely up to you. Whoever said we had to stop playing dress up when we grew up was a stupid-headed stick in the mud. This book has a dizzying array of designs that are fun, quick and easy to make, and they will take you on a glamorous adventure to a glittery wonderland. Viva la sparkle!

Life is short; be sparkly!

Mayot Pott

> "She's very sparkly. Definitely very sparkly. Very sparkly."
>
> —Rain Man

SKILL LEVEL GUIDE

All designs in this book are rated for your creative safety. Don't be afraid to move beyond your creative comfort zone—there is no failure beyond the failure to at least give it a whirl…right?!

Sparkle Virgin

If you're a Sparkle Virgin, you'll find these simpler projects the easiest.

Sparkle Vixen

If you're a Sparkle Vixen, you're ready to step it up a little and try something a bit more challenging.

Sparkle goddess

If you're a Sparkle Goddess, well, then you can do anything you want. If you want a challenge, these projects are for you.

THE ESSENTIALS OF SPARKLEDOM

Magic Sparkle Tools

In order to sparkle up your world, you will need an array of tools with which to create glittery goodness. Every creative effort is far, far easier to execute with the proper tools. Dahling, I know it sounds so dry and technical, and guess what…it is! Fear not, sparkle kitty, the fun stuff is a cake walk for those who are prepared!

Round-Nose Pliers are jewelry pliers with round graduated, pointed tips that provide the ideal foundation for all basic wirework. You can loop and wrap your wire and head pins to your heart's delight with these puppies.

Chain-Nose Pliers have flat, pointed pincers that live to grasp and pull wires. They are essential for wireworking, especially for manipulating head pins. The thinner the nose, the more freedom you have to work in tight spaces.

Flush Cutters are sharp little wire cutters that make your wire cuts clean and easy. Beading wire and metal findings cannot be cut with scissors. The wire will be compromised and your scissors will be shot.

Clockwise from top left: round-nose pliers, chain-nose pliers, rhinestone setter tool, hot-fix applicator tool, crimp tool, flush cutters

A **Crimp Tool** is a specialized pair of pliers used to flatten and fold crimps to create a secure clasp-to-wire connection. The crimp tool gives you a professional finish and helps to make your jewelry designs last. I know this tool is a little expensive, but your happiness is worth more than a few dollars, isn't it?

The **Hot-Fix Applicator Tool** is an all-grown-up version of the Be-dazzler, and man is it ever cool! This little tool heats up crystals with adhesive backings so you can stick them on porous surfaces like fabrics, suede and even paper! You will have so much fun with this thing, you may get lost for a while. Leave a trail of crystals in case they have to send out a search party.

A **Rhinestone Setter Tool** sets rhinestones and/or studs for you if you do not have the thumbs of steel and oodles of patience required for hand-setting. There are a variety of tools on the market that will bend the prongs for you. It's a personal preference for the most part, so try a few out and see which one does the job to your liking.

Magic Sparkle Materials

You can dangle, drop, glue, set and stud to your heart's content; you just need the proper foundation. Fill your drawers with a variety of wires, ribbons, chains and findings so your projects can suit your many facets. Think of these as the bones, because good bones are everything!

Clockwise from top right: beading wire, waxed linen thread, grosgrain ribbon, jump rings, clasps, earring wires, ribbon, selection of chain, head pins and eye pins, memory wire and leather cord.

Beading Wire comes in a veritable rainbow of colors and gauges. The best and most secure wire for stringing beads is a cabled multistrand stainless steel wire. This type of wire comes in a variety of diameters (thicknesses) and should fill the hole of your beads to keep designs from wearing down easily. The higher the strand count, the more flexible and strong the wire. Wires with higher strand counts are a bit more costly, but it is a matter of quality and durability. Read the packaging carefully for recommendations on what wire to select for your project.

Chain is a terrific medium for showcasing charms and dangles. It adds a modern edge to even the sweetest design. There is a vast array of chain out there, from plastic to precious metal. Try a variety of materials to give your work a little sass.

Other Stringing Materials include memory wire, rubber, leather, suede, stretch strand...the list goes on. Enjoy working with any and all of these items—each one offers a slightly different set of techniques and results. After all, you are a woman of ever-changing moods, are you not?!

Ribbon is a great way to add excitement to your projects. Just attach the sparkles to the ribbon or use the ribbon to add texture, color or interest to your projects. There is an endless variety of fun ribbon out there, so play, play dahling!

Crimp Tubes and Clasps provide the finishing touches on your jewelry designs. These handy little findings can be entirely functional, or they can become part of the design. Crimp tubes and crimp beads are tiny metal findings that are flattened and folded to connect clasps to wire or to create bead stations. They come in different finishes. Clasps come in all varieties, big and small.

Head Pins and Eye Pins are used mainly to create beaded dangles. Head pins have a flat bottom to secure a bead to make a dangle or an earring. They can be coiled or turned and attached to your jewelry designs with pliers. The eye pin has a looped end for when you plan to create connected beaded chains or charms. Both are available in base and precious metal, the latter being more expensive but far easier to manipulate.

Jump Rings are little metal rings that are a necessity for the jewelry artist. Use jump rings to attach dangles to chains or to connect beaded segments and give them flexibility. Jump rings can also be artfully connected to make elaborate chains and chain maille...if you are truly patient and have a lot of time on your hands. Good luck with that...

9

Sparkle, Sparkle, Who's Got the Sparkle?

Swarovski, That's Who!

Swarovski crystal is without question the world's finest crystal. Swarovski was the first to make cut-crystal beads and continues to be an innovator. Twice a year Swarovski debuts amazing innovations in color and style. There are other manufacturers of crystal beads, and many imitators. These other crystal beads may be far less expensive, but they are, conversely, far less fabulous. At right is a smattering of the crystal beads manufactured by Swarovski, because I love them. I would never presume to tell you what to buy, but don't come crying to me if your designs lack a certain level of fabulosity.

briolettes

star-shaped crystals

bicones

crosses

faceted rounds

step-faceted rounds

polygons

disco ball beads

cubes

flat-back and hot-fix crystals

Briolettes: This cut has had a recent surge in popularity in fine jewelry. A briolette is drilled at the top, and the rounded bottom of the bead is heavily faceted to create a highly reflective and refractive bead. For earrings, these beads are unparalleled.

Teardrops: This cut is similar to a briolette, but the hole is drilled from top to bottom for ease in stringing or hanging beads on head pins. Teardrops are fabulous for earrings or as charms on bracelets.

Cubes: The crystal cube is a relatively new shape, and it's available in a variety of sizes. The cubes shown here are drilled from top to bottom, but there are also cubes drilled on the diagonal for a more asymmetrical appeal.

Crosses and Such: Swarovski makes a wide variety of interesting crystal shapes including stars, crosses, snowflakes, hearts and starfish.

Bicones and **Top-Drilled Bicones:** The traditional bicone crystal bead is probably the most familiar style of crystal to the average consumer (next to the faceted round). They are the most affordable choice, and they come in virtually every size, color, finish and effect Swarovksi produces. Opt for the regular style, or choose the top-drilled style that hangs as a dangle when threaded on wire or a jump ring.

Disco Ball Beads: This bead has lots of fabulous facets running over the entire bead that make it look like a disco ball. If you can't find a disco bead, the faceted round is a perfectly acceptable substitute.

Flat-Back and **Hot-Fix Crystals:** These are either faceted or round flat-back crystal stones in a huge variety of shapes, sizes, finishes and colors. The flat-back variety can be glued onto all sorts of surfaces with a two-part epoxy. The back of the Hot Fix version is coated with a glue that liquefies when heated with a special tool or iron, so the stones can easily be adhered to any porous surface.

Step-Faceted Rounds: This cut is wicked cool, as they say in Massachusetts. It's faceted in rectangular steps that work down the bead on a diagonal. So it's twisted *and* faceted, which makes for very unique light refraction. The more ways you play with light in your designs, the more dynamic and thusly sparkletastic they become.

Clockwise from top left: scrapbook papers (on bottom), box, cherry button, key charms, buttons, skull charm, page pebbles, tin tile, bracelet blank, collage images, skate charm, transparency collage images

Sparkle Enhancers

You can't just sparkle all the ding-dang day long without adding a little dimension. Ya gotta add a little zig to your zag, baby. There's a wide world of charming charms, papers, blank frames, buttons, baubles, images—golly jeepers, it's a never-ending world of delights. You just have to free your mind.

Buttons: These are more than mere fasteners. Use them like beads, and expand your stringing and jewelry-making repertoire exponentially.

Metal Blanks: These frames and blanks are spaces waiting to be filled with your imagination. They're perfect for mixed-media designs, découpage and soldering.

Collage Images: You can mine old magazines, advertisements and greeting cards for images, or you can use a premade sheet instead. These sheets of collage images are a blast to use in mixed-media designs. Some are even printed on transparency sheets.

Scrapbook Papers: Even if you're not "scrappy," the scrapbook aisles can be tons of fun. These papers are chock full of fun and whimsical inspiration.

Flat Glass and **Plastic Stones:** When placed over an image or a printed word, flat glass stones and plastic pebbles from the scrapbook aisles protect the paper and magnify the image. To use them for jewelry, simply découpage a small-scale collage onto a metal blank, then glue a flat stone on top.

Charms: Integrating charms is the easiest way to add that touch of *je ne sais quoi*. Made from a variety of materials, shapes, sizes and themes, charms are endlessly fascinating. They make a perfect contrast to sparkly elements, and they provide dimension, depth and theme to your work. Gather up some charms, Princess Charming.

BEAD BASICS

Here is a step-by-step tutorial with photos of the basic skills you will need to master for the jewelry-making projects in this book. Practice makes perfect, so don't skip it! Before you know it, you'll be a Bead Master!

Attaching a Crimp Tube

This is the easiest and most secure method for attaching a clasp to a wire. I highly recommend you use this method to give your jewelry a finished and professional look.

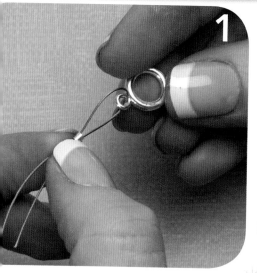

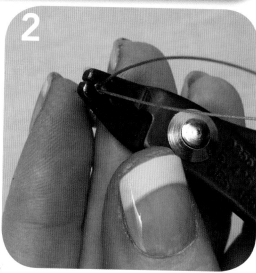

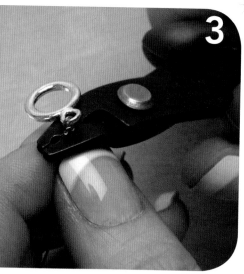

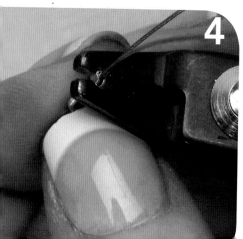

SPARKLY TIP:
take it from me

Keep the wires separated (uncrossed) inside the tube before you crimp. You will have to hold them in place with your thumb as they will really, really want to cross. You won't let them, though, because you are the mistress of the crimp tube!

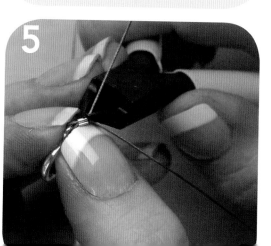

1. Slide wire through clasp and crimp tube
Cut a length of wire about 4" (10cm) longer than the finished length of the piece. Thread a crimp tube onto one end of the wire, about 2" (5cm) from the end. Thread the end of the wire through the clasp and back through the crimp tube, allowing a little of the end of the wire to stick through the crimp tube. Slide the crimp tube up on the wire, leaving about ⅛" (3mm) between the clasp and the tube to prevent rapid wear on the wire.

2. Compress tube into oval
Place the crimp tube in the first large, round indentation of the crimp tool, and gently compress the tube into an oval. This step is often omitted, but it helps to create a successful finish.

3. Secure wires inside tube
Place the crimped tube vertically into the second slot on the crimp tool with the smooth side facing toward the jaws of the pliers and create an indention in the middle of the tube, securing the wires inside the tube.

4. Fold crimp tube in half
Move the indented crimp tube back to the first opening in the crimp tool and fold the tube in half.

5. Trim end of wire
After crimping the tube, each wire should be neatly separated by the metal tube, not crossing. Use flush cutters to trim the excess tail of the wire, making sure to cut the wire flush against the crimp tube.

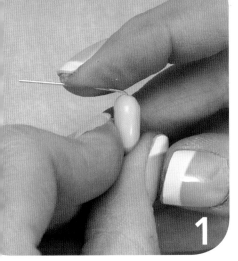

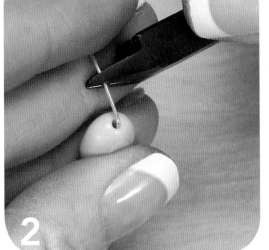

Turning a Head Pin

The turned or looped head pin is an essential skill for making earrings, charms and dangles. Practice makes perfect here—as you master the technique, your loops will continue to improve.

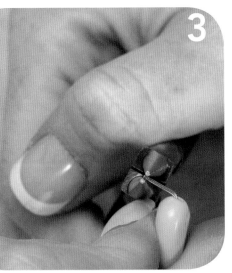

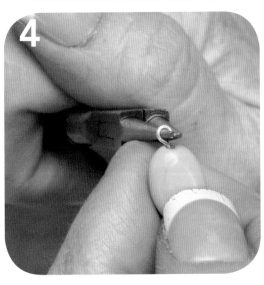

1. Bend wire
Slide the bead onto a head pin and bend the remainder of the wire with your fingers at a 90° angle, flush to the top of the bead.

2. Cut wire
Use wire cutters to trim the wire about ⅜" (1cm) above the bead.

3. Position pliers to make loop
Grab the tip of the wire with round-nose pliers.

4. Create loop
Roll the pliers toward you to create a loop.

5. Tighten loop
Use chain-nose pliers to tighten the loop so that it is fully closed with no gaps.

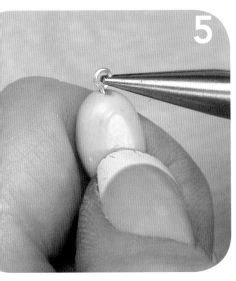

Opening and Closing a Jump Ring

When secured properly, jump rings provide an easy way to attach dangles and charms to your jewelry. Always double-check to be certain the jump ring is completely closed with tension to prevent losing your dangles!

1. Open jump ring
Grab the jump ring on either side of the break with round-nose and chain-nose pliers (or two pair of chain-nose pliers). Move the pliers away from each other laterally to open the jump ring.

2. Close jump ring
Use pliers to move the ends of the jump ring back toward each other to close it, again using a lateral movement. Use pressure while moving the ends past each other, then back toward each other until they "click" into place.

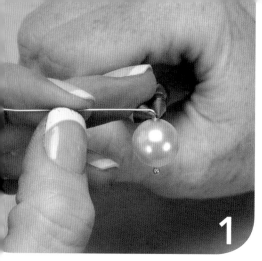

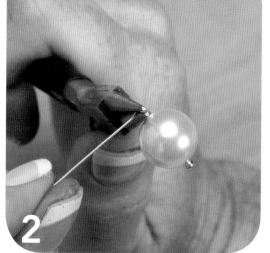

1

2

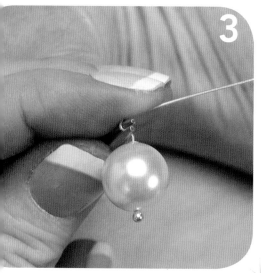

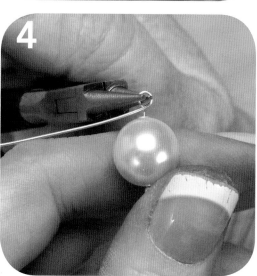

3

4

5

6

Making a Wrapped Loop

Wrapping or coiling a head pin is another essential skill for making earrings and dangles. This method creates a secure finish and can also become a decorative aspect of your design.

1. Bend wire
Slide the bead onto a head pin and grab the wire directly above the bead with the round-nose pliers. Bend the wire with your fingers to a 90° angle, just as when turning a head pin.

2. Position pliers
Position the pliers vertically to the top of the bead to prepare to make the loop.

3. Create loop
Use your fingers to bend the wire up and over the nose of the pliers and simultaneously move the pliers toward you to start making a loop. Making a neat, even loop takes practice, so don't worry if it isn't perfect the first few times.

4. Prepare to create coil
Continue holding the loop you made with the round-nose pliers and hold the bead between your thumb and middle finger. Begin to push on the tail of the wire with your index finger to begin to wrap it around the base of the loop.

5. Create coil
While holding the loop securely with the round-nose pliers, wrap the tail of the wire around the base of the loop. If using a base metal head pin, you may have to use another pair of pliers to help wrap the stiffer metal. Continue to wrap the wire around the base of the loop two to three times until the wrapped wire is flush with the top of the bead.

6. Trim wire and tighten wrap
Cut off the wire tail with flush cutters, with the flat side facing away from the tail end to make a flush cut. Tuck the very end of the wire tail into the wrap by tightening it with the chain-nose pliers.

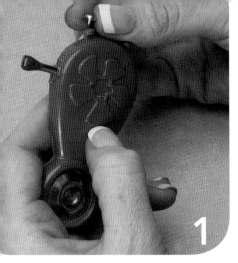

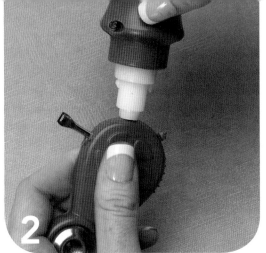

Setting Studs 101

A rhinestone or stud setter can be a great time-saver for setting flat metal studs into fabrics. It's not for setting studs of the male variety—sorry, gals. There are many versions available at craft stores, so try several to see which one you prefer.

1. Place stud in tool
Place the stud prong-side-down on the plastic bump on the plate tool.

2. Slide stud setter over stud
Slide the mouth of the stud setter over the stud and click the stud into the opening by pressing down.

3. Set stud in fabric
Place the fabric over the plate tool, centering the area to be embellished directly in the center of the indented plate. Hold the stud setter firmly and press down in a slow and continuous motion.

4. Check prongs
Turn the fabric over and check to be sure all the prongs are securely folded down. If they are not all secure, you can bend them down with a flat metal tool of your choice, or remove them and try again.

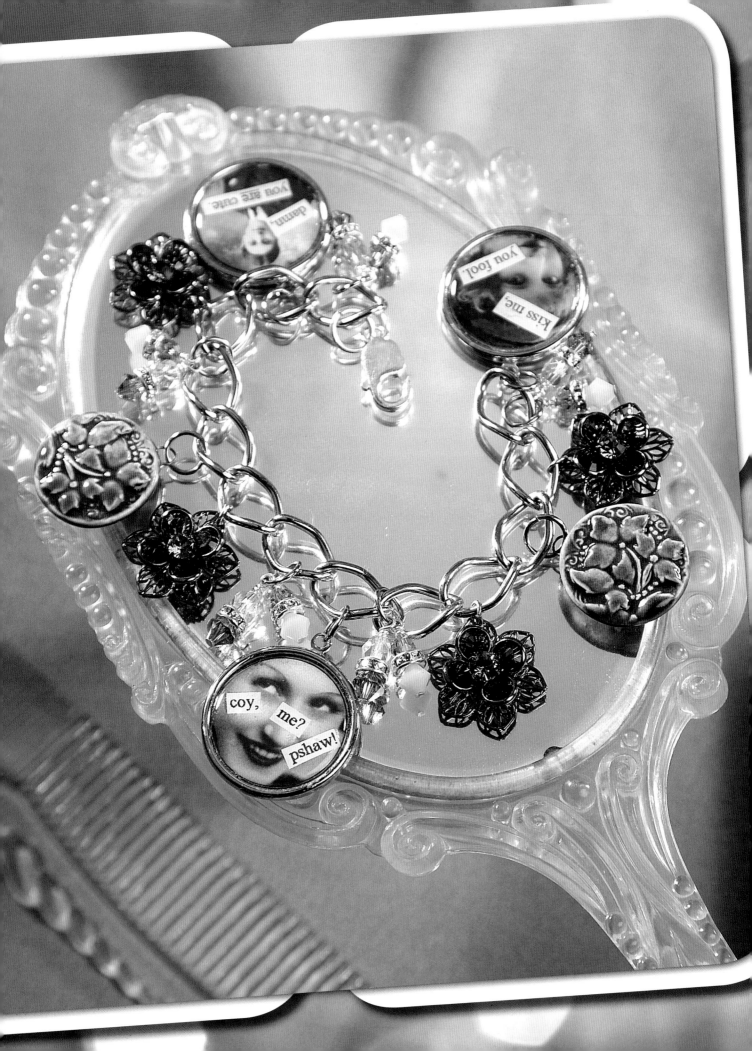

"You'd be surprised how much it costs to look this cheap."

—Dolly Parton

GIRLIE GIRL

"The really frightening thing about middle age is the knowledge that you'll grow out of it."

—Doris Day

*I*n a one-room shack down in the hollers of Tennessee there once lived a little girl named Dolly. She sang to her eleven brothers and sisters, and she grew up to be a successful singer/songwriter whose considerable musical talents and exuberant larger-than-life personality (and yes, it's true and she'll be the first to admit it, breasts) helped make her an icon. With her penchant for sparkly costumes, long nails, a bevy of wigs and naughty high heels, Dolly is a living celebration of all things girlie. She makes no excuses and she laughs at herself with joyous abandon. She plays five musical instruments, has had twenty-five songs reach number one on the Billboard country charts, and has seven Grammy awards. That's not too shabby for a backwoods girlie girl, now is it?

OK, so maybe you think being girlie is lame-o. Maybe you think it is impossible to be strong, smart, independent and frankly feminine at the same time. Maybe you wouldn't be caught dead in any shade of pink. Well, maybe you just haven't explored the power of the girlie girl. What do you have to lose by giving it a try? Take a walk on the girlie side, girlie. For maximum girlishness, try the luscious Keys to My Heart Necklace (page 22). If you don't want to think pink but you still want to feel flirty, take a gander at the Feel Lucky Necklace and matching earrings (page 20), and for the days when you want to pile on the charm try the Sweetie Pie Charm Bracelet (page 28).

Sparkle Virgin

WHAT YOU WILL NEED

SPARKLIES, ETC.

pink cotton twill tote bag with button-on purse handle loops

"Martini" iron-on transfer

"Shoe" iron-on transfer

"Shopping Bag" iron-on transfer

bamboo bead purse handle

raveled rosettes trim

silver-plated fuchsia Swarovski filigree

pink quilter's thread (extra strong)

UTILITIES

iron

hot-fix applicator tool (optional)

scissors

scrap piece of fabric

strong fabric glue

sewing needle

disposable gloves

A Girl's Life Tote

My best girlfriend Tam and I live far apart these days, and I so totally miss our girl time. Particularly all-day shopping, buying cute shoes and taking a break in between for a tasty beverage. The trifecta. So…here's to the divine Miss Tamara…I raise my martini glass to you. Shopping just isn't the same without you, doll.

SUPPLIES: CANVAS BAG, RAVELED ROSETTES AND BAMBOO PURSE HANDLES BY BAG BOUTIQUE/PRYM DRITZ; GLAM-IT-UP! IRON-ON TRANSFERS BY TULIP DUNCAN; CRYSTAL FILIGREE ACCENT BY SWAROVSKI; QUILTER'S THREAD BY COATS & CLARK; FABRI-TAC BY BEACON ADHESIVES

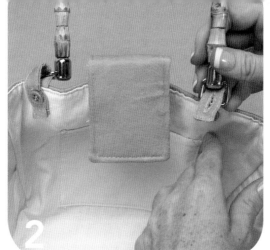

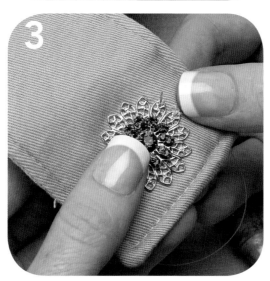

1. Apply transfers to purse

Follow instructions for preparing transfers. Heat the iron at the wool setting. Place the shoe image on the left side of the front of the handbag and press with the iron under a scrap piece of fabric for 30 seconds. Remove the plastic covering. If any crystals are loose, carefully reset them with a hot-fix applicator tool. Iron the image from behind to further secure the crystals. Repeat for the shopping bag image on the right front side of bag. Place the martini image on the center back of the purse and repeat the process.

2. Secure purse handles

Place the bamboo handles on the button-on loops, carefully adjusting the width of the handles if they don't fit.

true craft
c o n f e s s i o n s

I made a mess of the shopping bag transfer, so I improvised, rearranged and...voilá...mess averted. Fret not, pet. With enough glitter, you can make anything better!

3. Sew on crystal filigree

Hold the crystal filigree on the front flap of the purse at the back side of the magnet. Sew the filigree on around the outside of the magnet, using two stitches per outer petal.

4. Glue on trim

Leave a wide bead of fabric glue on top of the bag as you follow with the raveled rosettes trim. Work your way around from the front magnet, along the side, back, side and back to the front magnet.

5. Finish purse

Cut away excess trim to finish the purse.

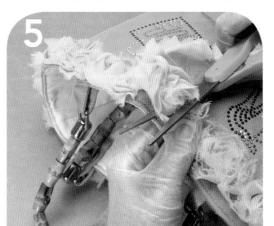

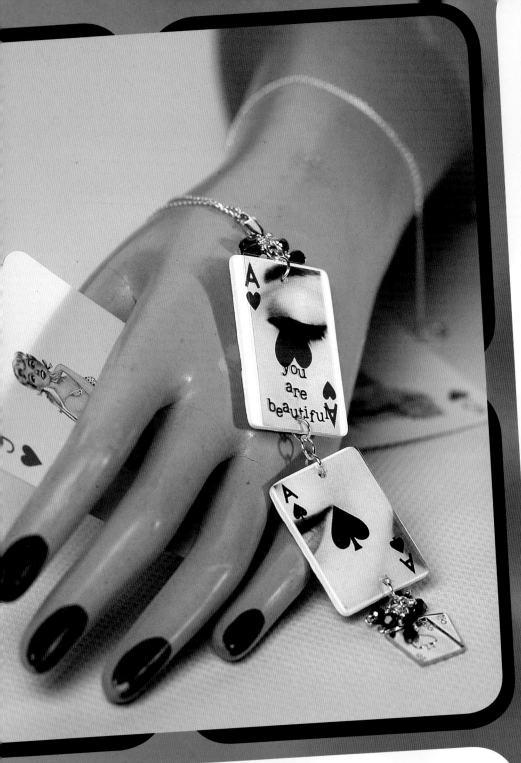

WHAT YOU WILL NEED

SPARKLIES, ETC.

PENDANT

one large ace of hearts painted wooden playing card

one small ace of spades painted wooden playing card

one microscope slide transparency image

six 4mm jet AB Swarovski rounds

three 5mm light Siam Swarovski rounds

three 4mm light Siam Swarovski rounds

one metal ace of spades charm

nine 4mm sterling jump rings

six 1½" (4cm) 22-gauge sterling head pins

one sterling lobster clasp

one 18" (46cm) sterling chain with clasp

EARRINGS

two small ace of hearts painted wooden playing cards

two microscope slide transparency images

four 4mm light Siam Swarovski rounds

four 4mm jet AB Swarovski rounds

two metal ace of spades charms

ten 4mm sterling jump rings

four 1½" (4cm) 22-gauge sterling head pins

two flat ball sterling French earwires

UTILITIES

round-nose pliers

chain-nose pliers

handheld wood drill with ⅛" (4mm) bit

scissors or craft knife

Feel Lucky Necklace

Hey, you, gorgeous, listen up. You are beautiful. You are sassy. You are the best thing since sliced bread. You rock. Don't doubt it for a moment. It's all about attitude...self-confidence...and the ace up your sleeve: Super Girlie Good Power™.

SUPPLIES: WOODEN CARDS BY CRAFTER'S SQUARE; TRANSPARENCIES FROM ARTCHIX STUDIO; CARD CHARMS FROM SACRED KITSCH STUDIO; CRYSTAL BEADS BY SWAROVSKI; STERLING FINDINGS FROM MARVIN SCHWAB/ THE BEAD WAREHOUSE

1

1. Cut images to fit cards

Cut transparency images from the sheet of images. Place the face on the large card, carefully cutting the bottom of the image to fit. Cut the bottom of the image to fit the small card.

2. Drill holes

Find the center point, then use a wood drill to carefully drill through the image and card. Drill through the bottom and top center of the card. Repeat for the smaller card.

3. Link cards

Thread the top hole of the top card with two jump rings. Link the second card to the first card with two more jump rings. Link a final jump ring to the remaining free hole at the bottom of the second card.

4. Add crystal dangles

Create a looped-top head pin dangle with three 5mm Siam beads and three 4mm jet beads. Use head pin remnants to make loop-bottom and coil-topped dangles with the remaining pendant beads. Add a jump ring with 5mm Siam, 4mm jet, 5mm Siam, lobster clasp, 4mm jet, 5mm Siam, 4mm jet dangles to the top jump ring. Close jump ring with pliers. Add a jump ring with 4mm Siam, 4mm jet, 4mm Siam, 4mm jet, 4mm Siam and 4mm jet to bottom of card. Slide jump ring and card in the center of this bottom jump ring. Link the lobster clasp attached to the chain to the top set of jump rings to finish the necklace.

2

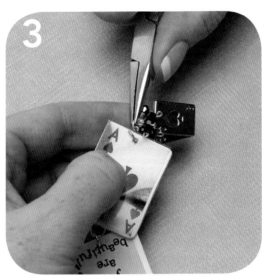

3

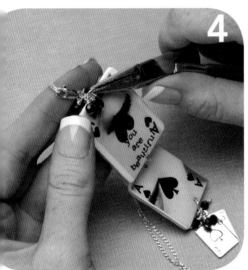

4

try this

Feel Lucky Earrings

Feel extra lucky when you wear these matching earrings. If you're headed to Vegas, more is more. If you are going to the grocery store, less might be more—or not. Just don't show your hand!

Make an adorable pair of lucky earrings using another image from the transparency sheets and the same processes you used in the pendant. Flip one sheet over so you get a left and right earring. Attach the components in the order shown.

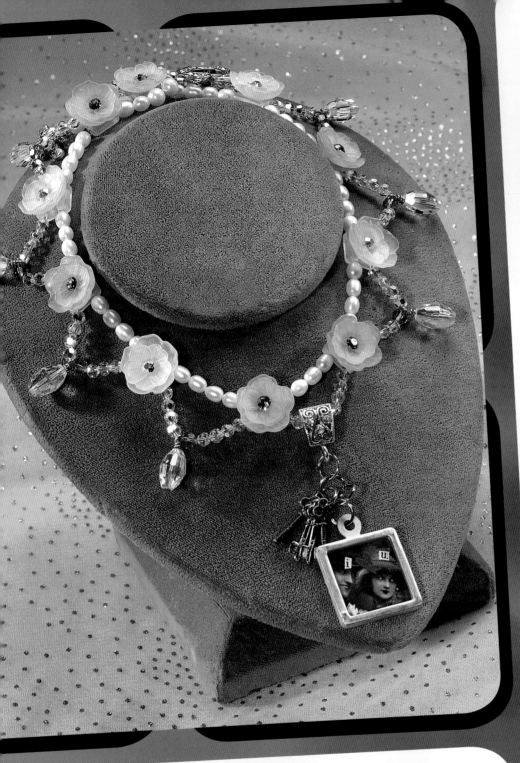

Sparkle
Vixen

WHAT YOU WILL NEED

SPARKLIES, ETC.

one brushed white metal frame

vintage lovers image

"i" and "u" printed out in 8-pt Times New Roman

tiny handmade red paper cut-out heart

four metal key charms (2 oxidized and 2 bright white metal)

six baby pink Lucite and crystal 2-hole flowers

four white Lucite and crystal 2-hole flowers

ten 12mm x 8mm crystal AB Swarovski elongated ovals

ten 5mm rose Swarovski rounds

eighty-eight 4mm crystal AB Swarovski rounds

forty-four 6mm freshwater pearl ovals

one light rose Pure Allure heart toggle clasp

one crystal AB Pure Allure fancy pendant bail

ten silver-plated head pins

two size 2 crimp tubes

five 10mm white metal jump rings

three 2mm white metal jump rings

49-strand .013" (.3mm) Beadalon wire (one 19" [48cm] length, one 22" [56cm] length)

UTILITIES

round-nose pliers

chain-nose pliers

crimp tool

cutting mat

craft knife

tweezers

bead board

glue stick

Keys to My Heart Necklace

Hey, cutie pie, got a dapper dandy determined to steal the keys to your adorable heart? Oh, my little romantic fool, subtlety schmubtletly…tell him, tell him, tell him that you love him!

SUPPLIES: LUCITE FLOWERS, CRYSTAL BAIL AND TOGGLE CLASP BY PURE ALLURE; FRESHWATER PEARLS BY FIRE MOUNTAIN GEMS AND BEADS; CRYSTALS BY SWAROVSKI; WIRE, JUMP RINGS AND CRIMPS BY BEADALON; METAL FRAME BY I KAN DEE/PEBBLES INC; VINTAGE IMAGE BY ARTCHIX STUDIO

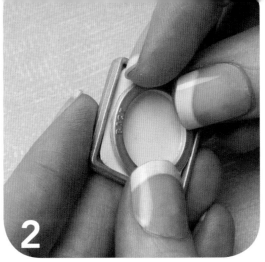

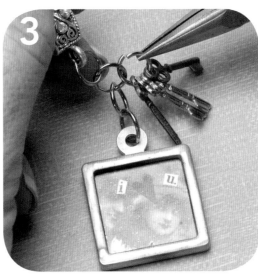

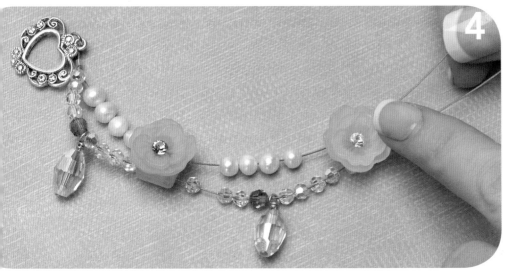

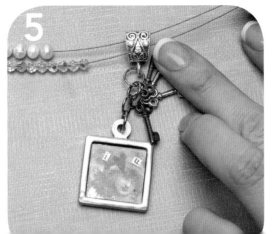

1. Create mini collage

Print out an "i" and "u." Use a craft knife and cutting mat to cut around the letters, but don't make it perfect! Cut the tiny heart by folding the paper, just like you did in grade school. Lay the plastic tile from the frame on top of the image and cut around it. Use tweezers to grasp the tiny cutouts and adhere them with glue.

2. Secure collage in frame

Pull the plastic film off the tile, then place the image behind it and place them into the back of the frame, tile first. Secure the tile and paper with the metal circle.

3. Create pendant

Attach four 10mm jump rings to the top of the pendant in a chain, linking the fancy bail to the top jump ring. Slide the keys onto a separate jump ring and attach them to the front of the second jump ring. Set the pendant aside.

4. Begin beading necklace

Slide the heart side of the toggle onto a 2mm jump ring, and attach the two wires to the jump ring with a crimp tube (see Bead Basics, page 12). String four pearls onto the top shorter wire. String four crystal rounds, one rose round, one elongated oval dangle, and four more crystal rounds onto the bottom longer wire. Thread the top and bottom wires into a pink two-hole flower. Repeat sequence, threading the beaded wires into a white flower. Alternate between pink and white flowers as you repeat the sequence until you reach the center of the design. If you like, you may lay out your design on a bead board before you begin stringing.

5. String on pendant

After the fifth flower, string four pearls onto the top wire and eight crystal rounds onto the bottom. Slide the crystal bail onto the strand with the crystals. Continue beading in established pattern. Attach two jump rings to the bar of your toggle clasp, then secure the wires with a crimp tube (see Bead Basics, page 12). Leave some exposed wire in the back to allow the design to drape when worn. The necklace should swag easily, and should not curl. Avoid pulling the wires too taut as you secure them.

23

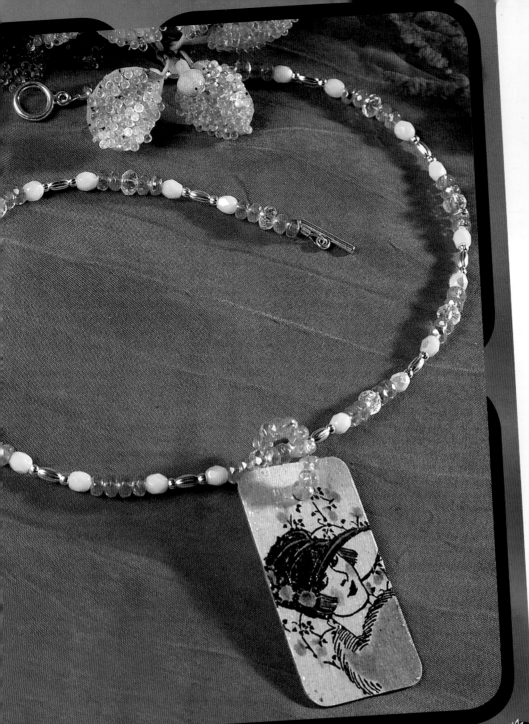

Sparkle
Virgin

WHAT YOU WILL NEED

SPARKLIES, ETC.

one 1" x 2" (3cm x 5cm) gameboard tag

sixty-five striated pink Czech glass rondelles

twenty-four mint green AB Czech glass ovals

thirteen crystal AB Czech glass rondelles

twelve .66mm silver-plated barbells

three 1mm x 1mm sterling crimp tubes

one small silver-plated toggle clasp

19" (48cm) .013" (.3mm) 49-strand Beadalon stringing wire

UTILITIES

rubber stamp with flapper image

black pigment ink

Fabrico markers sorbet pack

paper-gloss découpage medium

flush cutters

crimp tool

bead board

disposable paintbrush

disposable gloves

Oh, You Kid Pendant

A stamped and hand-colored game board tag takes center stage in this sweet little number. Flappers had all the fun—now you can too! Just jump right into that rumble seat and go, go, go!

SUPPLIES: GAMEBOARD TAG BY MAKING MEMORIES; CZECH GLASS BEADS FROM YORK NOVELTY IMPORT INC.; WIRE, CLASP AND CRIMPS BY BEADALON

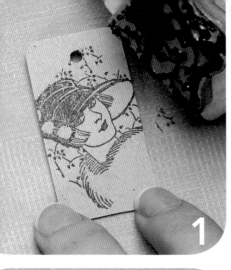

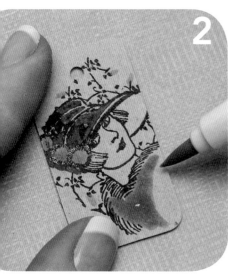

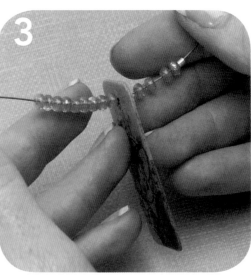

1. Stamp tag
Ink the stamp and place the tag on the stamp at an angle, using your fingers to compress the stamp on the tag. Allow the ink to dry.

2. Color in stamped image
Use markers to add color to the image, so it looks like a hand-tinted photo. Allow the ink to dry. Paint découpage medium onto the front of the tag with horizontal strokes. Allow to dry. Apply a second coat with vertical strokes. Allow to dry. Repeat for back of tag.

3. Create beaded bail
Thread a 2" (5cm) length of wire with four pink glass rondelles and thread it through the back of the tag. String nine more rondelles onto the wire and slide both wire ends into a crimp tube from opposite sides, creating a hoop.

4. Secure beaded bail
Crimp the bead and cut the excess wire with flush cutters. Set the pendant aside.

5. Bead necklace
Attach the clasp to one end of the 19" (48cm) length of wire with a crimp tube. String the necklace in the following pattern: two pink rondelles, crystal rondelle, two pink rondelles, green oval, barbell, green oval. At the center point of the design, slide the pendant bail on. Continue beading in the established pattern until you reach the final pink rondelle. Secure the end of the wire, and trim away any excess wire.

Sparkle Virgin

WHAT YOU WILL NEED

SPARKLIES, ETC.

tank top

iron-on sparkle letters to spell "sweet"

four plastic cherry charms

three plastic star buttons

five 5mm flat-back rhinestones

five 5mm metal rhinestone settings

white thread

UTILITIES

cardboard form to fit inside of tank top

permanent marker with extra-fine tip

iron

sewing needle

scissors

rhinestone setter

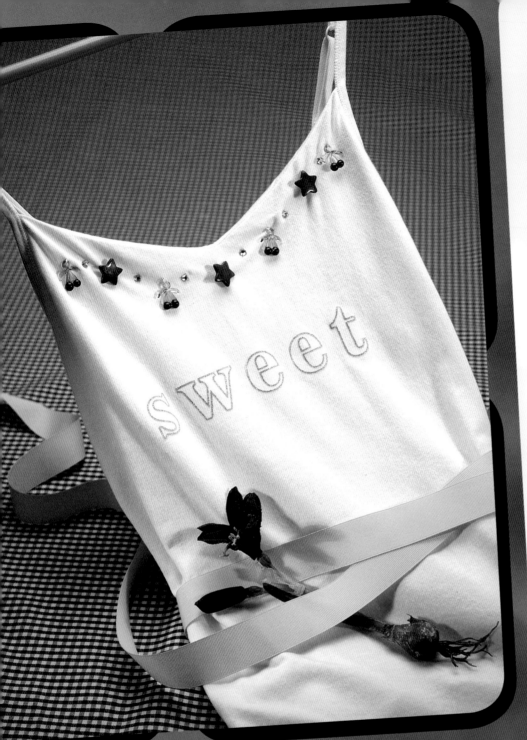

SUPPLIES: CHERRY CHARMS FROM SACRED KITSCH STUDIO; STAR BUTTONS BY JHB INTERNATIONAL; IRON-ON WHITE GLITTER TRANSFER LETTERS BY HEIDI SWAPP; RHINESTONE SETTER BY DARICE; RHINESTONES BY NICOLE

Sweet Thang Tank Top

Hey sweet thang, try this on for size. Like you even had to tell them, right? Hello…I am sweet *and* sassy…any questions?

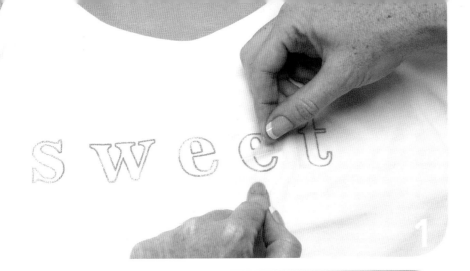

1. Iron on letters

Slide a piece of cardboard inside the tank top. Determine the letter placement on the shirt, positioning them in the center of the chest. Iron the letters onto the tank top.

2. Mark placement for cherries and stars

Place the cherries and stars on the neck to determine their placement. Make a tiny dot to mark each spot.

3. Sew on cherries

Sew the cherries in place using the dots as a guide. If you're using a tank top with a built-in bra, as I did here, make sure to sew inside of the bra part of the tank top. If you don't, the tank won't hold your boobies right.

4. Sew on stars and add rhinestones

Sew on the stars, again using the dots as a guide. Determine the placement of the rhinestones between the stars and cherries. Mark the placement with a pen. Use a rhinestone setter to set the stones on the shirt.

SPARKLY TIP:

take it off to sew

You may leave the tank on the cardboard form to sew on the cherries and stars, or you may remove it to make tying knots and bringing the thread in and out of the fabric easier. Don't sew it while wearing it, though. Hello!

true craft

c o n f e s s i o n s

I had to resew the buttons on this. The first attempt was, well, abysmal. The buttons were leaning forward like the tower of Pisa. Can I get a tank top do over, please?!

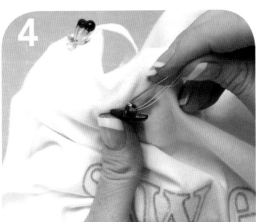

27

WHAT YOU WILL NEED

SPARKLIES, ETC.

three pendant blanks

three 1" (3cm) Circle Pix images

three phrases ("coy, me? pshaw."; "kiss me, you fool"; "damn, you are cute")

three 1" (3cm) clear scrapbook stickers

four rhodium-plated fuchsia and rose Swarovski filigree flowers

two porcelain flower pendants

five 6mm rose alabaster Swarovski bicones

five 5mm rose Swarovski rounds

five 6mm rose AB Swarovski bicones

five pale pink AB Czech glass rounds

ten 6mm metal and crystal rondelles

ten 22-gauge sterling head pins

four 3mm extra-heavy-duty jump rings

eleven 10mm extra-heavy-duty jump rings

one extra-large sterling lobster clasp

thirteen links heavy-duty stainless steel-plated curb chain

UTILITIES

glue stick

découpage medium

round-nose pliers

chain-nose pliers

flush cutters

cutting board

craft knife

sharp scissors

bone folder

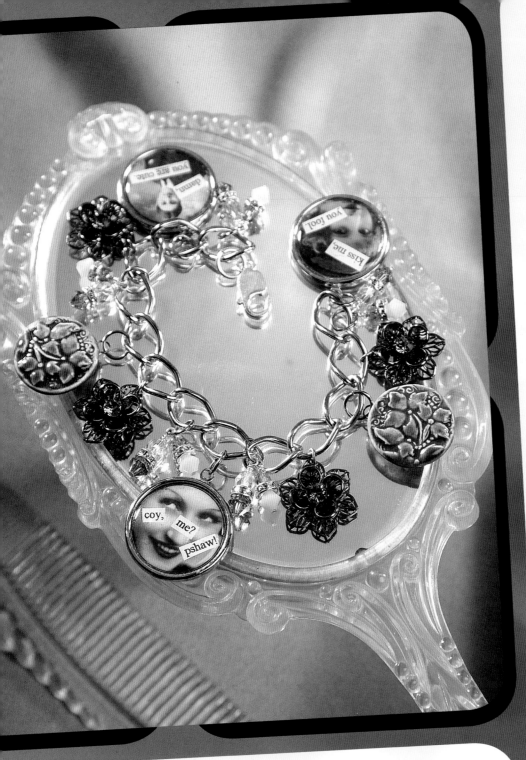

Sweetie Pie Charm Bracelet

For the true romantic, here's a truly charming charm bracelet. When you want to wear your heart on your sleeve…or your wrist…wear this. Oh-so-nice and just a little naughty…girlie.

SUPPLIES: METAL FRAMES BY EASTERN FINDINGS; LARGE CHAIN AND JUMP RINGS BY RINGS & THINGS; CIRCLE PIX BY ARTCHIX STUDIO; CRYSTAL BEADS AND FILIGREES BY SWAROVSKI; PORCELAIN BEADS BY EARTHENWOOD STUDIO; STERLING FINDINGS BY MARVIN SCHWAB/THE BEAD WAREHOUSE

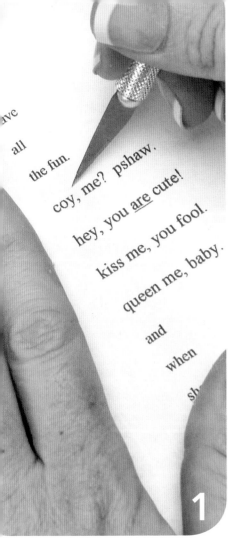

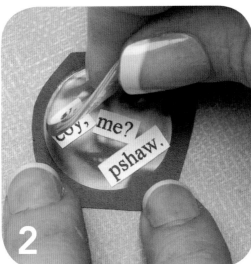

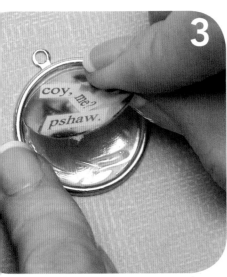

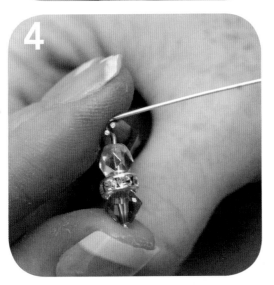

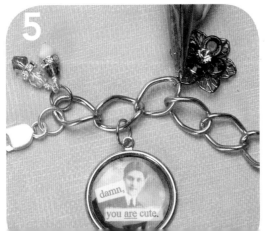

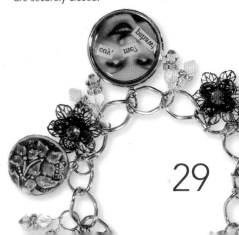

1. Cut out phrases

Print double-spaced phrases in 12-pt Times New Roman. Place the paper on a cutting mat, and use a craft knife to cut out the individual words and phrases you'd like to use.

2. Create mini collage

Adhere the phrases to the circle images you chose with découpage medium. Allow the glue to dry. Adhere a clear scrapbook sticker over each collage.

3. Adhere mini collage to pendant blank

Use a small amount of découpage medium to adhere the mini collage to the pendant blank. Rub a bone folder along the back of the collage to compress any air bubbles. Repeat to make two more pendants. Allow to dry.

4. Create dangles

Slide a 6mm rose bicone, a crystal rondelle and a pale pink round onto a head pin and make a wrapped loop with chain-nose and round-nose pliers (see Bead Basics, page 14). Repeat to make a total of five dangles. Make five more wrapped-loop dangles with the following beads: 6mm rose alabaster bicone, crystal rondelle, 5mm rose AB round.

5. Link dangles and pendants to chain

Link a lobster clasp to one end of the 13-link chain segment with a 10mm jump ring. Slide two different dangles onto a jump ring and attach the jump ring to the first link in the chain. Attach the pendant to the second link in the chain, and attach a crystal filigree flower to the third link with a 3mm jump ring. Continue to link dangles and pendants to the chain in the following sequence: two dangles, pendant, flower. Link the ceramic flower to the chain at the fifth link from one end and the third link from the other end. Check back through your work to make sure all the jump rings are securely closed.

29

"By the time we reached Virginia City I was considered a remarkable good shot and a fearless rider for a girl of my age."

—Calamity Jane

RHINESTONE COWGIRL

"I look just like the girls next door… if you happen to live next door to an amusement park."

—Dolly Parton

*O*nce upon a time there rode a fearless woman by the name of Martha Jane Canary, but you probably know her by her nickname, Calamity Jane. Lest you think cowgirls are a myth, read up on Martha Jane, and while you're at it, read about Phoebe Ann Moses, a.k.a. Annie Oakley, too. Oh, and don't forget the notorious Myra Maybelle Shirley, a.k.a. Belle Star, the female Jesse James. There were plenty of gals in the wild, wild West who could handle a horse, a gun and a cowboy with finesse. Don't forget Ms. Dale Evans either. She may have looked awful purdy, but I bet if the situation called for it, she could handle a six-shooter and a rowdy ranch hand and still keep her updo looking fabulous. Even the movie cowgirls had guts and glamor.

Take your cue from these cowgirls, and get ready to ride the range in style. Yee haw! Just saddle up your crafting chair and let's get to it! This chapter is chock full of country- and western-themed projects for the real live bronco buster or the decidedly urban cowgirl. From the all-American Come and Git It Lunch Pail (page 32) and a découpaged Riders of the Silver Screen Bracelet (page 42) to the Rodeo Girl Jacket Dolly Parton would find mighty fetching (page 44), this chapter is a celebration of the cowgirl in all of us. Happy trails to you!

Sparkle
Vixen

WHAT YOU WILL NEED

SPARKLIES, ETC.

one white metal lunch box

one sheet red gingham scrapbook paper

one sheet watermelon scrapbook paper

one sheet corn scrapbook paper

forty-five SS12 capri blue
Swarovski hot fix crystals

farm-themed mini charm set

⅜" (1cm) wide red and white
grosgrain star ribbon

UTILITIES

embellishing adhesive (Gem-Tac)

découpage medium with gloss finish

two-part quick-set epoxy

cutting mat

ruler

craft knife

bone folder

sewing scissors

pen

heavy-grit sandpaper

heavy-duty wire cutter

hot-fix applicator

scrap paper

Come and Git It Lunch Pail

Capture a little piece of Americana at its summertime best
with this jaunty lunch box, or carry it as an even jauntier little
purse. Three cheers for the red, white and blue, and for the
farm girl in all of us.

SUPPLIES: WATERMELON SLICES
SCRAPBOOK PAPER BY STEMMA/
MASTERPIECE STUDIOS; CORN
HUSK PAPERS BY JOHN DEERE
FOR CREATIVE IMAGINATIONS;
GINGHAM SCRAPBOOK PAPER RED
TABLECLOTH BY AROUND THE
BLOCK; RED STAR RIBBON FROM
SACRED KITSCH STUDIO; HOT-FIX
CRYSTALS BY SWAROVSKI; FARM
MINI CHARMS BY KAREN FOSTER
DESIGN; GEM-TAC BY BEACON
ADHESIVES; LOCTITE EPOXY BY
HENKEL; LUNCH BOX BY
PROVO CRAFT

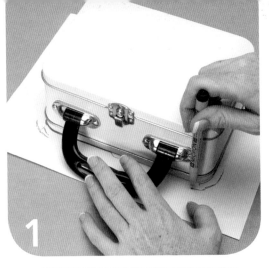

true craft
c o n f e s s i o n s

I was running out of time and asked my husband to help with this project. So, he should get the credit for the labor. Thanks, Dad Guy!

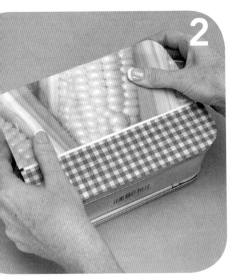

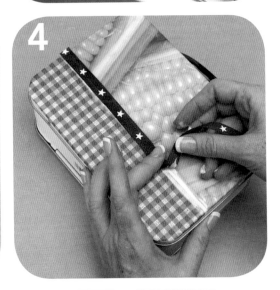

1. Create template
Place the lunchbox on top of a blank piece of paper and trace around it with a pen, angling the pen out slightly while you trace to allow a slight excess to fold the edges of the paper pieces over to seal the purse. Cut out the template with a craft knife.

2. Cut paper and adhere to box
Cut the melon and corn papers to 3¼" (8cm) wide and two pieces of gingham paper to 1⅞" (5cm) wide, rounding the corners on the top edge of the corn paper and the bottom edge of the gingham paper. Adhere the papers to the box with découpage medium, leaving the edges sticking out beyond the box edge. Adhere the corn paper at the top of one side and the watermelon paper at the top of the other side. Adhere gingham paper to the bottom of both sides. Allow medium to dry.

3. Adhere edges of paper
Cut along the corners of each piece of paper and around the latch as necessary. Use a bone folder to fold and glue down the edges of the papers. Allow the glue to dry. Paint over the paper with two coats of glossy découpage medium. Allow each coat to dry.

4. Adhere ribbon
Use embellishing adhesive, such as Gem-Tac, to adhere a piece of ribbon along the front of the lunch box to cover the line where the papers meet. Go over the ribbon with a bone folder to work it flat against the box. Repeat for the other side. Adhere a ribbon border around both edges of the box as well. Allow the adhesive to dry.

5. Adhere crystals to ribbon
Adhere hot-fix crystals between the stars on the ribbon with the hot-fix applicator tool.

6. Adhere charms to sides of box
Cut the loops of the charms with wire cutters. Sand the backs of the rough metal charms flat with heavy-grit sandpaper. Use two-part epoxy to adhere the metal charms to the side of the box. Adhere the tractor and weather vane charms to one side of the box and the barn and milk pail charms to the other. Take your time and allow charms to set before moving to opposite side.

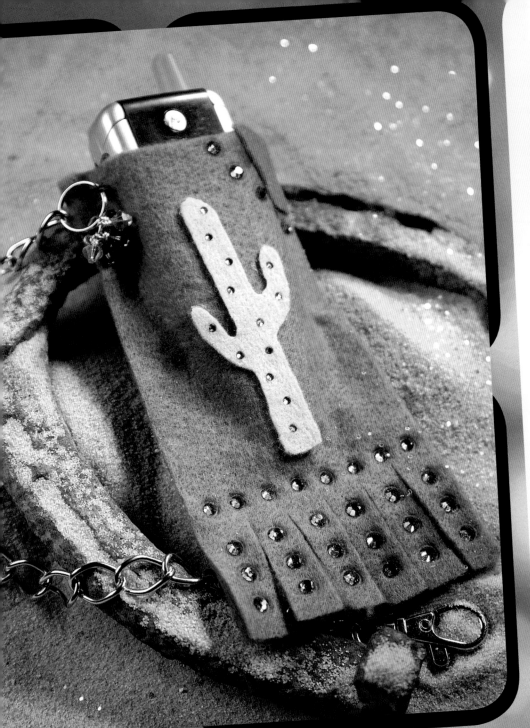

WHAT YOU WILL NEED

SPARKLIES, ETC.

forest green felt

acid green felt

orange felt

twenty-three SS20 sun hot-fix Swarovski crystals

eight SS16 erinite hot-fix Swarovski crystals

thirteen SS8 crystal sage hot-fix Swarovski crystals

three 6mm chrysolite AB Swarovski bicones

three 6mm hyacinth Swarovski bicones

19-link segment large imitation rhodium-plated chain

one 15mm silver-plated split ring

two 8mm silver-plated jump rings

six sterling head pins

one silver-plated lanyard clip

waxed linen thread

UTILITIES

extra-strength fabric glue

hot-fix applicator tool

round-nose pliers

chain-nose pliers

sewing scissors

permanent marker for tracing templates

heavy-duty embroidery needle

Git Along L'il Cell Phone Pouch

Every urban cowgirl needs a stylish pouch to carry her cell phone in when she heads out for a night of two steppin' and bull ridin'. Throw yer phone, ID and a credit card in here; chain the pouch to your low-slung jeans and yee haw!

SUPPLIES: HOT-FIX CRYSTALS BY SWAROVSKI; HOT-FIX APPLICATOR TOOL AND LANYARD FROM JEWELRYSUPPLY.COM; CHAIN FROM EASTERN FINDINGS; FELT BY CPE, THE FELT COMPANY

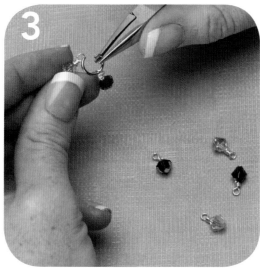

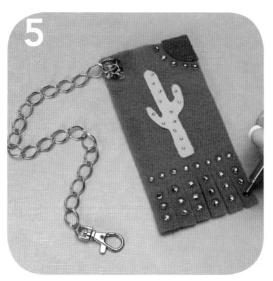

1. Cut out felt shapes and make fringe

Cut two pieces of acid green felt to 3" (8cm) wide by 6¼" (16cm) long for the pouch, or adjust the size based on your cell phone. Trace and cut out the felt shapes using the templates on page 126 as guides. Cut the bottom edge of the felt into strips at ½" (1cm) intervals. Glue the sun and the cactus onto one felt panel with fabric glue. Allow the glue to dry.

2. Create pouch

Glue the two pouch panels together at the edges with fabric glue. Allow them to dry.

3. Create jump ring with dangles

Create six coil-looped head pin dangles using beads and head pins (see Bead Basics, page 14). Slide all the dangles onto a jump ring, alternating the two colors. Set the jump ring with dangles aside.

4. Sew on split ring

Sew a split ring to the top left side of the pouch with waxed linen thread.

5. Adhere hot-fix crystals

Link the jump ring with dangles from step 3 to the split ring. Attach the chain to the split ring, then attach the lanyard clasp to the opposite end of the chain with a jump ring. Pre-place hot-fix crystals onto the pouch to finalize the design, and then use the hot-fix applicator to adhere the crystals to the felt shapes.

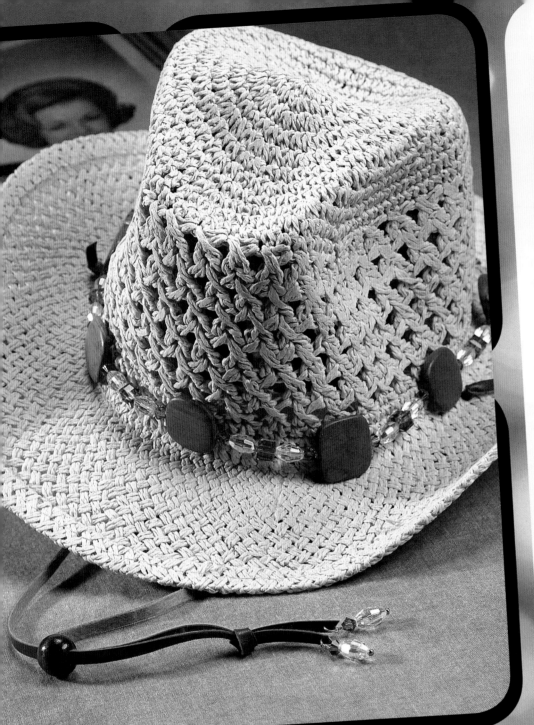

Sparkle Virgin

WHAT YOU WILL NEED

SPARKLIES, ETC.

straw cowboy hat

nine ⅞" x ⅞" (2cm x 2cm) flat wood beads

nine 8mm khaki Swarovski cubes

twenty 6mm indicolite Swarovski bicones

twenty 12mm x 8mm crystal AB Swarovski ovals

two sterling ball-tip head pins

two sterling 5mm jump rings

.018" (.5mm) 49-strand Beadalon wire

Supplemax monofilament fishing line

UTILITIES

measuring tape

round-nose pliers

chain-nose pliers

embroidery needle

scissors

Hang Yer Hat

You couldn't be an urban cowgirl without a flashy cowgirl hat, now could ya? Saddle 'em up and ride 'em out...you'll be cuter than a bug's ear and happier than a pig in...mud. What'd ya think I was gonna say?!

SUPPLIES: CRYSTAL BEADS BY SWAROVSKI; WOOD BEADS FROM BLUE MOON BEADS; STERLING FINDINGS FROM MARVIN SCHWAB/THE BEAD WAREHOUSE; WIRE AND SUPPLEMAX BY BEADALON

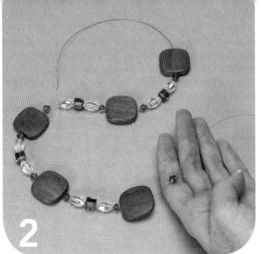

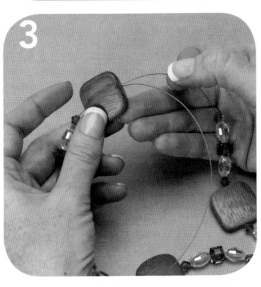

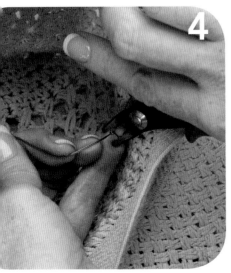

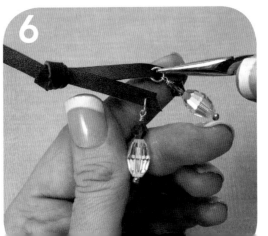

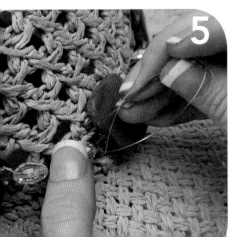

1. Measure hat
Measure the top of the cowgirl hat where the hat band will go. Remove any existing embellishments and the hat string. Don't destroy the hat string! Set the string aside for later.

2. String beads
If necessary, adjust your bead counts to suit the hat you have selected. String the beads onto a length of wire 3" (8cm) longer than the necessary finished length in the following pattern: wood, indicolite, crystal, khaki, crystal, indicolite, wood, etc. Repeat the pattern until all the beads are used or until you reach the desired finished length.

3. Secure hat band ends together
When you have added the final indicolite bead, thread the wire into the first wood bead and pull the wire taut.

4. Secure beads at front of hat
Find the front center section of your hat, and position the first/final wood bead dead center. Thread the wires into the straw and tighten the wires. Crimp the wires together to station the center bead. Trim away excess wire.

5. Secure beaded hat band
Sew some of the beads in place with a sewing needle and strong, flexible nylon thread to station the hat band.

6. Make dangles for hat strings
If your hat has a hat string, knot it in place. Use a needle to create a small hole in the very end of each hat string. Create two coiled-loop crystal and indicolite dangles (see Bead Basics, page 14). Slide one jump ring into each of the holes in the hat strings and link one dangle to each jump ring.

true craft
c o n f e s s i o n s

I didn't do the math. I'm not big on math. I can do it—it's just a hassle. Do the math. That way you won't have to do this project three times, like I did. Duh. Do the math...you'll be glad you did!

37

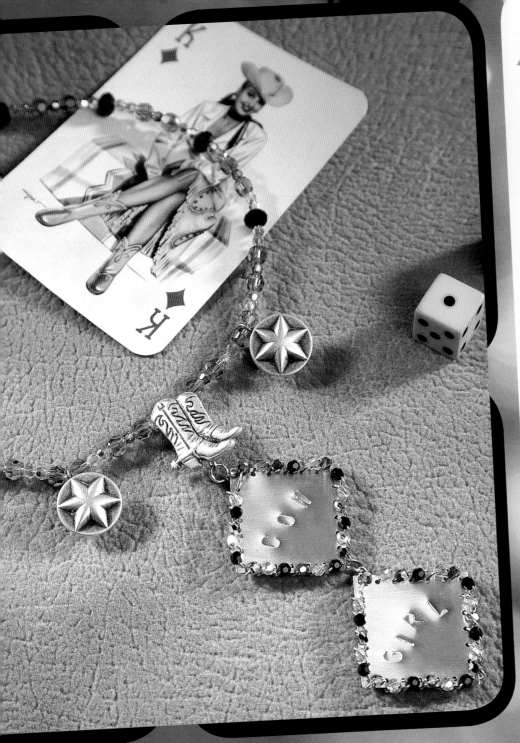

Sparkle goddess

WHAT YOU WILL NEED

SPARKLIES, ETC.

NECKLACE

two medium stitched tin tiles

two star metal buttons

one cowboy boot metal button

sixty-four 3mm light rose AB Swarovski rounds

fourteen 3mm jet Swarovski rounds

twenty-eight 3mm crystal vitrial medium Swarovski rounds

thirty-two 5mm rose Swarovski rounds

two 6mm rose Swarovski bicones

eight 6mm jet Swarovski rondelles

one small silver-plated toggle clasp

three silver-plated head pins

two 3mm silver-plated jump rings

two silver-plated crimp tubes

49-strand .018" (.5mm) beading wire

24-gauge silver-plated copper wire

EARRINGS

two cowboy boot buttons

two 5mm rose Swarovski rounds

two 11mm x 5.5mm jet Swarovski briolettes

two 11mm x 5.5mm rose Swarovski briolettes

two 6mm rose Swarovski bicones

six 3mm silver-plated jump rings

two silver-plated head pins

two flat-coil sterling French ear wires

UTILITIES

die stamp letter tool set

chasing hammer

round-nose pliers

chain-nose pliers

flush cutters

bead board

Happy Trails Necklace

"Happy trails to you, until we meet again…" Hitch your horse up and head on out to the watering hole looking mighty fine, li'l missy. I love the rustic but sparkly appeal of this design. Isn't it fun? Yee haw!

SUPPLIES: CRYSTAL BEADS BY SWAROVSKI; STERLING FINDINGS FROM MARVIN SCHWAB/THE BEAD WAREHOUSE; "SASSY" LETTERS FROM FIRE MOUNTAIN GEMS AND BEADS; SKULL CHARMS FROM SACRED KITSCH STUDIO

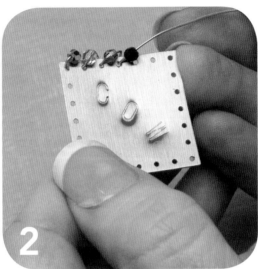

1. Stamp tiles

Use die stamps and hammer to stamp "cow" into one tin tile. Repeat for "girl" in the second tile.

2. Bead tin tiles

Thread 1' (30cm) of plated copper wire into the top hole in a metal tile and create a loop at the back of the tile. Thread the wire up through the first hole on the left and string a 3mm rose bead onto the wire. Sew the wire over, under and through the next hole in the tile. Thread a 3mm vitrial bead onto the wire and repeat. Continue threading beads onto the wire and sewing them in place in the following pattern: jet, rose, vitrial, ending with a rose bead at the top right hole.

3. Secure wire

Thread the wire into the final hole, adding a vitrial bead and threading the wire across the top front of the tile. Wrap wire into existing wire loop at top back of tile. Use pliers to tuck under any loose ends. Repeat with the second tile.

4. Make boot and star dangles

Thread a head pin with a single rose bicone and thread the head pin through the loop at the back of the boot button. Add a second bicone, bend the wire and make a second loop flush to the top of the bicone. Create the star dangles on head pins with two rose rounds as with the boot, but keeping the head on the pin and coiling the wire at the top of the top crystal. Set the star dangles aside.

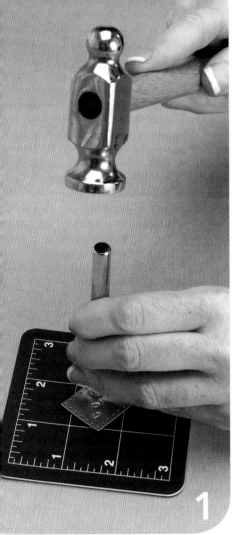

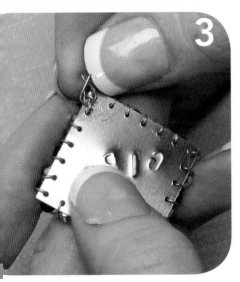

true craft
c o n f e s s i o n s

I mangled an entire package of tiles before I got this down. Back to the craft store I went, but they were fresh out. I hit two other stores until I found them. Yippee skippee! Make sure you have the letter stamp held straight in your hand with a firm grip before you whack it with the hammer so it doesn't slip.

39

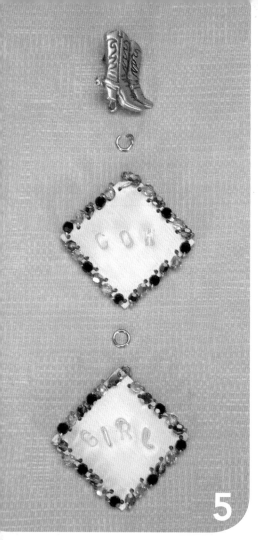

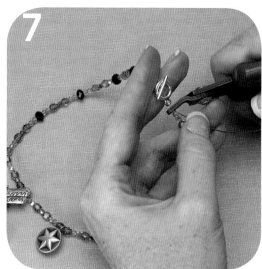

5

7

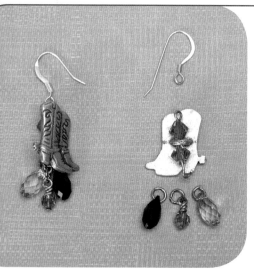

try this

Use two boot buttons and the same techniques you learned for the necklace to make a kicky little pair of earrings. Attach the beads shown to the bottom of the boot in a mirror order so you have a left and a right earring. Add a French earwire, and you're ready to line dance until the cows come home.

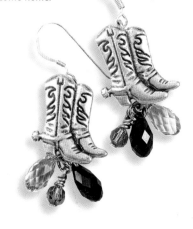

5. Link dangles and tiles
Attach the boot dangle to the "cow" tile with a jump ring and attach the "cow" tile to the "girl" tile with a second jump ring.

6. Lay out design
Arrange all the beads and dangles on the bead board in the following sequence: two 3mm rose, 5mm rose, vitrial, 5mm rose, two 3mm rose, 6mm jet rondelle until you reach the fifth grouping in this pattern. Replace the jet rondelle with a 5mm rose bead, one of the stars, a second 5mm rose bead, two 3mm rose beads, 5mm rose, vitrial, 5mm rose, two 3mm rose, the cowboy boot pendant. Lay out the second half of the design in a mirror image of the first half.

7. String necklace
Attach a clasp to one end of a 20" (51cm) length of beading wire with a crimp tube (see Bead Basics, page 12). String the necklace as you laid it out. Finish the design by securing the remaining end of the clasp to the free end of the wire with a crimp tube. Trim away the excess wire.

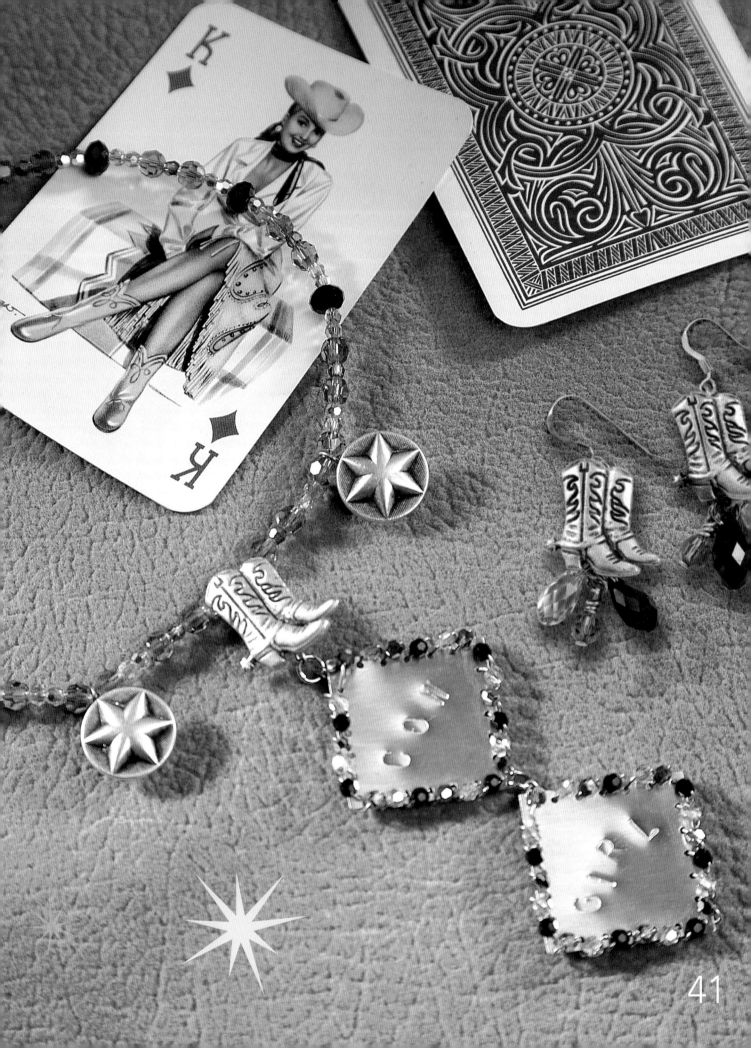

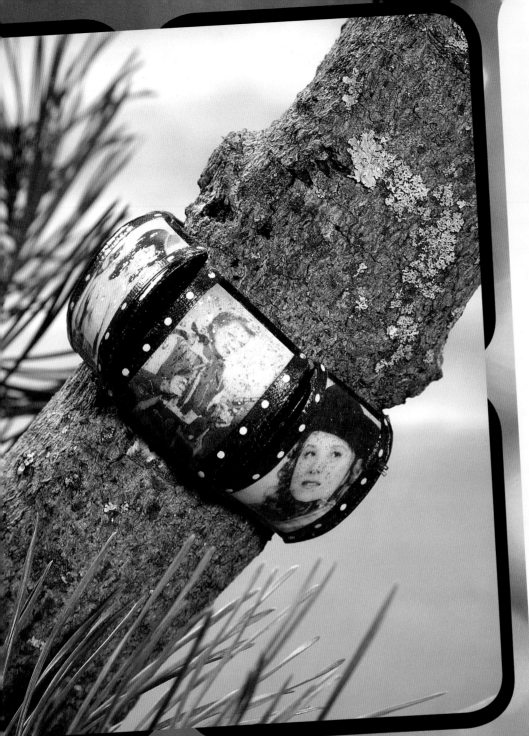

Sparkle Vixen

WHAT YOU WILL NEED

SPARKLIES, ETC.

black wooden bracelet blanks

black-and-white cowgirl images reduced to approximately 1" x 1¼" (3cm x 3cm), high resolution

white copy paper

red mini dot grosgrain ribbon

.8mm elastic bead cord

UTILITIES

computer

image-editing software (such as Microsoft Publisher, Photoshop or similar program)

high-resolution-capable printer

embellishing adhesive (Gem-Tac)

white craft cement (Instant Grrrip glue)

G-S Hypo Cement

sparkly découpage medium

disposable paintbrush

clear translucent dimensional silicone

scissors

craft knife

your sticky and sparkly fingers (sorry!)

Riders of the Silver Screen Bracelet

These gorgeous cowgirls may never have roped a cow or ridden off of the movie set into a real desert sunset, but they still had the guts to make it in the rough and rocky terrain of showbiz. Now that, my dear girls, is saying something, and I know of what I speak. It is entirely possible to be tough *and* glamorous, contrary to popular belief!

42

SUPPLIES: WOODEN BRACELET BLANKS BY DARICE; NICE AND NARROW™ RED MINI DOT RIBBON BY OFFRAY; INSTANT GRRRIP GLUE BY BOND ADHESIVES; SPARKLE MOD PODGE BY PLAID; GEM-TAC BY BEACON ADHESIVES; ELASTICITY BY BEADALON

1

2

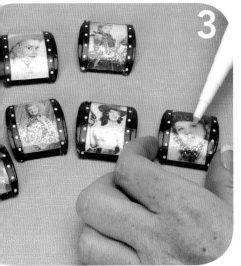

3

true craft
c o n f e s s i o n s

I made the bracelet tiles for the prototype and realized that one of my images was too washed out and had been cut improperly. I bucked up and redid it. I tried to convince myself it was okay, but it wasn't. So there.

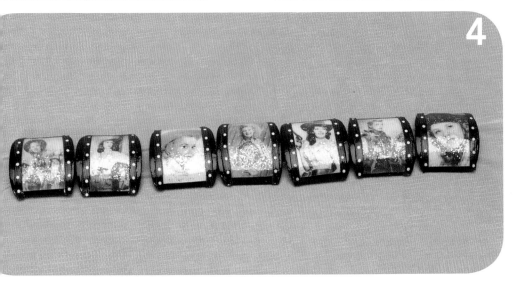

4

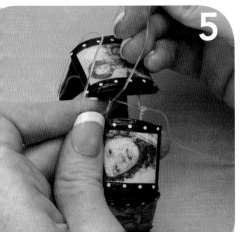

5

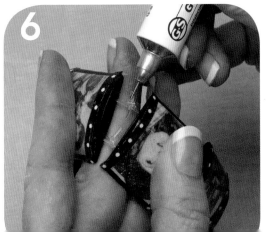

6

1. Adhere cowgirl images
Place all your 1" x 1¼" (3cm x 3cm) high-resolution cowgirl images into a single document using Microsoft Publisher or similar software. Print and cut out the images. Cut string from bracelet tiles to free them so you can lay them flat while you work. Glue images to wooden bracelet tiles with a thin layer of white craft cement (such as Instant Grrrip glue). Allow to dry.

2. Adhere ribbon to tiles
Cut pieces of ribbon to frame the edges of each image. Glue the ribbon pieces to the tiles with a thin layer of embellishing adhesive (such as Gem-Tac). Allow it to dry.

3. Apply silicone medium to tiles
Spread a thin layer of sparkly découpage medium onto the image with a disposable paintbrush. Allow it to dry. Spread on a second layer of the sparkly medium and allow it to dry. Use your fingers to spread a layer of clear translucent dimensional silicone over the entire tile, working out any air bubbles and sealing the ribbon ends. Repeat for the remaining tiles.

4. Thread tiles onto elastic
Cut two 9" (23cm) pieces of elastic bead cord. Decide the layout of the bracelet, then thread the two pieces of elastic bead cord through the holes in the tiles.

5. Secure elastic
Tie the ends of the elastic strands together with two double overhand knots, making sure there is not much slack in the bracelet. Repeat for second strand.

6. Secure knots
Cut off the ends of the Elasticity and dab each knot with G-S Hypo Cement. Allow the bracelet to dry before wearing.

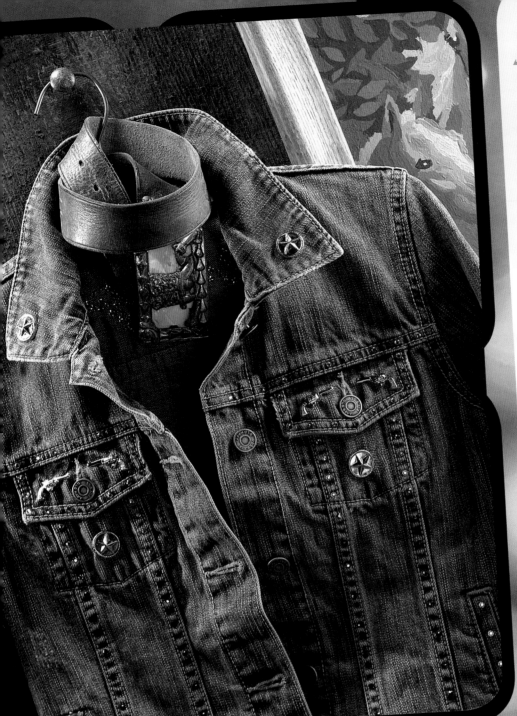

Sparkle goddess

WHAT YOU WILL NEED

SPARKLIES, ETC.

distressed jean jacket

vintage cowgirl image

fusible ink jet fabric sheet

one hundred sixty-nine SS16 peridot
Swarovski hot-fix crystal rounds

one hundred forty-seven SS16 fuchsia
Swarovski hot-fix crystal rounds

four white metal six-shooter gun studs

four white metal circle star studs

one white metal small star stud

one hundred thirteen white flat metal studs

UTILITIES

computer

image-editing software (such as Microsoft
Publisher, Photoshop or similar program)

scanner

ink-jet printer

flat knife or chain-nose
pliers to bend stud prongs

hot-fix crystal applicator tool

iron

permanent marker

SUPPLIES: HOT-FIX CRYSTALS
BY SWAROVSKI; QUICK FUSE
FABRIC SHEETS BY JUNE TAILOR;
HOT-FIX APPLICATOR TOOL BY
JEWELRYSUPPLY.COM

Rodeo Girl Jacket

Round 'em up, cowgirl, in this sparkly confection of a blue-jean jacket! Perfect for two-stepping or roping a cow in style, this is so good it hurts. Dale Evans has nothing on you!

SPARKLY TIP:
find a cowgirl image

I found my cowgirl in an old *National Geographic* from an antique store. You can find vintage magazines on the Internet, in thrift shops and antique shops. I cannot sanction the stealing of images from the Internet.

1. Set star and gun studs

Set the metal stud circle stars at the points of the collar and on the center of each upper pocket using a flat knife or chain-nose pliers. Poke all of the sharp prongs of each stud through the fabric of the jacket from the front through to the back. Use a flat knife or chain-nose pliers to bend each of the prongs down to secure each stud. Set metal stud guns on both sides of the top of each pocket flap.

2. Apply hot-fix crystals

Pre-place hot-fix crystals along the seams at the front of the jacket, beginning with the green crystals. Once you have the crystals arranged to your liking, affix the crystals with the hot-fix applicator tool, holding it on top of each crystal for ten seconds. Repeat with fuchsia crystals along slanted pockets and vertical seams.

3. Iron image onto jacket

Scan your image into your computer and use Microsoft Publisher or other image software to manipulate it to fit the center back panel of the jacket, then save the image in a high-resolution format. Print the image onto a fusible fabric sheet, hand feeding the sheet into your printer. (Be careful it doesn't jam.) Determine the placement of the image and iron it onto the center back of the jacket. My image was 10" x 5½" (25cm x 14cm).

4. Affix crystal border

Working in sections, lay out and then apply green and fuchsia hot-fix crystals along the edge of the cowgirl image, alternating colors, adjusting the spacing a little when you reach the edges, if necessary. Just reheat the crystals and very carefully move them to accommodate the row. Check back through the crystals to ensure they are all affixed properly.

5. Write "rodeo girl"

Lightly handwrite "rodeo girl" in your prettiest script along the shoulder of the back of the jacket, making sure the letters fill the area.

6. Affix studs to letters

Stud the letters with flat round metal studs. Use a star on the "i" of girl.

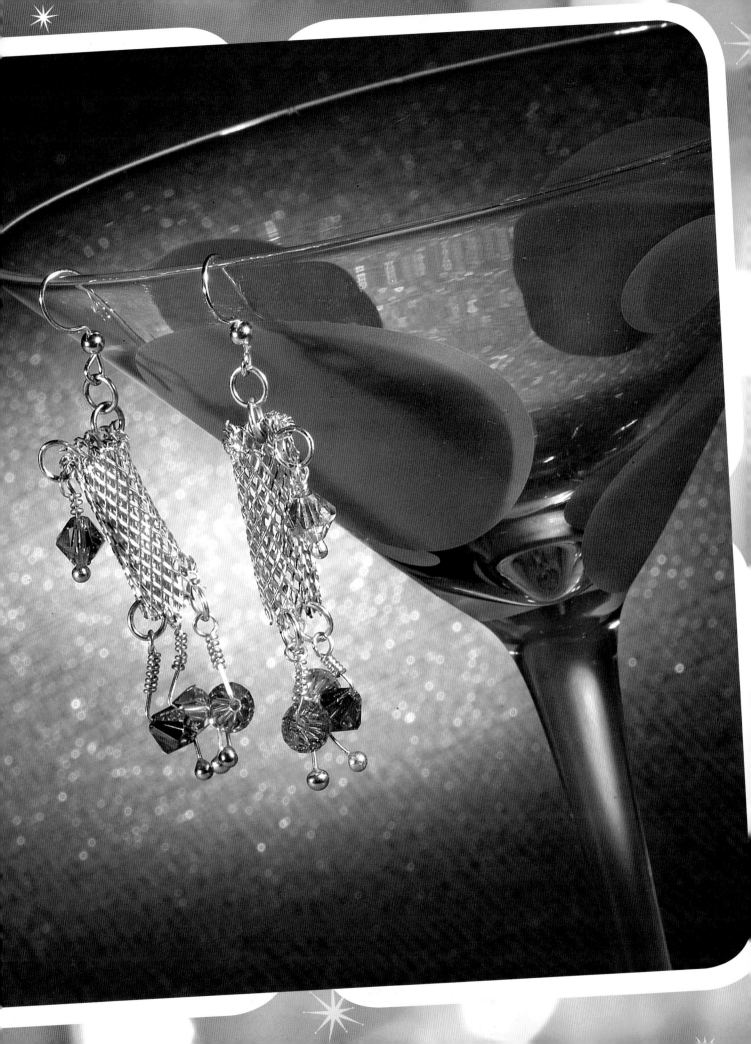

FASHIONISTA

"In difficult times fashion is always outrageous."

—Elsa Schiaparelli

"How many cares one loses when one decides not to be something but to be someone."

—Coco Chanel

A long time ago in a place not so very far away, women had to wear corsets and uncomfortable, binding dresses. Then along came a fashion goddess who rescued the mortals by giving them all little black dresses and bedecking them with sparkly costume jewelry. Her name was Gabrielle 'Coco' Chanel, and she changed the face of women's fashion. She gave us the classic Chanel suit, the navy pea coat and bell bottoms, not to mention the seminal classic perfume Chanel No. 5. In another kingdom, fashion queen Elsa Schiaparelli reigned supreme. Elsa is perhaps the most mimicked (without credit) jewelry and fashion designer of the past one hundred years. The shocking hot pink color she used in her designs became her trademark, along with her surrealist motifs and her fantastical collaborations with Salvador Dali. She introduced shoulder pads, shorts for female tennis players, animal-print fabrics and zippers dyed to match garments.

Follow in the footsteps of Coco and Elsa and make your own fashion. Who the hell decides what's in and what's out anyway, and why should we care?! If you find the perfect dress and you can't find a bloody thing to match…what's a girl to do? Stop traipsing through the mall and make your own dang accessories, that's what! Don't follow the trends— set them, my love. The fashion designers are always stealing ideas from the gals on the street who march to their own drummers. March on…in a fierce pair of boots and a fabulous necklace that you made all by yourself! Huzzah! If you like to dance on the edge, try the Squirm Choker (page 54), or if you want a pretty splash of unexpected colors, make the Secret Garden Necklace (page 58). And, of course, what self-respecting fashionista would be without a Diva Shoes Purse Charm (page 52)?

47

Sparkle *Virgin*

WHAT YOU WILL NEED

SPARKLIES, ETC.

grey ribbed cotton tank top

ten SS34 chalk white nacre hot-fix Swarovski round pearls

ten SS6 crystal AB hot-fix Swarovski rounds

three pink iron-on open-center stars

four black iron-on open-center stars

three white iron-on open-center stars

UTILITIES

cardboard form to fit inside tank

iron

hot-fix applicator tool

Work It Out Tank Top

Let's get physical…ugh…never mind. I never did like that song! If ya gotta work it out, do it in style! Yoga, Pilates, treadmill, elliptical thingie… Heck, even when you are just thinking about exercising while eating some Ben and Jerry's, this little number is perfecto! As an added bonus, making this star-spangled tank top is no sweat, baby.

SUPPLIES: IRON-ON STARS FROM SACRED KITSCH STUDIO; HOT-FIX CRYSTALS AND PEARLS BY SWAROVSKI; HOT-FIX APPLICATOR TOOL FROM JEWELRYSUPPLY.COM

1. Iron on stars and affix crystals

Slide the cardboard into the tank top. Station stars around the neckline, placing a pink star in the center and a white and a black star evenly spaced on the left side of the tank and a black and a white star on the right side. Place stars evenly spaced along the bottom of the tank just above the hem in the following order: white star in center, pink and black stars on left, and black and pink stars on right. Iron the stars onto the tank, making sure all the points are adhered. Iron over the stars several times if necessary. Use the hot-fix crystal applicator to affix a crystal in the center of each star.

2. Affix hot-fix pearls

Add a new tool tip to fit the pearls and heat it up. Apply hot-fix pearls in between each star on top and bottom. Add a pearl on each end of the stars at the top of the tank.

3. Finish tank

Apply the final hot-fix crystal on the bottom row to finish the tank.

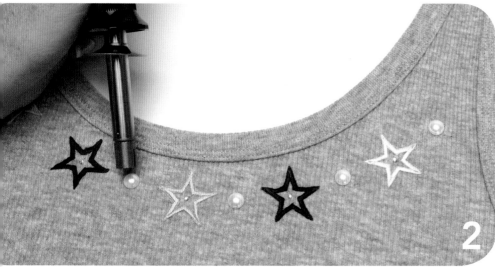

SPARKLY TIP:
finicky stars

The stars are a tad finicky. You will need to take your time ironing them on. If the points won't adhere, use a little fabric glue. If all else fails, you can try sewing them on. The things a gal will do for fashion…

49

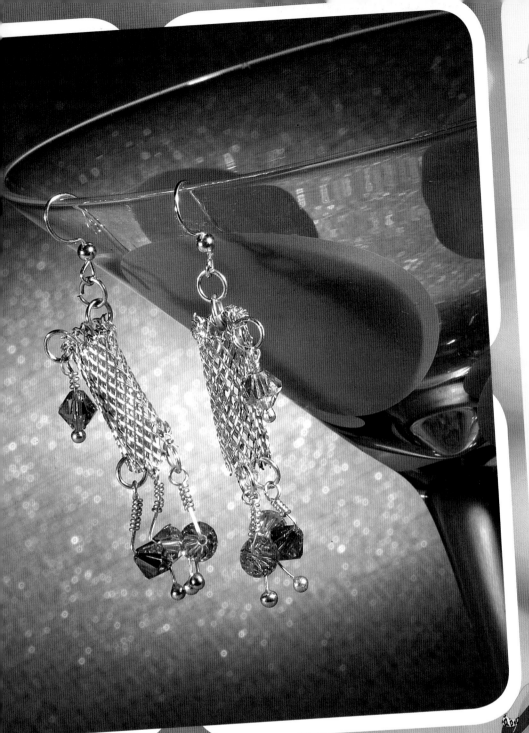

WHAT YOU WILL NEED

SPARKLIES, ETC.

wire form ⅟₁₆" (2mm) pattern
metal mesh sheet

two 6mm chrysolite Swarovski bicones

two 6mm light peach Swarovski bicones

two 6mm padparascha Swarovski bicones

two 6mm light violet Swarovski bicones

twelve 5mm sterling jump rings

two sterling ball French wires

eight sterling ball tipped head pins

UTILITIES

round-nose pliers

flush cutters

chain-nose pliers

wooden dowel (small paintbrush works fine)

scissors

Enmeshed Earrings

Metal mesh has a modern edge. Add a smattering of crystals and some funky wire shapes and you get a very mod, very hip, very chic little pair of earrings. *Ca c'est très haute couture.*

SUPPLIES: WIRE MESH SCREEN BY AMACO; STERLING FINDINGS FROM MARVIN SCHWAB/THE BEAD WAREHOUSE; CRYSTAL BEADS BY SWAROVSKI

50

1. Fold under edges of mesh
Use scissors to cut two 1" (3cm) metal mesh squares. Bend the edges of the metal mesh wire back on itself to create a 1/8" (3mm) seam.

2. Create mesh tube
Wrap each mesh square with seam lengthwise around a small paintbrush or thin wooden dowel to create a tube.

3. Crimp edges of tubes
Use pliers to carefully crimp or fold one edge of each wire tube.

4. Create wrapped dangles
Slide a bead onto a wire, holding it in place 1/4" (6mm) from the ball tip and bending it at a 90° angle. Bend the wire over the top of the bead 90° in the opposite direction from the first bend. Wrap the wire tail repeatedly around itself beneath the loop to create a long wrap. Make two dangles with each of the following crystals: chrysolite bicones, light peach bicones and padparascha bicones.

5. Link dangles to bottom of tubes with jump rings
Attach one of each color of the beaded dangles from step 4 to the bottom of each mesh tube with jump rings. If you have trouble getting a jump ring into place, use fine-tipped round-nose pliers to open a space in the mesh.

6. Finish earrings
Create two coil-top light violet head pins. Attach one dangle to the front of each crimped tube edge with a jump ring. Attach a jump ring to the top back of each tube and secure closed with pliers. Add a second jump ring and a French wire. Adjust French wire so earring hangs properly when worn.

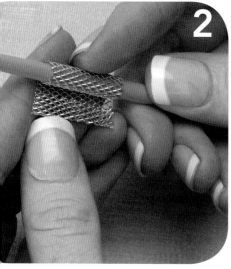

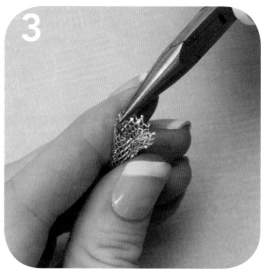

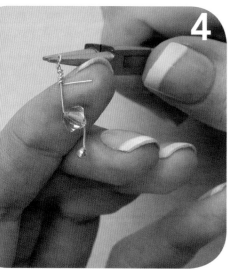

51

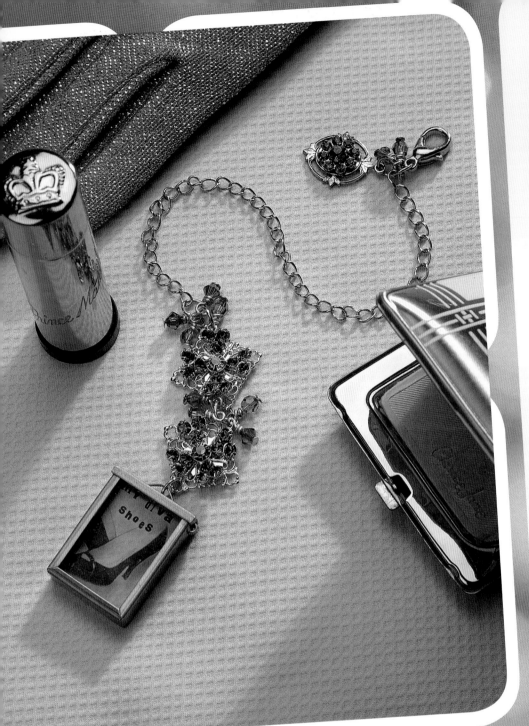

WHAT YOU WILL NEED

SPARKLIES, ETC.

one metal and acrylic shadow box frame

one transparency image (my diva shoes)

two square smoky topaz and light Colorado topaz Swarovski crystal filigrees

one oval olivine and smoky topaz Swarovski crystal filigree

five 5mm smoky topaz Swarovski bicones

five 5mm light Colorado topaz Swarovski rounds

one large gold-plated jump ring

forty-three links gold-plated chain

six 6mm gold-plated jump rings

ten gold-plated head pins

gold-tone lobster clasp

UTILITIES

sharp scissors

round-nose pliers

chain-nose pliers

flush cutters

Diva Shoes Purse Charm

Shoes…girls…need I say more? No, really. I have nothing else to say. I think this one speaks for itself.

SUPPLIES: SHADOW BOX AND TRANSPARENCY FROM ARTCHIX STUDIO; CRYSTAL BEADS AND FILIGREES BY SWAROVSKI; FINDINGS BY BEADALON

1. Cut out transparency image
Carefully cut out the image from the transparency sheet. The image should fit the frame perfectly. Measure the frame before cutting just to be sure.

2. Remove film
Use chain-nose pliers (or your fingers if you're extra-dexterous) to remove the film from each acrylic piece in the box frame.

3. Assemble frame
Slide both acrylic pieces into the frame box. There is a space between the two acrylic pieces.

4. Slide image into frame
Place the image in the frame between the acrylic pieces. Close the latch at the top of the box.

5. Link filigrees, crystals and charm
Create coiled-loop dangles with each of the crystals (see Bead Basics, page 14) and set them aside. Link the crystal filigrees together with a jump ring. Add a chain of two jump rings to the top filigree, and add one jump ring to the bottom filigree. Link two light Colorado topaz rounds and two smoky topaz bicone dangles to each jump ring. Link one of each dangle to the oval filigree and set it aside.

6. Attach chain and clasp
Link one end of the 43-link gold-plated chain segment to the top jump ring from step 5. Link the lobster clasp along with the oval crystal filigree to the free end of the chain with a jump ring. Thread the chain through a loop in your purse and secure the clasp to the jump ring at the top of the purse charm to secure it.

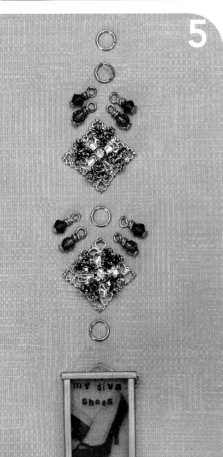

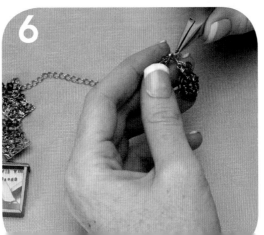

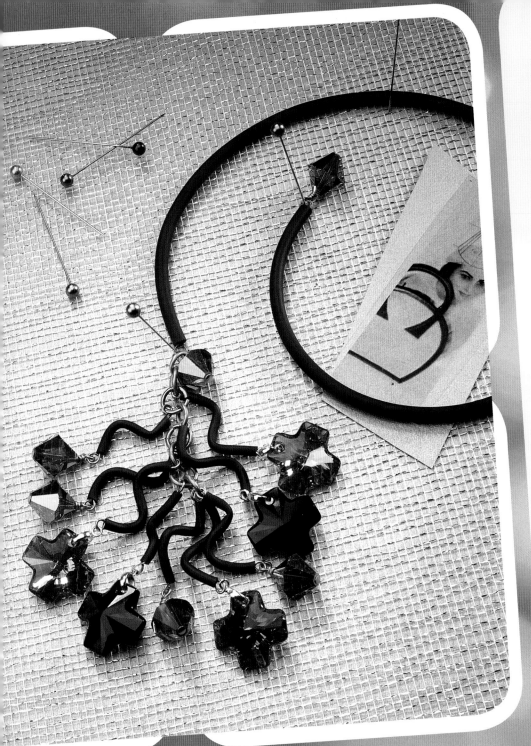

Sparkle
Vixen

WHAT YOU WILL NEED

SPARKLIES, ETC.

three 20mm metallic silver Swarovski crosses

two 20mm jet Swarovski crosses

six 14mm Montana blue AB Swarovski bicones

five silver-plated pinch bails

six silver-plated head pins

Remembrance necklace memory wire

6mm rubber tubing

4mm rubber tubing

16-gauge ColourCraft silver wire

UTILITIES

jump-ring maker

round-nose pliers

chain-nose pliers

flush cutters

memory wire shears

Squirm Choker

Edgy, hip, cool as a cucumber…here's a crazy little mixed-up rubber and crystal design for the next art opening or museum social. Grab some free wine and stir up some stimulating conversation. Heck, wearing this design might just make *you* the topic of conversation.

SUPPLIES: CRYSTAL BEADS AND PENDANTS BY SWAROVSKI; RUBBER TUBING, MEMORY WIRE, COLOURCRAFT WIRE, JUMP RING MAKER AND FINDINGS BY BEADALON

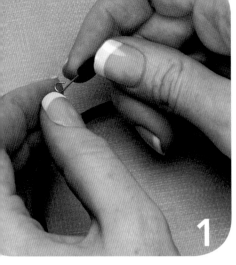

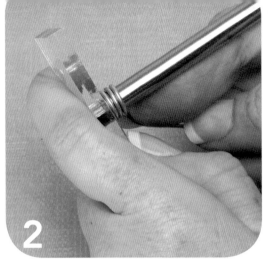

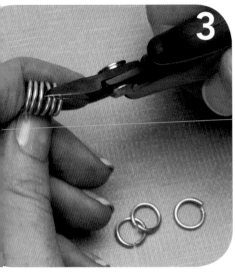

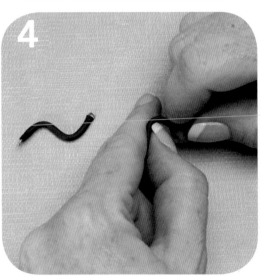

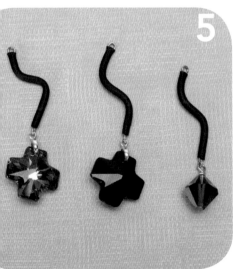

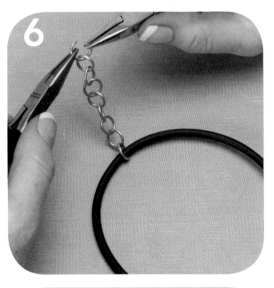

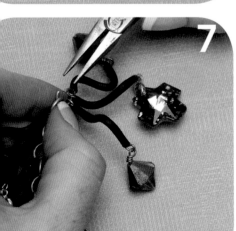

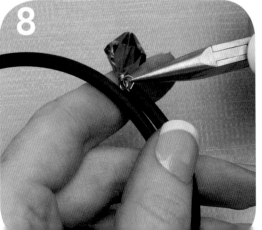

1. Cover wire with tubing
Use memory wire shears to cut a piece of memory wire to fit around your neck with about 1" (3cm) overlap in the back. Bend one end back with round-nose pliers to create a loop. Measure the stretched-out memory wire against the 6mm rubber tubing, and cut the tubing with flush cutters to fit the wire with about ¼" (6mm) overlap. Slide the tubing onto the wire, then turn the wire end with round-nose pliers.

2. Wrap wire for jump rings
Wrap 16-gauge ColourCraft wire around the jump-ring maker tool to create nine 10mm jump rings.

3. Cut wire into jump rings
Slide the coiled wire off the jump ring maker and use flush cutters to cut the coils into separate jump rings.

4. Create curved rubber pieces
Cut the 4mm rubber tubing to about ⅛" (3mm) shorter than the head pin at each end. Thread one tube onto a head pin and turn a loop at both ends of the wire (see Bead Basics, page 13). Bend the wired tube into an "s" shape. Repeat for a total of nine rubber segments.

5. Make dangles
Create six coiled-loop head pins with the Montana blue bicones (see Bead Basics, page 14). Slide a pinch bail into the top of one of the crosses. Slide the cross down so that both ends of the bail are facing upwards. Use the chain-nose pliers to carefully tighten the bail. Make a total of five cross dangles and four bicone dangles.

6. Build chain
Slide a jump ring onto the choker, then build a chain of nine jump rings.

7. Link dangles to chain
Attach dangles to the chain as follows, beginning at the top: metallic cross on second jump ring; blue bicone on third jump ring; jet cross on fourth jump ring; blue bicone on fifth jump ring; silver cross on sixth jump ring; jet cross on seventh jump ring; blue bicone, silver cross and blue bicone on final jump ring.

8. Finish choker
Attach one coil-top bicone to each loop on the end of the choker.

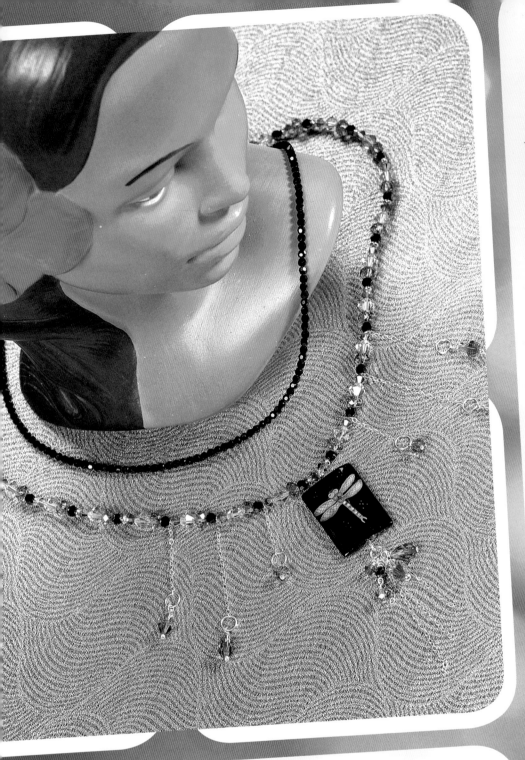

WHAT YOU WILL NEED

SPARKLIES, ETC.

hand-painted dragonfly
pendant on black onyx tile

three 6mm hyacinth Swarovski bicones

three 9mm x 6mm black diamond
Swarovski teardrops

one hundred twenty-three
3mm jet Swarovski rounds

twenty-five 4mm jet AB Swarovski rounds

twenty-five 6mm topaz Swarovski rondelles

twenty-four 4mm fire opal Swarovski bicones

twenty-two 6mm shadow crystal
Swarovski bicones

three 4mm shadow crystal Swarovski bicones

sixteen 2mm sterling rondelles

six ball-tip sterling head pins

six 22-gauge sterling head pins

fine sterling curb chain (two 17-link, two
25-link, one 13-link, two 14-link, one
33-link, one 26-link, one 22-link segments)

one large sterling lobster clasp

eight 5mm sterling jump rings

one 10mm sterling heavy-duty jump ring

four sterling crimp tubes

49-strand .018" (.5mm) beading wire
(one 20" [51cm] segment, one
24" [61cm] segment)

UTILITIES

crimp tool

round-nose pliers

chain-nose pliers

flush cutters

bead board

Art School Necklace

This design captures the delicate movements of a dragonfly. Tiny
sterling chains suspend dazzling crystal drops…a hand-painted
pendant provides the fiery palette…sensuous, hot, mysterious
and decidedly sexy. Feeling it? Oh, yeah!

SUPPLIES: DRAGONFLY PENDANT
FROM GLOBAL CURIOSITY; CRYSTAL
BEADS BY SWAROVSKI; STERLING
FINDINGS BY MARVIN SCHWAB/THE
BEAD WAREHOUSE; BEADING WIRE
BY BEADALON

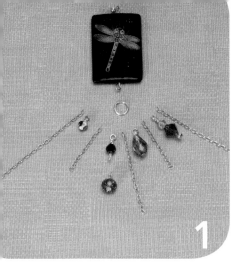

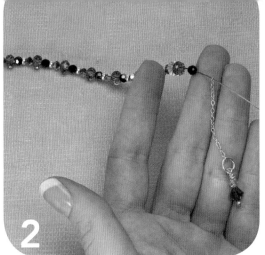

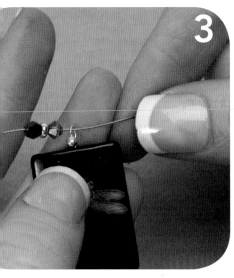

1. Create central pendant

Thread the dragonfly pendant onto a ball-tip head pin with the ball at he top of the pendant. Use the tips of the round-nose pliers to bend the ball over and create a loop/bail. Create a second loop flush to the bottom of the pendant. Create coil-topped head pin dangles (see Bead Basics, page 14) with the following beads: three 4mm shadow crystal and 6mm hyacinth on ball-tip head pins, three plain head pin topaz, two ball-tip black diamond, one plain pin black diamond, one plain pin 4mm fire opal. Link the 33-, 14-, 22-, 13- and 26-link chain segments and dangles to one 5mm jump ring as shown. Link the jump ring to the bottom loop of the pendant. Set the pendant aside.

2. Bead necklace

Before beginning to bead, create two each of all the chain dangles as follows: 17-link section linked to a jump ring with a 4mm shadow crystal and hyacinth ball-tip dangle; 25-link section linked to a jump ring with a ball-tip black diamond tear drop; 14-link section linked to a jump ring with a topaz drop. Set chain dangles aside.

Attach the shorter length of beading wire to a lobster clasp with a crimp tube (see Bead Basics, page 12). String the wire with 123 3mm jet rounds, then crimp the end to a 10mm jump ring. Attach longer length of beading wire to the lobster clasp, and bead it in the following sequence: jet AB, sterling rondelle, fire opal, topaz, 6mm shadow crystal, jet AB, sterling rondelle, fire opal, topaz. Repeat pattern to ninth jet AB round. Replace sterling rondelles with chain dangles in the next three sections, as shown.

3. Finish beading necklace

Slide on dragonfly pendant at center of design. Repeat the established pattern from the first half of the design in a mirror effect to finish beading the necklace.

4. Finish necklace

After beading the longer wire, attach it to the 10mm jump ring underneath the jet strand using a crimp tube. Check back through jump rings to ensure they are all secured.

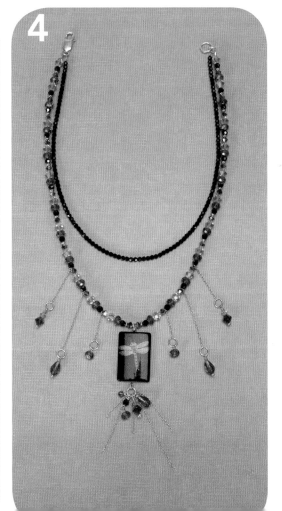

try this

Art School Bracelet

f you like to match, why not make a cute ittle bracelet? No sense in wasting any of those leftover beads! String the base pattern from the core section of the neclace onto a ength of .018" (.5mm) wire and build the racelet to fit your wrist.

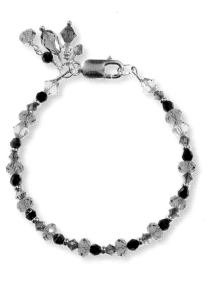

57

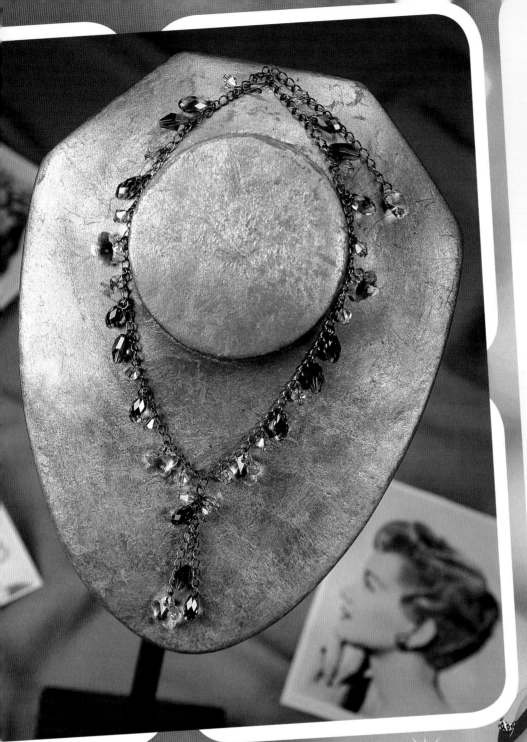

WHAT YOU WILL NEED

SPARKLIES, ETC.

five 11mm x 5.5mm padparascha
Swarovski briolettes

five 11mm x 5.5mm erinite
Swarovski briolettes

six 14mm light rose Swarovski flowers

five 11mm smoked topaz Swarovski polygons

seven 6mm chrysolite Swarovski bicones

five 6mm light peach AB Swarovski bicones

five 6mm violet AB Swarovski bicones

medium curb gunmetal bulk chain (4-link,
6-link, 8-link, 17-link, 92-link sections)

gunmetal eye pin

twenty-two gunmetal head pins

seventeen gunmetal jump rings

UTILITIES

round-nose pliers

chain-nose pliers

flush cutters

bead mat

Secret Garden Necklace

Rich, saturated color combined with the magical sparkle of
Swarovski crystal on gunmetal chain makes for a necklace you
will reach for again and again and again. It's a veritable garden
of delights…for a delightfully stylish woman…you!

SUPPLIES: CRYSTAL BEADS BY
SWAROVSKI; GUNMETAL FINDINGS
BY RINGS & THINGS

58

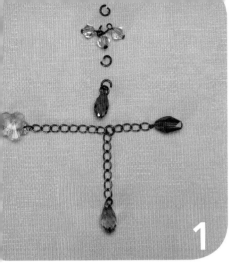
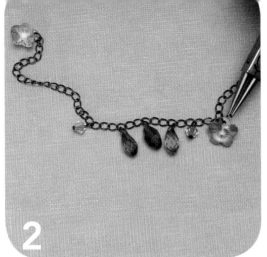

1

2

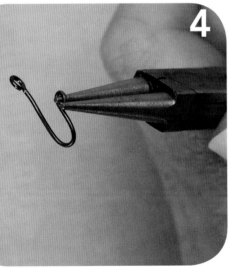

3

4

try this

Secret Garden Earrings

Make some sassy little earrings by modifying the hook you made for the necklace into a French wire style by not adding the smaller loop on the end. Add three varied chain lengths and three of the beads from the necklace.

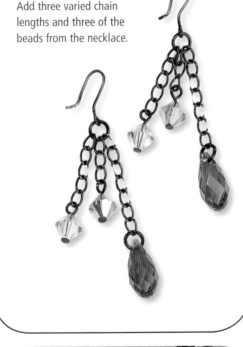

1. Create central dangle

Create loop-top dangles with the polygon and bicone beads. Set aside. Attach a jump ring with one of each loop-topped briolette colors to another jump ring. Add two more jump rings to form a short chain. Place a briolette and the three short chain lengths on the bottom of the lowest jump ring in the chain. Attach a polygon to the shortest chain, an erinite briolette to the second shortest chain and a flower on a jump ring to the longest length.

2. Link dangles to chain

Attach a flower on a jump ring to the end of the 92-link section of chain. Leave 2" (5cm) of chain bare, then attach a dangle every third link in the following sequence: padparascha briolette on jump ring, loop-topped brown polygon, loop-topped peach bicone, erinite briolette on jump ring, loop-topped violet bicone, flower on jump ring. Continue until you reach the center. Repeat the pattern in a mirror version of the first half along the opposite end of the chain.

3. Begin clasp

Bend the eye pin into a "u" shape. The eye should be perpendicular to the bend in the wire.

4. Finish clasp

Use the very end of the round-nose pliers to create a tiny loop in the end of your "u" shape. Use your fingers to shape the "u" into a hook. (The hook needs to catch on the chain or jump ring you will connect it to for it to stay hooked when worn.) Link the hook to the free end of the 92-link section of chain.

5. Attach central dangle

Find the center link and attach a jump ring. Attach the central dangle from step 1 to the bottom of the jump ring. Attach a jump ring and the 17-link chain to the other end of the 92-link chain. Working from the hook, start on the fourth link and attach a chrysolite bicone. Attach a flower on a jump ring to the end of the extension chain. Check back through the design to ensure all links are properly closed.

5

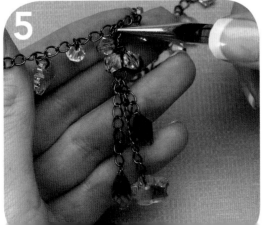

59

"I never worry about diets. The only carrots that interest me are the number you get in a diamond."

—Mae West

SCREEN QUEEN

"If you always do what interests you, at least one person is pleased."

—Katharine Hepburn

Once upon a time they invented a magical kingdom called Hollywood. There lived tough and sassy Mae West, a woman who knew who she was and made no excuses for it. She had a gift for turning a phrase until it positively dripped with sexual innuendo. In addition to performing, she wrote and directed controversial and successful plays and screenplays. Even late into her life people were astonished at how youthful she remained, which says something for being a bad girl, doesn't it? Another sprightly actress who called Hollywood home was the incomparable Ms. Audrey Hepburn. As Mae was ripe, juicy and raw, Audrey was slender, graceful and refined. Her gamine girlishness combined with just a splash of quirky left-of-center charm to make her an endlessly endearing actress. She brought a unique combination of strength and vulnerability to every role, and you couldn't help but love her and her flawless sense of style. I always say, if you want to know if something is stylish, ask yourself, "Would Audrey wear this?"

There's nothing like putting on the Ritz and painting the town red. Dig around a little bit and rent a classic film one night instead of the latest blockbuster so you can see just how amazing all of these bonafide movie stars were. Then bedeck yourself in some fabulous jewelry so you can act out your part. If you want to feel like a naughty glamour girl try the Mae West-inspired And When She Was Bad Charm Bracelet (page 66) or channel the spirit of Holly Golightly in the Holly Would Tiara (page 70) and the Holly Would, Too Multistrand Choker (page 72). Then announce your new screen queen status with the Star Treatment Door Hook (page 64).

WHAT YOU WILL NEED

SPARKLIES, ETC.

seven 8mm black diamond Swarovski cubes

twenty 6mm crystal AB Swarovski twisted step-faceted rounds

sixteen 6mm shadow crystal Swarovski bicones

sixteen 6mm jet Swarovski rondelles

EZ Crimp sterling S-hook clasp

49-strand .018" (.5mm) beading wire

UTILITIES

crimp tool

flush cutters

bead mat

Film Noir Bracelet

Myrna Loy, Jean Harlow, Lauren Bacall, Bette Davis, Joan Crawford, Louise Brooks, Barbara Stanwyck, Claudette Colbert…you should get to know these women if you don't yet. Rent some black-and-white films, and you will fall in love with all of them. Something about the way light works in black-and-white movies…the importance of shadow…the nuance…the subtlety…sigh. Wear this, and then in your sexiest voice do your best Lauren Bacall imitation.

SUPPLIES:
CRYSTAL BEADS BY
SWAROVSKI; WIRE
AND CLASP BY
BEADALON

62

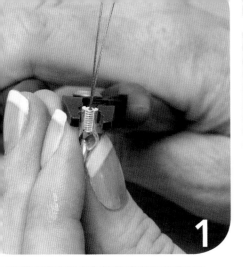

1

1. Attach wire to EZ Crimp

Attach two 8" (20cm) lengths of wire to one end of the clasp by squeezing the shiny sides of the end together in the front opening of your crimp tool.

2. String first half of pattern

Slide a crystal step-faceted bead, a jet and a shadow crystal bicone onto each wire. Thread both wires through opposite ends of a cube, crossing them inside the cube and pulling the wires taut (don't make this too tight or your design will be stiff).

3. Finish pattern and continue beading

Separate the wires and slide a step-faceted round crystal, a jet and a shadow crystal onto each strand. Thread both wires through a cube.

4. Finish bracelet

Repeat the full pattern (step 2 and step 3) until there are seven cubes. Then slide a step-faceted crystal, a jet and a shadow crystal onto each wire. Slide both wires into the second piece of the clasp. Use pliers to pull wires flush to the end of the clasp, leaving some slight play or slack in the wire. Cut excess wire with flush cutters.

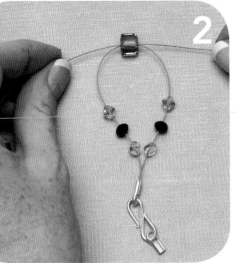

2

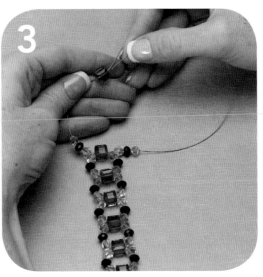

3

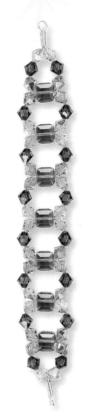

4

try this

Film Noir Variation

Simply adding color to the mix gives the design a very different feel. Don't get stuck in the copycat rut. Forge new pathways, dahling!

Change the bead colors and shapes to create a completely different effect. Be aware, however, that different beads affect the finished length of your design, so plan accordingly. Also, you can make this design longer to fit a larger wrist by adding another cube section to the design.

true craft

c o n f e s s i o n s

I found this technique in a bead book by the divine Ms. Carole Rodgers. It is a variation she came up with on a single needle stitch. Always give credit where credit is due.

WHAT YOU WILL NEED

SPARKLIES, ETC.

wooden star hook

wooden letter tiles

Glamour Girls collage sheet image

twenty-seven SS16 chalk white
cream flat-back faux Swarovski pearls

UTILITIES

toothpicks

disposable paintbrush

sandpaper

découpage medium

sparkly découpage medium

gold acrylic paint

carpenter's wood glue

two-part epoxy

Star Treatment Door Hook

It's high time you faced facts...you are a star! So start acting like one, doll. Hang this star door hook out for all the world to see, and then you can see how it feels to be fabulous. As if you didn't already know.

SUPPLIES: WOODEN STAR HOOK BY WALNUT HOLLOW; GLAMOUR GIRLS SHEET BY ARTCHIX STUDIO; FLAT-BACK PEARLS BY SWAROVSKI; MOD PODGE AND SPARKLE MOD PODGE BY PLAID; FAUX SCRABBLE TILES BY LARA'S CRAFTS; WOOD GLUE BY ELMER'S

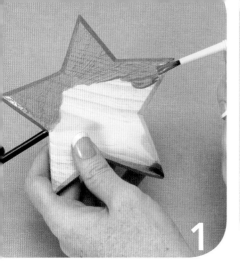

1. Paint star
Lightly sand the raw wooden star and the tiles. Paint the star gold, leaving an open space in the middle for the image. Allow it to dry.

2. Paint letter tiles
Paint sparkly découpage medium onto the tiles and allow it to dry.

3. Adhere image and letter tiles
Cut out the image and adhere it to the center of the star with découpage medium. Allow it to dry. Paint découpage medium onto the image, allow it to dry and repeat with a second coat. Adhere the tiles to the star with wood glue. Allow the adhesive to dry.

4. Adhere pearl border around image
Adhere pearls to the edges of the image with premixed two-part epoxy. Allow it to set.

5. Apply sparkly découpage medium
Paint the entire star with sparkly découpage medium. Try to avoid painting the surface of the pearls. Allow the medium to dry.

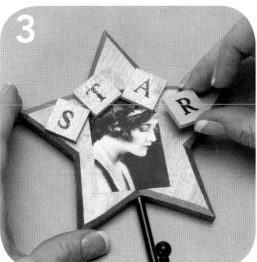

SPARKLY TIP:
star sighting

If you wanna see star power, see Theda Bara, Marilyn Monroe, Louise Brooks, Rita Hayworth, Bette Davis, Joan Crawford, Dorothy Dandridge, Ginger Rogers, Elizabeth Taylor, Myrna Loy, Jean Harlow, Anna May Wong, Alla Nazimova, Clara Bow, Lauren Bacall, Carole Lombard and the glorious Marlene Dietrich...ah, the list is endless...they just don't make movie stars like that anymore...

true craft
c o n f e s s i o n s

After I finished this design, I realized it was a little off-center. Kind of like me. Oh well, stuff happens. You have to decide if you can live with it or not, then either change it or move on!

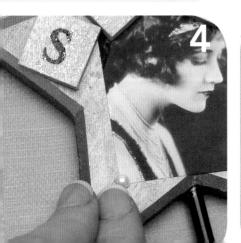

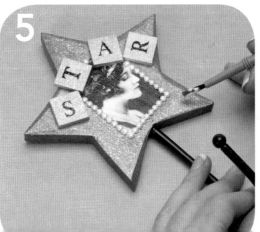

65

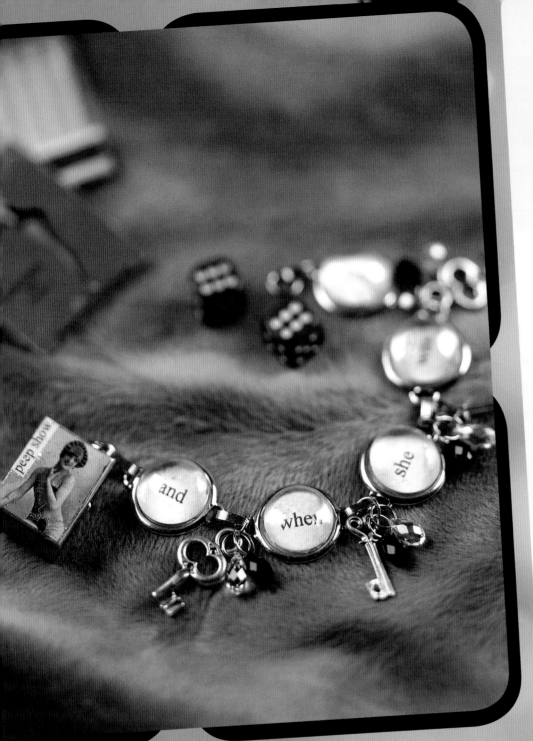

WHAT YOU WILL NEED

SPARKLIES, ETC.

one metal bracelet blank

printed phrases

five flat-back glass stones

one metal box charm

one flapper sticker image

one collage sheet leg image

four metal key charms

four 11mm x 5.5mm jet Swarovski briolettes

four 11mm x 5.5mm crystal AB Swarovski briolettes

one SS 12 rose foil-back Swarovski flat-back crystal

twelve 6mm silver-plated jump rings

one 10mm heavy-duty jump ring

UTILITIES

two pair chain-nose pliers

tweezers

scissors

hot-fix applicator tool

sparkly découpage medium

glue stick

embellishing adhesive (Gem-Tac)

SUPPLIES: EPHEMERA IMAGES AND KEYS FROM ARTCHIX STUDIO; BRACELET BLANKS FROM EASTERN FINDINGS; SHADOW BOX FROM SACRED KITSCH STUDIO; CRYSTAL BEADS AND FLAT-BACK STONE BY SWAROVSKI; JUMP RINGS FROM RINGS & THINGS

And When She Was Bad Charm Bracelet

Feeling naughty? Well, have I got a bracelet for you, doll. *Mae be* you will and *Mae be* you won't, but you'll always leave them wanting more.

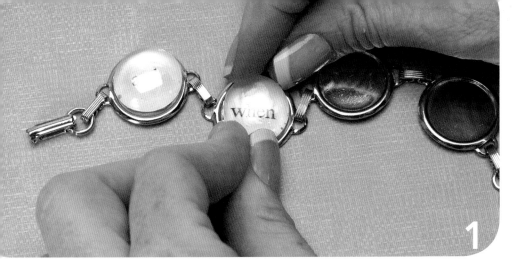

1. Adhere word bubbles to bracelet blanks

Print out "and when she was bad" in Times New Roman 12 pt, keeping each word on a separate line and double-spacing between words. Place a glass pebble on top of each word and adhere with embellishing adhesive (such as Gem-Tac). Allow to dry. Cut around each pebble. Glue the pebbles into the bracelet blanks with Gem-Tac. Allow the adhesive to dry.

2. Decorate outside of box

Print out "peep show" twice in Times New Roman 9 pt, and cut around each phrase. Trace the box onto the sticker and cut the sticker. Adhere the sticker to the front of box, and adhere the phrase to the left side of the sticker with a glue stick. Paint over the mini collage with sparkly découpage medium. Allow it to dry.

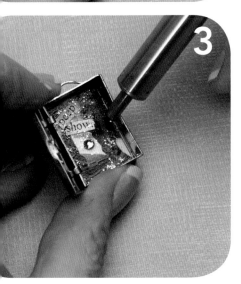

true craft

c o n f e s s i o n s

The glass pebbles fell off of the first prototype, so I had to find a stronger glue. The metal got rusty from getting wet. It's a good idea to test drive your ideas for road wear. Sometimes it takes a few attempts to get it just right. Keep on trucking!

3. Decorate inside of box

Trace the box onto the leg image and cut the leg image. Glue the image inside the box with embellishing adhesive (such as Gem-Tac). Allow it to dry. Cut out both words ("peep" and "show") and adhere them inside the box with a glue stick. Paint the inside with sparkly découpage medium and allow it to dry. Affix a hot-fix crystal to the image inside the box with the applicator tool.

4. Link charms and dangles to bracelet

Attach each key directly to a bracelet link between words with a jump ring, slide each briolette onto a jump ring and link each one in front of a key. Attach the shadow box to the final link in the bracelet with a heavy-duty jump ring. Check back through the design to ensure all jump rings are properly secured.

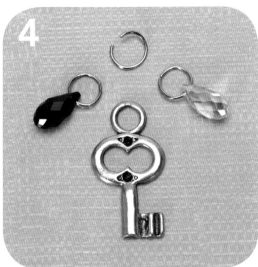

"When I'm good, I'm very good. But when I'm bad, I'm better."

—Mae West

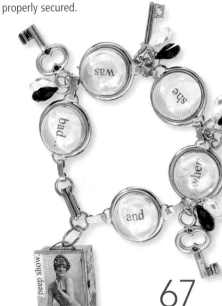

67

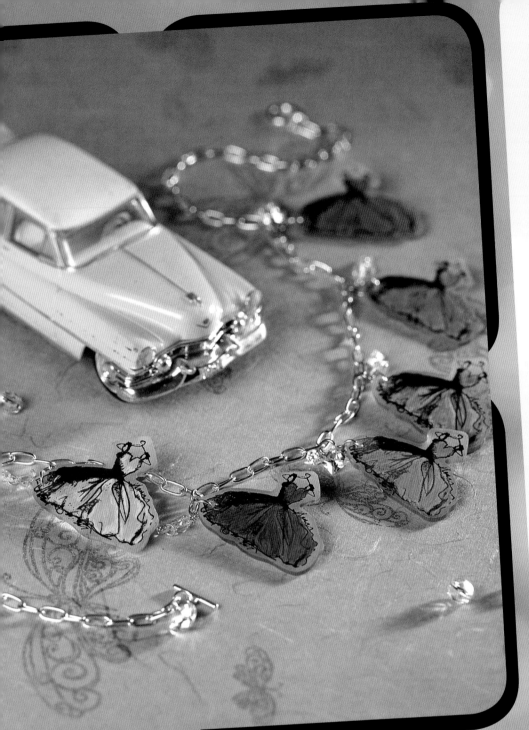

WHAT YOU WILL NEED

SPARKLIES, ETC.

shrink plastic (Frosted Ruff N' Ready)

various sizes and shapes of cubic zirconia (CZ) beads (two for each dress)

85-link segment elongated stainless steel cable chain

one small silver-plated toggle clasp

eighteen 4mm silver-plated heavy-duty jump rings

six 24-gauge sterling oval jump rings

six 24-gauge sterling head pins

UTILITIES

round-nose pliers

chain-nose pliers

flush cutters

sharp, small scissors

star-shape punch tool

small sheet brown paper bag cut to fit baking tray

spatula

dress stamp

StazOn Ink

colored pencils

notebook

Marilyn Necklace

I adored Marilyn Monroe…as did many. In my favorite photo of her she is barefoot and dressed in a ballerina's dress, and this stamp reminded me of that dress. I added cubic zirconia (CZ) beads, because they are a working girl's best friend. I made it Technicolor, like Warhol's Marilyn, a woman of many colors and moods.

SUPPLIES: STAMP 8353 BY DAWN HAUSER FOR INKADINKADO; RUFF N' READY BY SHRINKY DINKS; CHAIN AND CZ BEADS FROM BEADALON; HEAVY-DUTY JUMP RINGS FROM RINGS & THINGS; STERLING FINDINGS FROM MARVIN SCHWAB/THE BEAD WAREHOUSE

1. Stamp dresses on shrink plastic
Stamp the dress image you choose on the frosted side of a sheet of shrink plastic six times.

2. Color dresses
Use two shades of one color to shade each dress. Make one dress each in fuchsia, blue, green, orange, purple and yellow.

3. Cut out dresses, punch holes and shrink dresses
Use sharp scissors to cut around each dress, leaving a small border around the lines of the stamp. Punch a star-shaped hole in the far right side of each dress. Shrink the dresses by following the shrink plastic's instructions, carefully reaching into the oven and uncurling them if they start to curl up too much while cooking. Place a notebook on top of the images while cooling to press them flat.

4. Make CZ dangles
Thread a larger double-drilled cubic zirconia (CZ) with a head pin from front to back, and bend the head pin wire up 90°. Bend the head pin wire back down and coil the wire around the top of the bead to make a dangle. Thread smaller CZs onto oval jump rings and connect them to the larger CZs.

5. Link dresses and dangles to chain
Slide a jump ring through each dress and add a CZ dangle on each, with the dangle hanging on the shiny side of each dress. Thread each dress with two more jump rings. Bend the chain in half, count up to the fourth link on each side and attach a dress. Attach a dress on each side at the seventh link up from previous dress. Attach a toggle clasp to each chain end. Add one large CZ on an oval jump ring to the second link from the toggle bar.

true craft
c o n f e s s i o n s

The first version of this necklace had clear plastic tiles that spelled "Marilyn." I decided after looking at it for a week that it didn't need to be so literal. I removed the tiles. Sometimes you have to step away and get a little perspective on your designs.

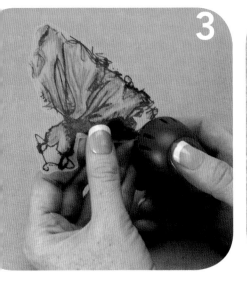

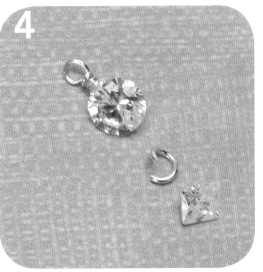

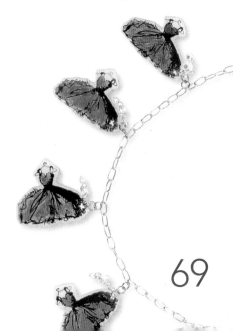

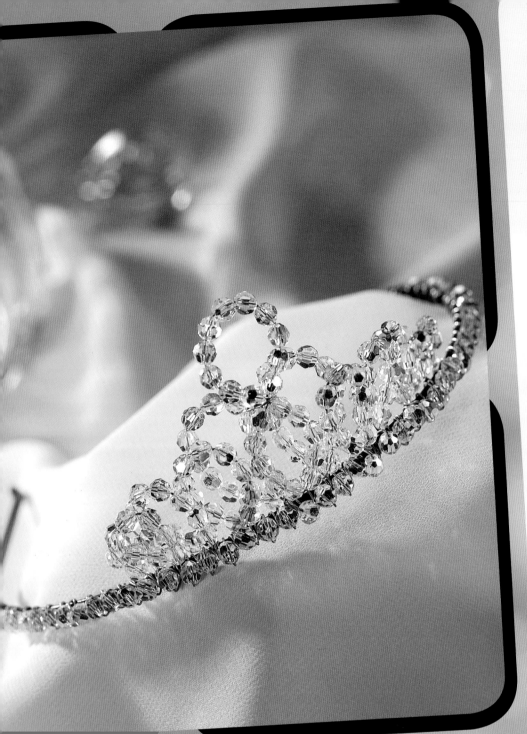

Sparkle
Vixen

WHAT YOU WILL NEED

SPARKLIES, ETC.

one hundred sixty-eight 5mm crystal AB Swarovski rounds

20-gauge silver-plated copper jewelry-making wire

black headband with wire-wrapped teeth

UTILITIES

wire cutters

Holly Would Tiara

Holly would, indeed, and so should you. Wear a tiara during the day, that is! I wore this to my book signings and later to have pizza with some friends. Even if you don't have breakfast at Tiffany's…heck…you can wear this puppy to breakfast at Denny's.

SUPPLIES:
CRYSTAL BEADS
BY SWAROVSKI;
HEADBAND BY
GOODY; BEADING
WIRE BY BEADALON

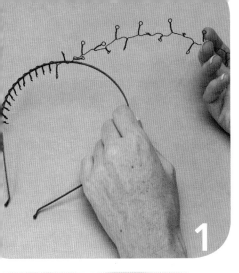

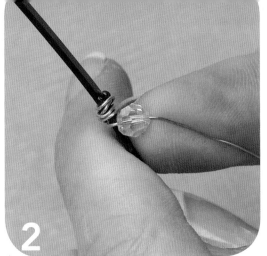

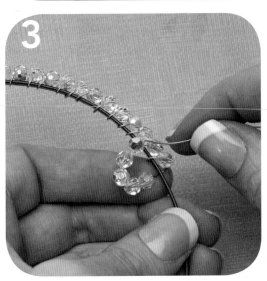

1. Remove teeth
Cut one end of the wire teeth and unwrap the wire from the headband.

2. Wrap first crystal
Cut a 4' (1.2m) length of jewelry wire and wrap one end of it tightly around the headband at the glue spot from the teeth four times. Tuck in the wire tail. String a crystal bead onto the wire, then wrap the wire over and under around the front of the band. Wrap the wire around twice and add a second bead. Repeat for seventeen more beads.

3. Make loops
Add five beads to the wire and create a loop. Twist the loop at the base to tighten it. Wrap the wire around the band twice to secure the first loop. Wrap one crystal. String on seven beads and make a loop as before. Wrap two crystals. String on nine beads and make another loop. Wrap two crystals. Make a loop with eleven crystals, followed by two wrapped crystals. Make a thirteen-crystal loop followed by two wrapped crystals.

4. Make central loop
Wrap one crystal. String twenty-one crystals onto the wire and make a figure eight. Twist the loop at the base as before.

5. Secure central loop to finish tiara
Bead the second half of the tiara in a mirror image of the first half. If you run out of wire, get a new wire and tuck all ends under. Secure the center figure-eight loop to the two flanking thirteen-bead loops with extra bits of wire to finish.

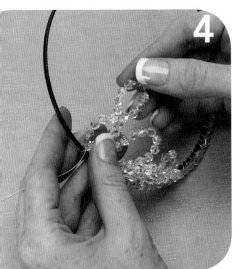

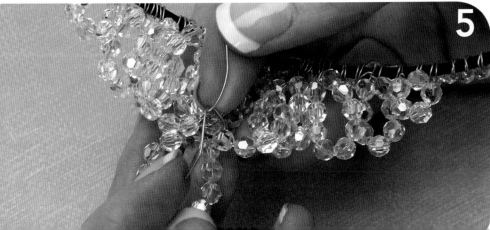

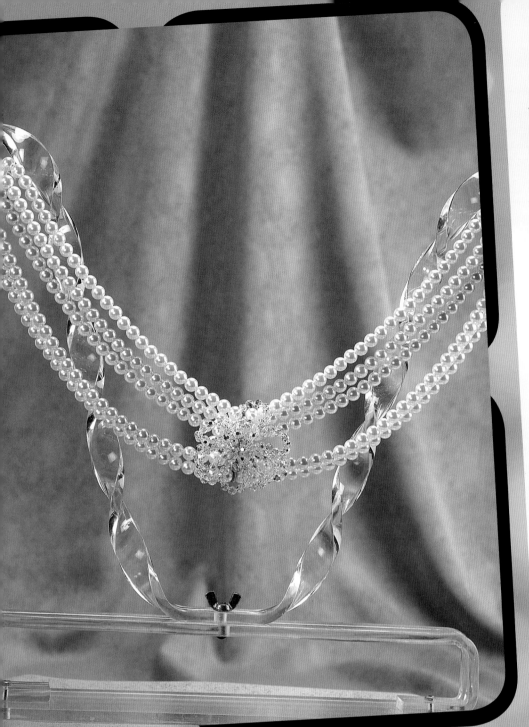

WHAT YOU WILL NEED

SPARKLIES, ETC.

three hundred eight 8mm white faux pearls

one hundred thirteen 5mm crystal AB Swarovski rounds

one sterling five-strand clasp

ten sterling split rings

ten sterling crimp tubes

22-guage silver-plated copper jewelry-making wire

49-strand .018" (.5mm) beading wire (18", 20", 22", 23", 24" lengths [46cm, 51cm, 56cm, 58cm, 61cm])

large safety pin

UTILITIES

crimp tool

flush cutters

bead mat

Holly Would, Too Multistrand Choker

For those days when you absolutely, positively have to get in tune with your inner Audrey, just don the tiara *and* the necklace, a pair of long black gloves, a little black dress, put your hair up in a French twist and play some Henry Mancini on the turntable. Oh…you will be so gorgeous!

SUPPLIES: CRYSTAL BEADS BY SWAROVSKI; FAUX PEARLS AND BEADING WIRES BY BEADALON; MULTISTRAND STERLING CLASP AND STERLING SPLIT RINGS BY FIRE MOUNTAIN GEMS

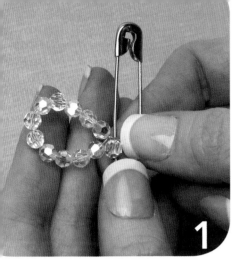

1

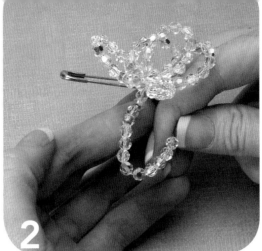

2

true craft
c o n f e s s i o n s

I made this necklace twice. The first time I thought I had the pearls perfectly graduated, until I put the necklace on and realized there were too many pearls on each of the bottom strands. Snark! I managed to cut the pearls off at the crimp tube and recrimp each strand…which was a far better solution than restringing this little piggy, let me tell you!

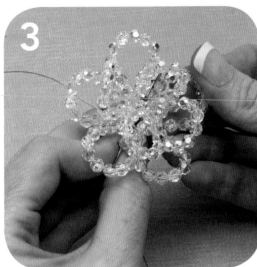

3

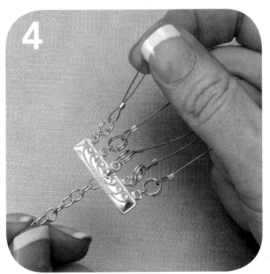

4

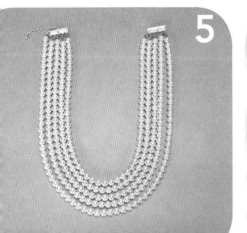

5

1. Begin crystal flower
Wrap a 3' (1m) section of 22-gauge wire around the stable bar of the pin three times. Wrap one crystal, then wrap the wire twice around the pin bar. Thread 11 crystals on the wire, loop the wire and twist it at the base to secure. Wrap the wire twice around the pin bar. Make two more 11-crystal loops.

2. Continue flower
Thread 13 crystals onto the wire, loop the wire and twist it at the base to secure, then wrap the wire twice around the outside of the other loops. Make five more 13-crystal loops. Work so the smaller loops are in the center and the larger loops are on the edges, forming a flower.

3. Finish flower
Add a final crystal bead to the pin bar and wrap the wire three times to secure, tucking the wire end into the wires underneath the pin bar with your pliers. Set the flower aside.

4. Secure wires to clasp
Attach one split ring to each loop of the five-strand clasp. Attach the shortest wire strand to the top loop in the five-strand clasp with a crimp tube. Attach the remaining wires to the split rings in descending order of length.

5. String pearls
String the shortest wire with 55 pearls and crimp it to the other clasp, making sure it is attached at the top loop. (Keep the clasp closed to help keep the strands falling properly while beading.) Bead each remaining wire in descending order with the following numbers of pearls: 58, 61, 65, 69. Secure each strand to the remaining clasp component with split rings. Opt to attach the crystal flower to the center of all five strands, or wear the components separately.

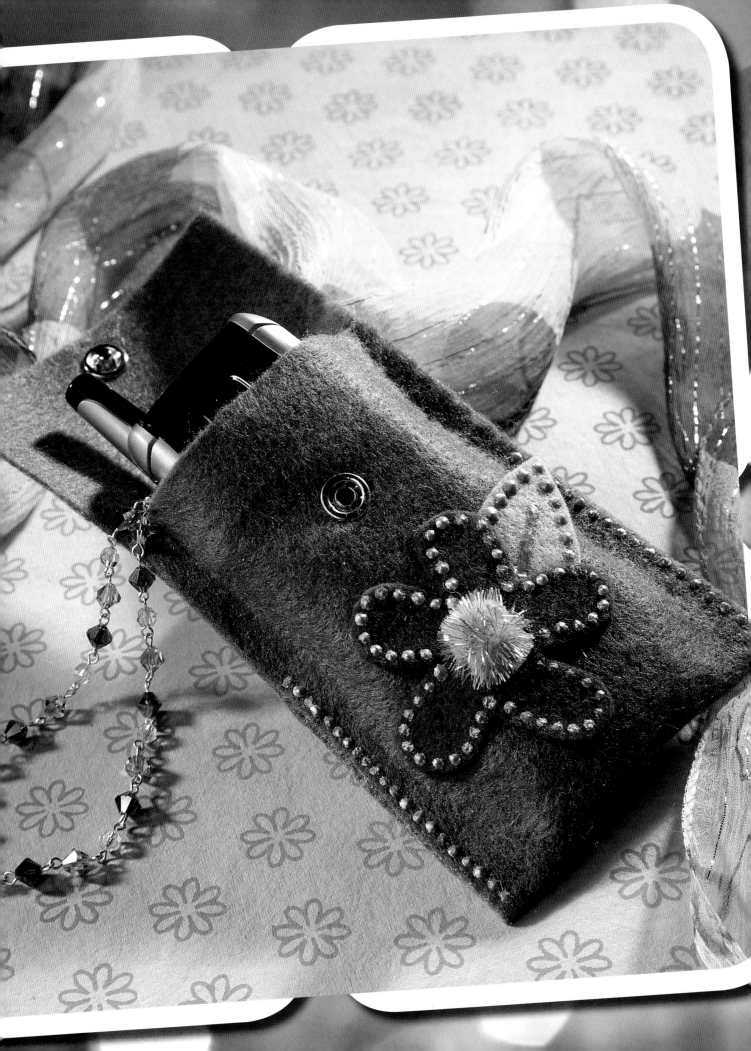

> "The biggest adventure you can ever take is to live the life of your dreams."
>
> —Oprah Winfrey

Diva in Training

> "Cherish forever what makes you unique, 'cuz you're really a yawn if it goes."
>
> —Bette Midler

Not long ago and not far away, there lives a powerful queen who built her own kingdom. Her goodness and power are known so far and wide that she needs but one name: Oprah. She is the ultimate diva, a woman who embraces her girlishness and carries herself with dignity and grace, all while giving tirelessly of herself to others. She overcame immeasurable odds to become the most successful African-American of the twentieth century. A child of unwed teenage parents, a sexual and physical abuse survivor who was raised in the Milwaukee ghetto, she was not exactly the most likely to succeed. Yet her tenacity, talent, beauty and intellect led her to greatness. She is one of the most influential figures in the world today, and she makes no apologies for who she is, what she believes in or how she lives. She also gets that a woman is beautiful because she sees herself that way, and not because other people tell her so. All hail, Queen Oprah.

Inspire greatness in a future diva today! The future of girlie goodness depends on older divas sharing with the next generation. Show a young lady she's a superstar with the Twinkle, Twinkle Diva Star Bracelet (page 84) or celebrate the princess within her with the lovely Pretty Princess Necklace (page 80). Or give a touch of sparkle to a tiny diva-to-be with the Oh Bébé Onesie (page 78). There is nothing more important than showing young women they are goddess-like, and that they can do and be absolutely anything they can imagine. It's tough enough to be a girl without strong women in your corner cheering you on. Shower the young ladies you know with positive affirmations of their self-worth. You can start by giving a young lady you love something sparkly to help her shine.

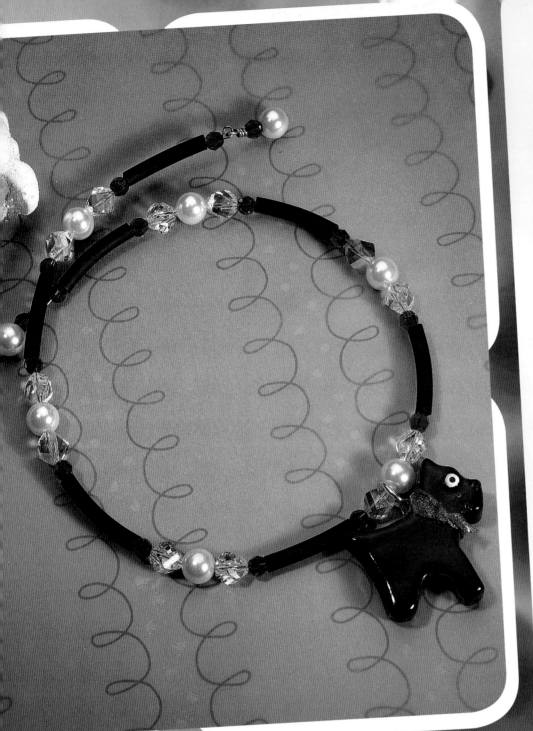

WHAT YOU WILL NEED

SPARKLIES, ETC.

one handcrafted black
Scottie dog pendant

eight 8mm faux pearls

twelve 8mm crystal AB
Swarovski helix beads

sixteen 5mm light Siam
Swarovski crystal rounds

15" (38cm) segment
Remembrance memory wire

seven 1" (3cm) segments
black rubber tubing

two 22-gauge silver-plated head pins

UTILITIES

round-nose pliers

chain-nose pliers

memory wire shears

flush cutters

ruler

How Much Is That Doggie? Choker

How much is that doggie in the window? Jeepers, is anything
more lovable than a Scottie dog? Well, of course! You are, silly,
when you wear this adorable little choker.

SUPPLIES: CRYSTAL
BEADS BY SWAROVSKI;
PEARLS, MEMORY
WIRE, RUBBER TUBE
AND FINDINGS BY
BEADALON

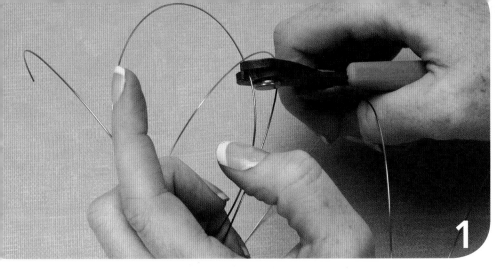

1. Cut wire and tube
Use memory wire shears to clip off a 15"
(38cm) section of memory wire. Use flush
cutters to clip off seven 1" (3cm) sections
of tubing. Make sure to measure first!

2. Bead necklace and secure ends
Create two beaded coiled-loop dangles,
each with a pearl on the bottom and a
Siam crystal on the top (see Bead Basics,
page 14). Use round-nose pliers to bend
one end of the memory wire back over
itself into a small loop, then slide a beaded
dangle onto the loop and secure the loop
closed with pliers. Bead the necklace in
the following sequence: Siam bead, rubber
tube, Siam bead, helix bead, pearl, helix
bead, Siam bead, rubber tube. Repeat the
sequence six times, ending with a Siam
bead. Use pliers to bend back the memory
wire, and attach a beaded dangle to the
end before securing the loop.

3. Secure dog pendant to necklace
Slide a jump ring onto the bail of the
Scottie dog, then attach it to the center of
the necklace, securing the jump ring closed
with pliers (see Bead Basics, page 15).

SPARKLY TIP:
say never

I know what they say, but there is one
time when you should definitely say
never. Never, ever cut memory wire with
flush cutters. Use memory wire shears.
Unless you like working with a razor
sharp wire and ruining your flush cutters.

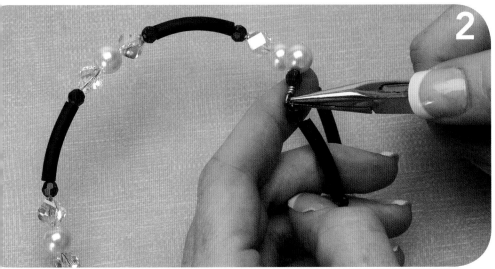

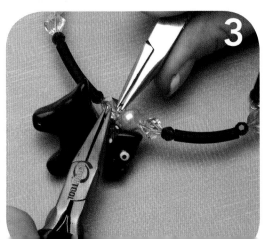

77

WHAT YOU WILL NEED

SPARKLIES, ETC.

white cotton baby onesie

fairy fabric transfer image

"bébé" printed in 48-pt Verdana

forty-six SS10 crystal cosmojet
Swarovski hot-fix round crystals

four SS16 peridot Swarovski
hot-fix round crystals

UTILITIES

hot-fix applicator tool

computer

printer

scissors

cardboard form for inside of onesie

fabric glue

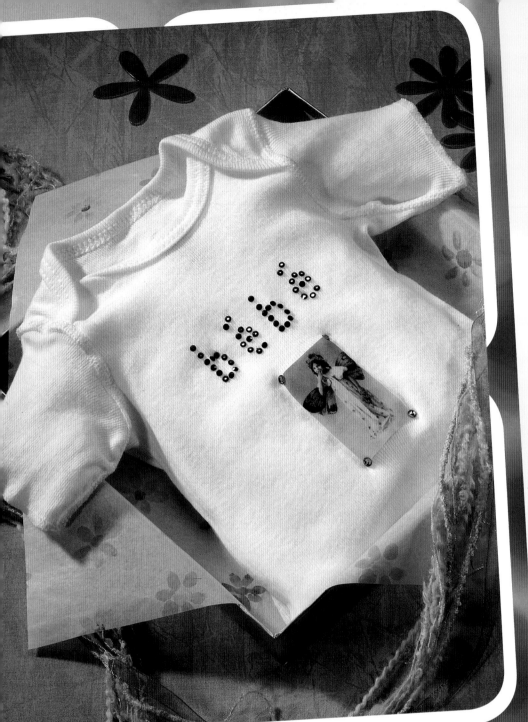

SUPPLIES: FABRIC TRANSFER
SHEET IMAGE FROM ARTCHIX
STUDIO; HOT-FIX CRYSTALS
BY SWAROVSKI; HOT-FIX
APPLICATOR TOOL FROM
JEWELRYSUPPLY.COM; LIQUID
STITCH BY PRYM/DRITZ

Oh Bébé Onesie

Is a girl ever too young to sparkle? *En français* even? *Mais, non!*
For your precious little *bébé*, here's a precious little dress-up onesie.

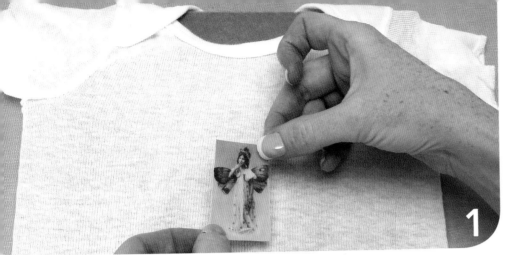

1. Adhere image to onesie
Cut out the image you'd like to use from the fabric sheet. Glue the image to the onesie with fabric glue. Allow it to dry.

2. Affix crystals to letters
Print out "bébé" and slide the word under the onesie at breastbone height. You may trace the word or leave it under the shirt as a guideline. Use the hot-fix applicator tool to affix hot-fix crystals to the onesie to spell out "bébé." Add the accent marks freehand.

3. Affix crystal accents to image
Affix four peridot crystals onto the corners of the fabric image.

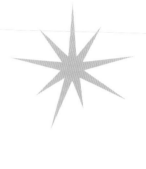

true craft
c o n f e s s i o n s

This may look like a simple project and believe me, it is. Yet, I found a way to completely mangle four prototypes before I finally got this version. Then, just as I finished it, I realized that I had somehow managed to get some paint on the inside of the last one. That's when I strive to find my Zen mind and let it go!

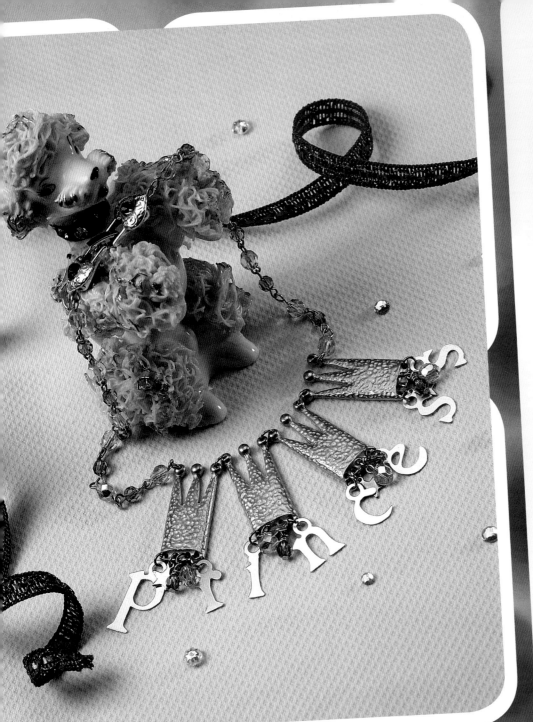

WHAT YOU WILL NEED

SPARKLIES, ETC.

four 2-to-4 textured pewter crown pendants

eight metal lower-case eyelet
letters to spell "princess"

fourteen 5mm light rose Swarovski rounds

sixteen 8mm pale pink AB Czech rounds

four extra-small silver-plated flat star charms

twenty-one 4mm silver-plated jump rings

thirty-two silver-plated head pins

one metal and light rose Swarovski
crystal fold-over heart clasp

UTILITIES

round-nose pliers

chain-nose pliers

flush cutters

Pretty Princess Necklace

Every little girl is a princess; there are absolutely no exceptions to
the rule. This pretty-as-a-princess choker spells it out for the rest of
the world, just in case someone forgets. Just remember, little one,
you don't need to be rescued…you need to be worshipped!

SUPPLIES: CRYSTAL BEADS BY
SWAROVSKI; CZECH GLASS BEADS
FROM YORK NOVELTY IMPORT
INC.; EYELET LETTERS BY MAKING
MEMORIES; CRYSTAL AND METAL
CLASP BY PURE ALLURE; FINDINGS
BY BEADALON

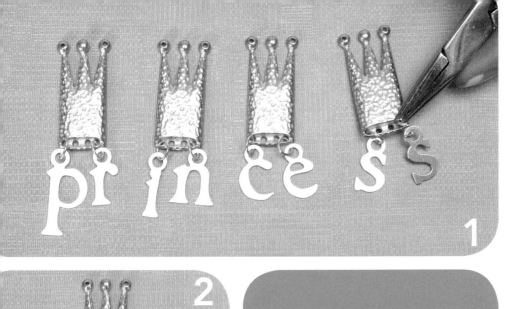

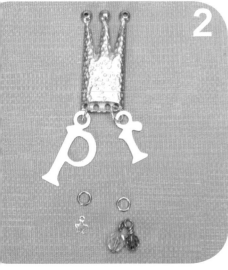

1. Link letters to crowns
Attach two letters to the outside bottom holes in each crown with jump rings to spell "princess."

2. Create dangles
Slide each star onto a jump ring. Create four looped-top light pink round dangles and four looped-top light rose round dangles (see Bead Basics, page 14). Attach the stars and dangles to the holes in each crown with jump rings.

3. Link crowns together
Link the crowns together using jump rings threaded through the top holes of each crown.

4. Build rosary chain
Add a jump ring to the outermost hole in each outermost crown. Double loop the remaining beads and link them together to make a chain, starting and ending with a light pink crystal. Create two 11-link segments in total.

5. Finish necklace
Thread a head pin into the center hole of each side of the clasp. Create a loop, then bend the opposite end of the pin into a second loop. Attach the ends of the rosary chain to the loop you created on each side of the clasp.

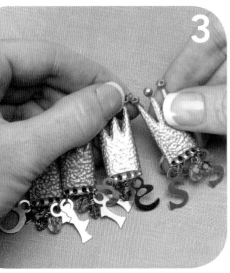

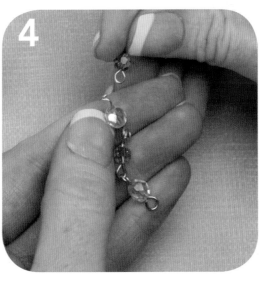

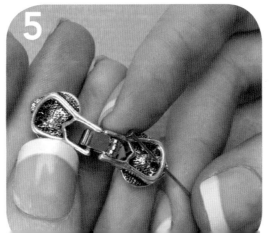

WHAT YOU WILL NEED

SPARKLIES, ETC.

lunch pail

cotton vintage-inspired kid fabric

baby pink eyelash yarn

nine SS5 foiled fuchsia
flat-back Swarovski stones

plastic letter tiles to spell "snack time"

UTILITIES

disposable plastic plate

large craft brush

disposable plastic brush

hot glue gun

fabric scissors

marking pen

sandpaper

disposable gloves

découpage medium

sparkly découpage medium

two-part quick-set epoxy

hot glue sticks

SUPPLIES: LUNCHBOX
BY PROVO CRAFT; FUZZY
EYELASH YARN BY
BERNAT; LETTER TILES
BY WESTRIM CRAFTS;
FLAT-BACK STONES BY
SWAROVSKI; FABRIC
FROM J&O FABRICS;
LOCTITE EPOXY BY
HENKEL

Snack Time Lunch Pail

A girl's simply gotta have her lunch, and eat it too. So why not pack it in sparkly style? Eating your veggies never looked like so much fun! Use this as a funky purse or a lunch box…or just keep cool stuff in it on a shelf in your room.

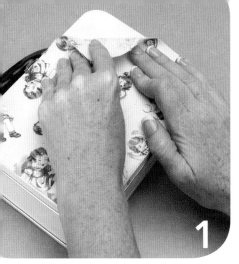

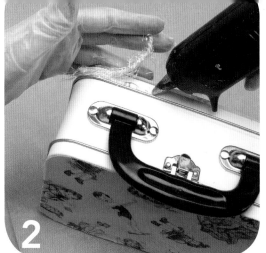

1. Cut and adhere fabric

Lay fabric wrong side up on your work surface and place the lunchbox on top of it, making sure the motif on the fabric lines up nicely across the front of the box. Use a marking pen to trace around the lunchbox. Cut out the fabric with fabric scissors. Cut out another piece of fabric for the other side. Adhere the fabric to the front and back of the box with découpage medium. Allow the medium to dry.

2. Adhere eyelash yarn border

Use a glue gun to run a bead of glue around the edge of the box for the yarn to follow, beginning at the top. Use your gloved hand to carefully compress the yarn into the glue. Be careful not to burn yourself! Repeat for the other side of the box.

3. Trim yarn

Trim the eyelash yarn when you've finished the border.

4. Apply sparkly découpage medium

Paint sparkly découpage medium over the fabric on both sides of the box. Paint the sides of the box with two coats of sparkly découpage medium as well. Allow the medium to dry.

5. Sand letter tiles

Lightly sand both sides of the letter tiles.

6. Adhere letters to box

Mix two-part epoxy on a disposable plate. Use a disposable brush to apply a thin layer of epoxy to a tile and adhere it to the box. Repeat for all the letters on both sides. The glue takes five minutes to set, but allow a bit longer for it to dry completely. Adhere one crystal to each letter tile in a random fashion with epoxy. Use a toothpick to apply the epoxy to the backs of the crystals.

SPARKLY TIP:
it stinks

You must work quickly because two-part epoxy sets up and dries very fast. You only need to use a very small bit of two-part epoxy. Follow the directions. It stinks…literally. Ventilate!

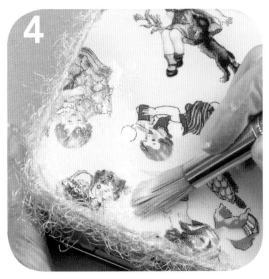

true craft
c o n f e s s i o n s

When I glued the letters to the sides of the pail, the epoxy smeared out of the sides and it looked really bad. That's when I brought out the Mod Podge Sparkle, which ended up giving the design better continuity. Mistakes are opportunities in disguise!

83

Sparkle
Vixen

WHAT YOU WILL NEED

SPARKLIES, ETC.

eight pewter diva charms

four 11mm x 5.5mm light
rose Swarovski briolettes

four 6mm peridot Swarovski butterflies

four 5mm aquamarine Swarovski butterflies

four 5mm crystal AB Swarovksi butterflies

twenty-five extra-small silver-plated
flat star charms

one peridot Swarovski crystal
and metal textured toggle clasp

28-link section stainless steel
elongated cable chain

sixteen silver-plated head pins

forty-eight 3mm silver-plated jump rings

UTILITIES

round-nose pliers

chain-nose pliers (two pairs optional)

flush cutters

Twinkle, Twinkle Diva Star Bracelet

Twinkle, twinkle diva star, make them wonder who you are. This
dainty delight is chock full of the good stuff! Being a girl is the
best thing going…shhh…don't tell the boys!

SUPPLIES: TOGGLE BY PURE
ALLURE; CRYSTAL BEADS BY
SWAROVSKI; DIVA CHARMS
FROM ARTCHIX STUDIO; CHAIN
BY BEADALON

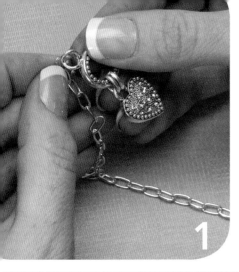

1

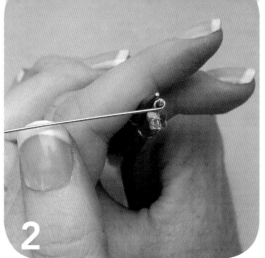

2

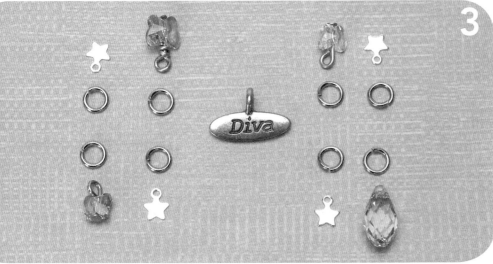

3

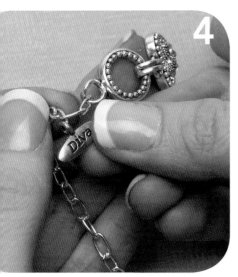

4

5

1. Attach clasp to chain
Attach the circle clasp component to one end of the chain with pliers.

2. Create butterfly dangles
For the blue and white butterflies, make looped dangles. Make coiled-top dangles with the green butterflies (see Bead Basics, page 14).

3. Lay out dangle components
Lay out all the crystals and dangles you'll attach to the charm bracelet. Slide each star, butterfly and briolette onto a separate jump ring.

4. Attach diva charms
Use pliers to open the chain links and slide on a diva charm every three links, hanging them on opposing sides as you progress and starting at the circle end of the toggle.

5. Attach dangles to chain
Beginning at the circle end of the toggle, attach a bead and a star, alternating the placement on opposite sides of the chain links with jump rings in the following pattern (attach a star charm to each diva charm link): rose briolette and star, crystal butterfly and star, star and diva charm, peridot butterfly and star, aqua butterfly and star, star and diva charm. Leave the last three chain links empty to accommodate the clasp. Attach the bar end of the toggle clasp to the final link in the chain. Check back through all jump rings and chain links to ensure they are all secured.

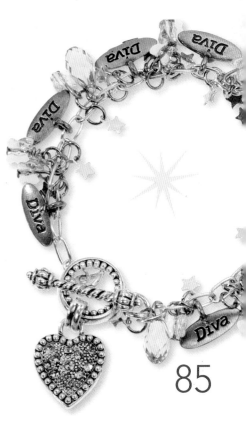

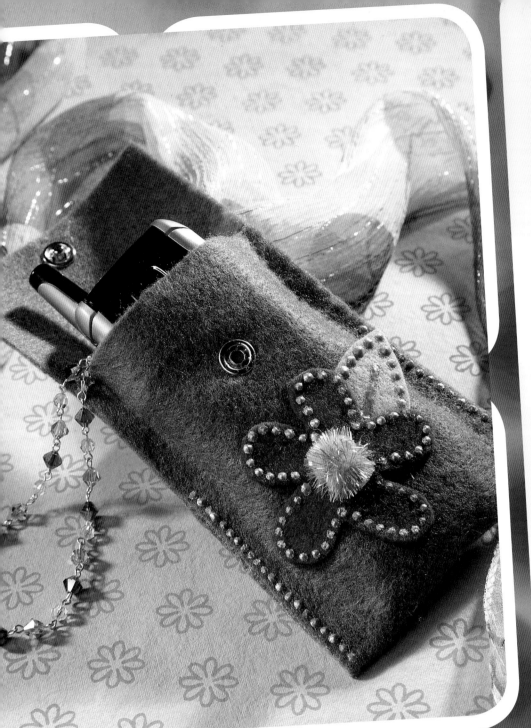

Sparkle *Vixen*

WHAT YOU WILL NEED

SPARKLIES, ETC.

purple polyester felt

fuchsia polyester felt

yellow polyester felt

acid green polyester felt

eight 6mm Indian red 2mm AB Swarovski bicones

nine 6mm peridot Swarovski bicones

nine 4mm jonquil Swarovski bicones

eighteen 1½" (4cm) sterling head pins (each one makes two rosary links)

one braided cell phone charm attachment

one sparkly pom-pom

one metal snap

UTILITIES

snap setter

chasing hammer

extra-strong fabric glue

gold bead paint

scissors

2 Cute 4 Words Cell Phone Pouch

Today's forecast: felty with a strong chance of sparkle. Hold the phone…seriously, hold the phone…in this cute as a bug's ear cell phone pouch! Then keep it from getting lost in the shuffle by attaching the crystal and sterling chain to your belt loops or the inside of your purse handles.

SUPPLIES: FELT BY CPE, THE FELT COMPANY; BEAD PAINT BY TULIP; CELL PHONE CHARM AND LOBSTER CLASP BY BEADALON; STERLING HEAD PINS BY MARVIN SCHWAB/THE BEAD WAREHOUSE; FABRI-TAC BY BEACON ADHESIVES; IRIDESCENT POM-POMS BY CREATIVE HANDS

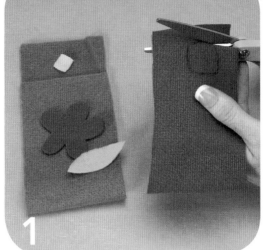

1. Cut felt
Cut two rectangles of purple felt for the pouch: one 7" x 3½" (18cm x 9cm) and the second 4¾" x 3½" (12cm x 9cm). Use the templates on page 126 to cut out the remaining felt shapes.

2. Adhere pom-pom center
Use fabric glue to adhere a pom-pom center to the pink flower. Allow glue to dry.

3. Set snap in pouch flap
Use a chasing hammer to set the snap in the flap of the pouch.

4. Hide snap
Adhere the small yellow square on top of the pink square with fabric glue. Adhere the layered squares to the front of the flap with fabric glue to hide the snap.

5. Add decorative dots
Close the flap and adhere the leaf and flower to the front center of the pouch with fabric glue. Allow the glue to dry. With flap closed, apply dots of gold paint to the edges of he pouch and around the flower, leaf and squares. Allow the paint to dry.

6. Create rosary chain
Make double-looped head pins with all of the crystals (see Bead Basics, page 13). Link the double-looped head pins together in the following order to build a rosary chain: yellow, green, red, ending with a green crystal. Simply insert the metal portion into the appropriate spot in your cell phone to create a decorative and functional loop.

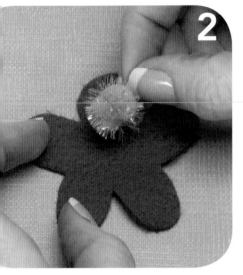

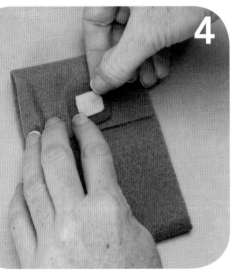

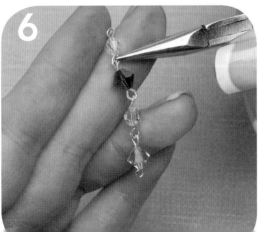

true craft

c o n f e s s i o n s

As you can see, not all of the little paint blobs are perfectly perfect. It is cool if you want to make perfectly perfect stuff, but honestly, I don't. That kind of thing truly doesn't bother me. If it bothers you, then by all means, strive for perfection!

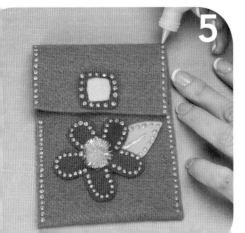

87

"So if diva means giving your best, then yes, I guess I am a diva."

—Patti LaBelle

DISCO DANCER

"I don't care if I'm beautiful; I don't care what I am on the outside. It isn't about the outside."

—Donna Summer

ack when disco reigned supreme, Donna Summer (born LaDonna Adrian Gaines) was the undisputed Queen. She was the first African-American woman in rotation on MTV and the first female artist to win a Grammy for best rock vocal performance. She also holds the record for the longest held note in a song by a woman at sixteen seconds in "Dim All the Lights." Her song "Love to Love You Baby" was so controversial for its suggestive content that it was banned from radio stations across the country. Love it or hate it, you have to admit that disco gave women permission to be both strong and sexy. That's not such a bad thing, if you ask me. Check out the divine Chaka Kahn, the divalicious Miss Patti LaBelle and the funktacular sounds of Sister Sledge for some kickin' funk-infused disco song stylings.

Want to shake your groove thang and trip the light fantastic, but have no earthly idea what to wear? Worry not, tiny dancer, this chapter is positively bursting at the seams with sparkly delights to bedeck your curvalicious body whilst you dance the night away. Dance like no one is watching, dance until you draw a crowd, or sit on the sidelines and sip a martini; it's entirely up to you. Any way you choose, you will look absolutely fabulous, dahling. Try the Shine a Star Earrings (page 104) for maximum glitterati action, or wrap the Bad Girl Belt (page 90) around your shiny disco pants and shake those hips. Or check out the icy cool of the Studio 54 Multistrand Necklace (page 106) if you want to be a disco sophisticate.

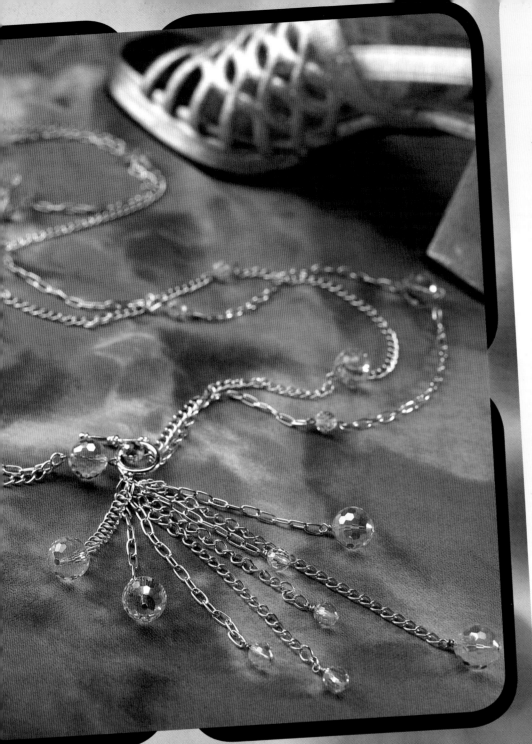

WHAT YOU WILL NEED

SPARKLIES, ETC.

twelve 8mm crystal AB
Swarovski disco ball beads

twelve 14mm crystal AB
Swarovski disco ball beads

medium curb chain

elongated cable chain

toggle clasp

twenty-four silver-plated head pins

UTILITIES

round-nose pliers

chain-nose pliers

flush cutters

Bad Girl Belt

Hey you, bad, bad girl on the sidelines, throw this belt on and
hit the dance floor and show them your sassiest moves. Why
the heck not, sister? With a belt like this on your sexy hips, you
couldn't look bad even if you tried! (You can sport this as a
necklace too, FYI.)

SUPPLIES: CRYSTAL
BEADS BY SWAROVSKI;
CHAIN AND FINDINGS BY
BEADALON

1

2

1. Make double-looped head pins
Create eight double-looped head pins (see Bead Basics, page 13) for each style of bead (16 total double-looped head pins).

2. Make coiled-loop head pins
Create four coiled-loop head pins (see Bead Basics, page 14) for each style of bead (8 total coiled-loop head pins).

3. Separate chain segments for tassel
Use your pliers to open and close links in the elongated cable chain into four segments: 9-link segment, 12-link segment, 14-link segment and 18-link segment. Separate the curb chain into four segments: 13-link segment, 19-link segment, 23-link segment and 28-link segment.

true craft
c o n f e s s i o n s

This belt fell apart en route to the publisher. Why? Because I did not check back through the design to ensure that all links and loops were properly closed. Do as I say, not as I do!

3

91

4. Create beaded tassel

Attach one coiled-loop bead to the end of each segment of chain using pliers. Attach the beaded segments to a jump ring attached to the circle end of your toggle clasp. Set the tassel aside.

5. Link bead to bar end of clasp

Link a double-looped 14mm disco ball bead to the bar end of the toggle clasp. Set the bar aside.

6. Attach tassel to chains

Attach a double-looped 14mm bead to a single elongated cable link with a jump ring. Link the jump ring to the the tassel-embellished circle end of the toggle clasp.

7. Create first beaded chain

Create the first beaded chain, working from the 14mm bead on the toggle bar end of the clasp in the following pattern: 8mm bead, 18-link chain segment, 14mm bead, 18-link chain segment. Repeat the pattern until you have used eight chain sections and seven beads. End by attaching the final chain segment to the 14mm bead on the circle end of the toggle clasp, using your pliers to secure.

8. Create second beaded chain and finish belt

Begin the second beaded chain segment by attaching a 30-link section of curb chain to the double-looped bead on the toggle end of your clasp. Continue adding curb chain segments and beads in the following order: 14mm bead, 30-link chain, 8mm bead, 30-link chain, 14mm bead. Repeat the pattern until you have used seven beads. Attach a 10-link segment of chain to the seventh bead and finish the belt by attaching this beaded chain to the circle end of clasp, as shown in photo.

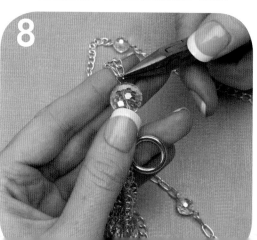

"Toot, toot, hey, beep, beep…bad girls…talking 'bout bad, bad girls…"

—Donna Summer

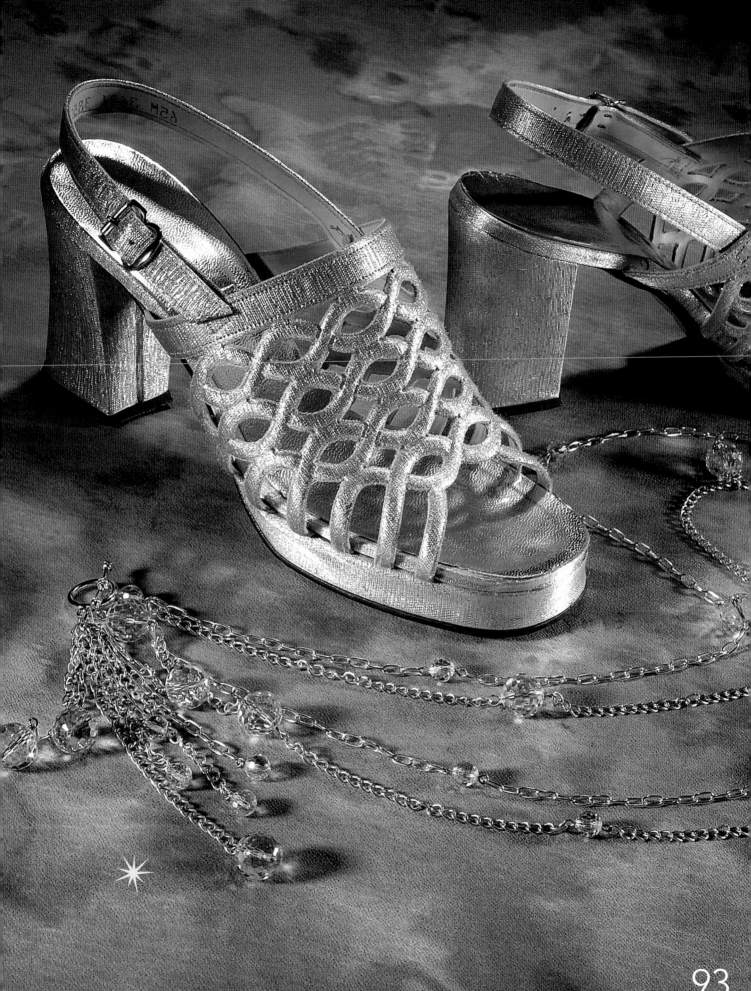

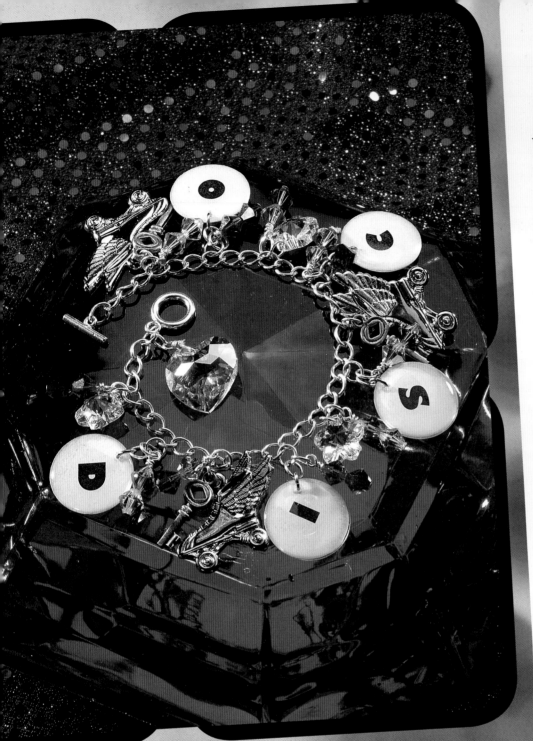

WHAT YOU WILL NEED

SPARKLIES, ETC.

ten large clear plastic scrapbook stickers

print out of letters to spell "DISCO" in 24-pt Gill Sans Ultra Bold

one 18mm crystal AB Swarovski heart

three 12mm crystal AB Swarovski flowers

three metal roller disco charms

three metal key charms

four 6mm Siam Swarovski bicones

four 6mm hyacinth Swarovski bicones

four 6mm jonquil Swarovski bicones

four 6mm peridot AB Swarovski bicones

four 6mm indicolite Swarovski bicones

four 6mm light violet Swarovski bicones

thirteen 22-gauge sterling head pins

one small silver-plated toggle clasp

one 34-link segment of medium stainless curb chain

thirty-six 4mm sterling (or silver-plated) jump rings

UTILITIES

computer

printer

sharp scissors

round-nose pliers

chain-nose pliers

flush cutters

bead reamers

Brand-New Key Charm Bracelet

Oh, I could rock the roller disco action. Yes, yes I could. So could you, if you had a brand-new pair of roller skates…and this discoriffic charm bracelet. Then wear it with satin short shorts and a baby doll tee. You'll have a date with Shaun Cassidy in a heartbeat.

SUPPLIES: CRYSTAL BEADS BY SWAROVSKI; PAGE PEBBLES SCRAPBOOK STICKERS BY MAKING MEMORIES; ROLLER SKATE CHARMS BY SACRED KITSCH STUDIO; KEY CHARMS BY ARTCHIX STUDIO; CHAIN AND TOGGLE BY BEADALON; STERLING FINDINGS BY MARVIN SCHWAB/THE BEAD WAREHOUSE

1. Cut around letters

Print out letters. Stick a scrapbook sticker over each letter (centering the letter in the sticker). Cut out each letter slowly with sharp scissors, working your way around the letter to cut the paper flush to the edge of the sticker.

2. Sandwich letters with stickers

Stick a second scrapbook sticker on the back of each letter.

3. Drill holes

Use a bead reamer or a small drill bit to create a small hole at the top of each letter dangle, positioning the holes at various places above the letters so they hang in a random fashion. Thread each letter charm with a jump ring, and then close the jump rings.

4. Create rainbow crystal dangles

Make six coiled-loop head pin dangles (see Bead Basics, page 14): two Siam and hyacinth dangles, two jonquil and peridot dangles and two indicolite and light violet dangles.

5. Begin to create heart dangle

Thread the heart crystal with a head pin from front to back.

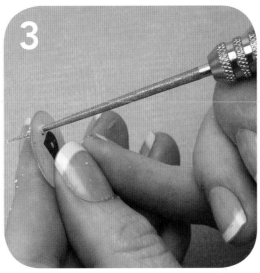

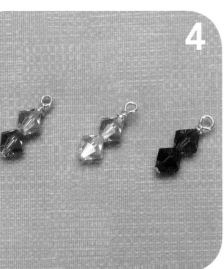

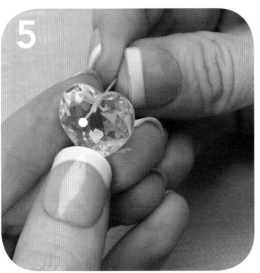

"I've got a brand new pair of roller skates; you've got a brand new key."

—Melanie, in "Brand New Key"

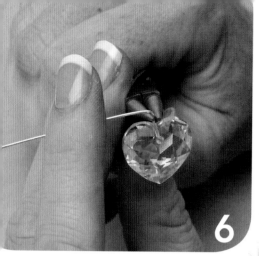

6. Bend wire up to top of heart
With round-nose pliers, bend the head pin to 90°, then bend it up to the top of the heart.

7. Finish heart dangle
Turn a loop in the head-pin wire with round-nose pliers. Hold the loop with the pliers and make a coiled wrap with your fingers.

8. Link dangles and charms to chain
Attach dangles to the 34-link section of curb chain from left to right, with each item on a separate jump ring. Begin by linking a red and orange dangle and a flower on separate jump rings from the fourth link. Continuing from the fourth link, every third link add the following dangles: "D" on the bottom of 2 connected jump rings with yellow and green dangle; roller skate, key, and blue and purple dangle; "I" on 2 jump rings with red and orange dangle; flower with yellow and green dangle; "S" on 2 jump rings with blue and purple dangle; roller skate, key with red and orange dangle; "C" on 2 jump rings with yellow and green dangle; flower with blue and purple dangles; "O" with red and orange dangle; skate, key with yellow and green dangle.

9. Attach toggle clasp
Attach the toggle bar to the right side of the chain. Attach the circle end of the toggle clasp on a jump ring. Add the heart from step 7 on a second jump ring to the circle end of the clasp. Check all jump rings to secure.

SPARKLY TIP:
customize your color

Hey, you can print the letters onto colored or patterned paper for a different finished effect. Personalize the designs to suit your uniquely fabulous taste, doll.

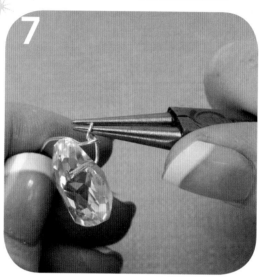

96

Sparkle Virgin

WHAT YOU WILL NEED

SPARKLIES, ETC.

one plain cotton T-shirt

twenty-one 16mm citrine hot-fix Swarovski crystals

nineteen 16mm fuchsia hot-fix Swarovski crystals

fourteen 16mm peridot hot-fix Swarovski crystals

twelve 16mm jet hematite pearl hot-fix Swarovski crystals

nine 16mm jet hematite flower shape hot-fix Swarovski crystals

UTILITIES

scissors

hot-fix applicator tool (16mm attachment)

foam brush

paper or plastic disposable plate

cardboard form to fit inside of T-shirt

fine-tip black permanent marker

Funky Monkey stamp

black fabric paint

scrap of fleece fabric

Disco Monkey T-Shirt

Swing little disco monkey, swing from the trees, swing to that crazy disco beat. Does it get any cuter than monkeys and crystals? Methinks not! It's so easy and fun to take a plain T-shirt and make it into your own work of art...so...get to it, girlie!

SUPPLIES: HOT-FIX CRYSTALS BY SWAROVSKI; HOT-FIX APPLICATOR TOOL BY JEWELRYSUPPLY.COM; FUNKY MONKEY STAMP 1140-H BY RUBBER SOUL; FABRIC PAINT BY PLAID

true craft

c o n f e s s i o n s

I made a boo-boo, so one little monkey became king. Lucky monkey! I would use the lemons into lemonade cliché...but I just can't bring myself to do it.

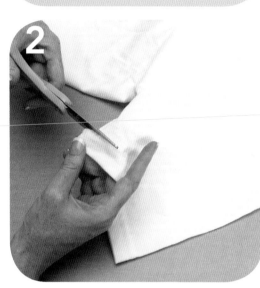

1. Cut out neckline

Use sharp fabric scissors to cut out the neckline of the T-shirt, cutting off approximately 4–5" (10-13cm) of fabric.

2. Cut sleeves

Cut about 1" to 2" (3cm to 5cm) off the ends of the sleeves of the T-shirt.

3. Cut bottom hem

Cut off the bottom hem of the T-shirt, cutting approximately 2" to 3" (5cm to 8cm) above the hemline, or to your desired length.

4. Stamp monkeys onto shirt

Slide the shirt onto a piece of cardboard. Spread fabric paint onto a piece of fleece and apply paint to the stamp. Stamp monkeys onto the shirt at various heights, working from left to right. Allow the paint to dry.

5. Touch up monkeys

Don't worry if your monkeys aren't perfect. Use a black permanent marker to touch them up after they dry.

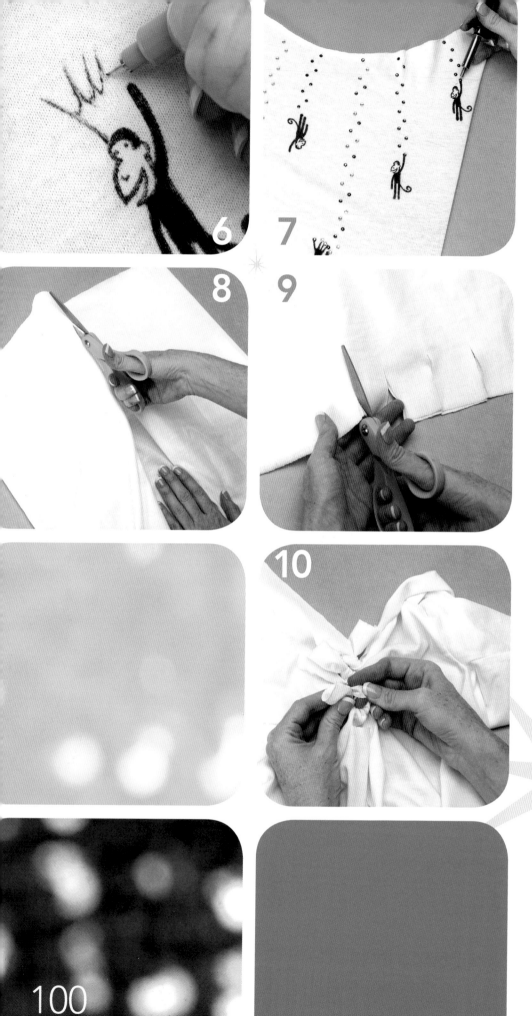

6. Crown monkey

Use a fine-tip black permanent marker to add a crown to the lowest monkey, for he is the King of the Monkeys.

7. Affix crystals

After the monkeys are dry, begin affixing crystals with the hot-fix applicator tool, working from left to right. The vines start with a crystal at the top of the outstretched monkey hands. Then they are placed randomly left and right of center to mimic a vine. For the vines, the T-shirt as pictured uses (from left to right): seven peridot crystals, 15 citrine crystals, nine jet crystals, 27 assorted color crystals, 12 fuchsia crystals and six jet crystals.

8. Cut back of T-shirt

When the crystals are all in place, turn the shirt over to cut the back down the center.

9. Cut strips

Measure and cut eight strips (each approximately 2" [5cm] wide) which will be used to create ties going down the back of the shirt. Cut into the T-shirt approximately 2" (5cm).

10. Tie strips together

Knot the strips together at the back of the T-shirt. You may want to try the T-shirt on after you have a few of the strips knotted to make sure the fit is what you want.

WHAT YOU WILL NEED

SPARKLIES, ETC.

blank wooden purse

vintage magazine images of two eyes and the letters to spell the names of your idols

ink-jet copies of idol images from record album or old magazine

thirty-eight SS 16 citrine Swarovski hot-fix crystals

UTILITIES

hot-fix applicator tool

small and large paintbrushes

disposable paintbrush

computer

printer

image-editing software (such as Microsoft Publisher, Photoshop or similar program)

scissors

craft knife

cutting mat

ruler

light green acrylic paint

burnt orange acrylic paint

glossy découpage medium

SUPPLIES: ACRYLIC PAINT BY DECOART; HOT-FIX CRYSTALS BY SWAROVSKI, MOD PODGE GLOSSY BY PLAID

Donny vs. Bobby Wooden Purse

A long time ago in the early '70s, Bobby Sherman and Donny Osmond were the Hottie McHot teen idols. Teen idols come and go…so insert your own personal faves on your purse. I picked Bobby and Donny because they happened to be cool back when I was seven, and they happened to be in the pile of records I found at the antique store when I did this project. Record albums are easy to find at thrift shops, yard sales and antique stores, and they come pretty cheap. Get out there and rummage!

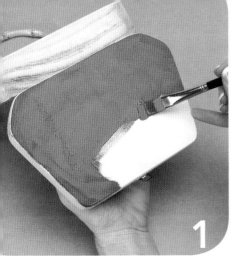

1

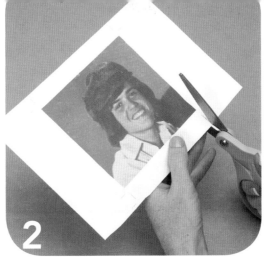

2

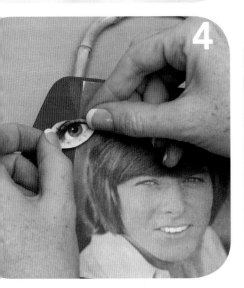

3

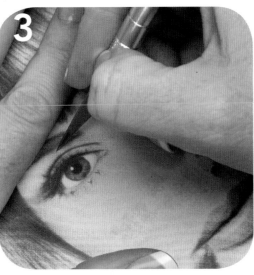

1. Paint front of purse

Paint the purse front with two coats of orange paint (or color of your choice). Don't worry about painting under the spot where your large images will go. Allow the paint to dry. Paint the purse back with two coats of green paint (or color of your choice). I picked orange and green for a '70s' vibe, but you can choose a different color scheme that best fits the era represented by your teen idols.

2. Cut out images

Find images of your teen idols from record albums or vintage magazines. Copy and scan the images of your choice into an image manipulation program and size them to fit the front and back panels of the purse. (I used Microsoft Publisher.) Print the images and cut them out.

3. Cut out letters and eyes

While the paint is drying, select and cut out images of eyes and the letters of your idol's name from a vintage magazine. Use a cutting mat and a craft knife.

4. Decorate purse

Adhere idol images to front and back center of purse with découpage medium over dry paint. Allow to dry. Adhere eyes and letters to images with découpage medium. Allow to dry. Paint a layer of glossy découpage medium over the entire purse. Allow to dry. The image may bubble up, but don't worry, it will dry flat. Paint a second layer of découpage medium over the entire purse, alternating brush strokes to add texture. Allow to dry.

5. Affix crystals

Copy the heart template on page 126 and punch out a hole in each circle. Lay the template over one of your teen idol's eyes and mark the crystal placement. Use a hot-fix crystal applicator to affix crystals to each marked spot.

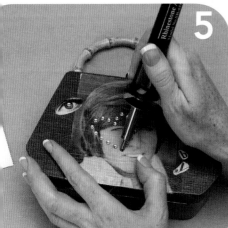

4

true craft
c o n f e s s i o n s

I was down to the last day of my deadline, and this purse was the last project. I was basically delirious. The large images started bubbling up horribly after I painted them with Mod Podge...and I totally freaked out! Then they dried flat and all was well. Phew.

5

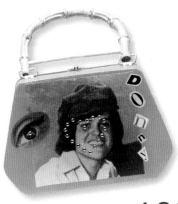

103

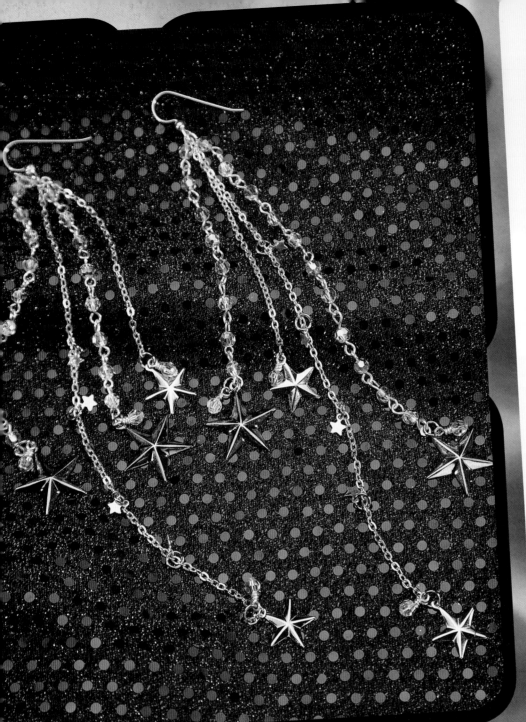

WHAT YOU WILL NEED

SPARKLIES, ETC.

forty-six 4mm crystal AB Swarovski rounds

four large nautical star charms

four small nautical star charms

eight tiny star charms

forty-four sterling 22-gauge head pins

two 6" (15cm) and two 2½" (6cm) sections small dapped silver-plated chain

sixteen small heavy-duty silver-plated jump rings

two sterling ball French wires

UTILITIES

round-nose pliers

chain-nose pliers

flush cutters

Shine a Star Earrings

Shine a star in some fabulous star-studded shoulder dusters, baby. These need no more than your cute little earlobes, a wrap-around dress and some platforms.

SUPPLIES: CRYSTAL BEADS BY SWAROVSKI; NAUTICAL STARS BY SACRED KITSCH STUDIO; TINY STARS BY ARTCHIX STUDIO; STERLING FINDINGS BY MARVIN SCHWAB/THE BEAD WAREHOUSE; CHAINS BY BEADALON

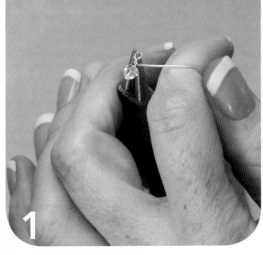

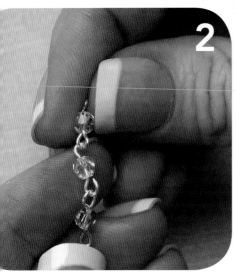

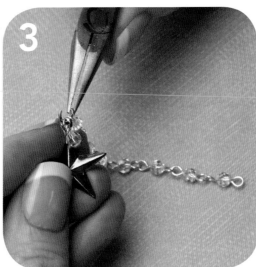

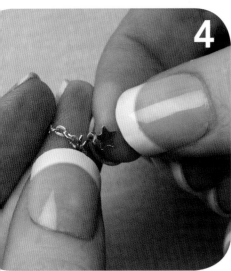

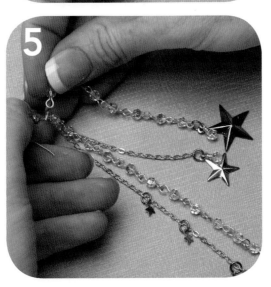

1. Make dangles

Create eight coil-looped single crystal bead dangles. Create 38 double-looped crystal bead dangles by sliding a bead down to around ⅛" (3mm) from the top of the wire. Bend the wire and use pliers to make a loop, then bend the wire flush to the bottom of the bead to make a second loop (see Bead Basics, pages 13-14).

2. Build rosary chain

Build two 11-link segments and two seven-link segments of rosary chain, opening and closing the links with pliers as you build the chain. Take time to ensure the links are secured.

3. Link large star to bottom of chain

Attach a coiled top dangle and a large star on a jump ring to the bottom rosary link. The dangle should fall in front of the star. Repeat with the remaining three rosary chains.

4. Link tiny stars to chains

Use flush cutters to create four 6" (15cm) segments of chain. Attach tiny stars to the chains at 1" (3cm) intervals with jump rings. Link a total of four stars to each chain. Link a coiled-top head pin and a small nautical star to the end of each chain with a small jump ring.

5. Link chains to earwires

Attach the chains to the French wires, making one earring a mirror image of the other to create a left and a right earring. For the right ear, attach the chains in the following order: 11-link rosary, 6" (15cm) star chain, 7-link rosary, 2½" (6cm) chain. Reverse the order for the left earring. Check back through the design to ensure all links and jump rings are secured.

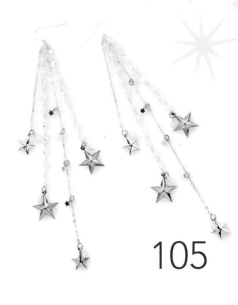

105

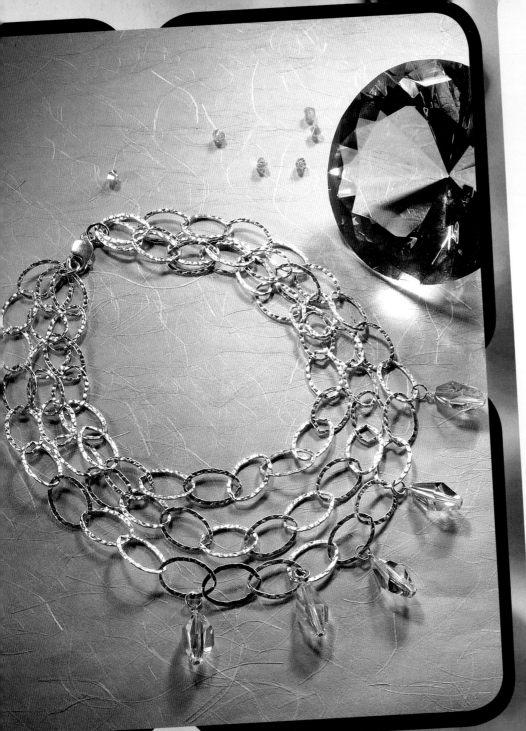

WHAT YOU WILL NEED

SPARKLIES, ETC.

NECKLACE

five 18 x 12mm crystal
AB Swarovski polygon beads

one 24-link, one 25-link and one
28-link segment of 14mm x 20mm
sterling patterned cut chain

one extra-large sterling lobster clasp

five 22-gauge sterling head pins

two 8mm heavy-duty sterling jump rings

five 5mm sterling jump rings

EARRINGS

two polygon beads

two 3-link segments of 14mm x 20mm
sterling patterned chain

two sterling head pins

four 5mm sterling jump rings

two hammered-metal post earrings

UTILITIES

flush cutters

round-nose pliers

chain-nose pliers

Studio 54 Multistrand Necklace

This is just cool. That's all there is to it. Wear this when you want to look hot. Sometimes less is more. This is one of those times. Trust me.

SUPPLIES: CRYSTAL BEADS
BY SWAROVSKI; CHAIN AND
FINDINGS BY MARVIN SCHWAB/
THE BEAD WAREHOUSE

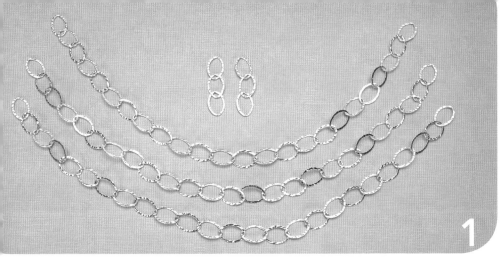

1. Separate chain segments
Cut the chain into segments in the following lengths: one 24-link section, one 25-link section, one 28-link section.

2. Link chains to jump rings and clasp
Attach all three sections of chain together to a jump ring with the longest segment on the bottom and the shortest on top. Repeat for the opposite end of the chains, keeping chains stacked as before. Attach a large lobster clasp to one jump ring with pliers.

3. Link dangles to necklace
Create five coiled head pin polygon bead dangles (see Bead Basics, page 14). Attach the dangles to the longest chain, from the bottom of the ovals, in the following order: 18th link from clasp on each side, 20th link from clasp on each side, and center link. Check back through jump rings to ensure they are all secured.

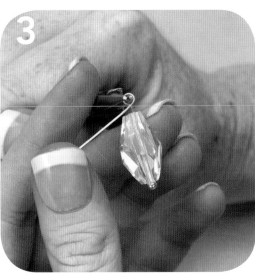

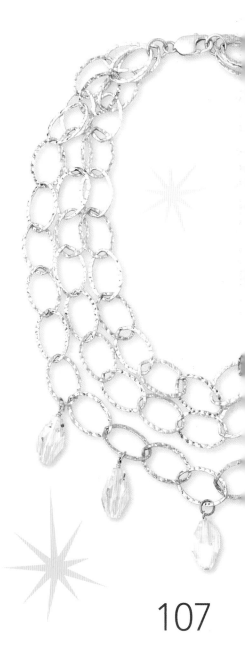

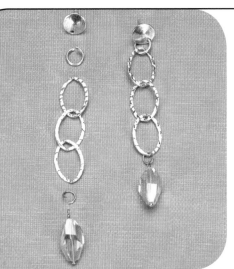

try this

Studio 54 Earrings
Go for all-out glamour with this pair of simply gorgeous matching earrings.

Make these easy earrings by connecting coiled polygon beads on a jump ring to a three-link segment of chain. Attach the chain with dangle to a hammered-metal post earring with a second jump ring. Repeat, unless you want only one earring.

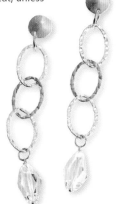

> *"I still see a lot of girls not claiming their power. Just sort of letting other people tell them what to do, and that's a learning process, like it was for me."*
>
> —Joan Jett

ROCK STAR

> *"I was perceiving myself as good as a man or equal to a man and as powerful and I wanted to look ambiguous because I thought that was a very interesting statement to make through the media. And it certainly did cause quite a few ripples and interest and shock waves."*
>
> —Annie Lennox

Women in rock have paved a lot of road the hard way, and they deserve our admiration. One of those ladies, Joan Jett (with her band the Blackhearts), is a rock and roll icon who didn't sugarcoat her tough attitude or kowtow to stereotypes of acceptable female behavior. OK, she rocked her butt off and we loved her for it. Patti Smith, a true rock goddess, infused her edgy music with an intellectual and poetic sensibility. Joni Mitchell began as a gifted folk singer/songwriter, and later created mind-blowing music that broke the stereotypes of how much control women could have over their careers and their creativity. Of course, we can never, ever talk about rock without paying homage to the amazing shooting star that was Janis Joplin. We also must give credit where credit is most sorely overdue: to African-American R&B/rock singers, from whose music rock and roll springs.

What girl hasn't dreamed of standing center stage and rocking like Joan, Joni or Janis? Rock stars are cool. Rock stars have attitude. Rock stars are sexy and tough. Even if you wouldn't dare stand on stage in front of a crowd of ten, secretly in your deepest heart haven't you ever wondered what it might be like? Well, sassy britches, it's time to strut your stuff like Tina Turner. Rock out at the water cooler. Kick butt in the elevator. If you want to rock with the big girls, why not sport a few rocking accessories? Try the Skull + Crossbones iPod Case (page 116) on for size, or explore your pirate side with the Pirate Jenny Charm Bracelet (page 112). If you really want to feel like a true rock and roll diva, sport the Hearts in Chains Necklace (page 120). These projects are also highly recommended for enjoying while on tour…just in case you really do grow up to be a rock star.

WHAT YOU WILL NEED

SPARKLIES, ETC.

small black canvas tote about 11" x 9" x 3" (28cm x 23cm x 8cm)

eighteen 5mm crystal AB foil-back rhinestones

eighteen 5mm silver-tone prong rhinestone settings

six open-star metal buttons

four metal scissor button embellishments

ninety-four SS12 rose Swarovski hot-fix crystals

waxed linen cord

UTILITIES

hot-fix applicator tool

ruler

heavy-duty embroidery needle

rhinestone setter tool

white marking pencil

Mistress Crafty Tote

What's a crafty rock star to do on the tour bus?! Sparkle stuff up, that's what! Take control of your need to make the world a more sparkly place and whip those urges into fabulous creations…Mistress Crafty.

SUPPLIES: RHINESTONES AND SETTINGS BY NICOLE; HOT-FIX CRYSTALS BY SWAROVSKI; HOT-FIX APPLICATOR TOOL FROM JEWELRYSUPPLY.COM; METAL SCISSORS BY STREAMLINE; STAR BUTTONS BY JHB INTERNATIONAL

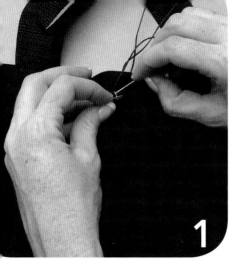

1

2

3

4

5

6

1. Sew on buttons
Use a ruler and white marking pencil to note even placement of buttons and rhinestones across the top of the bag. Sew all the buttons on with waxed linen cord and a heavy-duty embroidery needle.

2. Affix rhinestones to bag
Place a stone upside down in the tool. Slide the prong setting on top of the tool. Move the top of the tool so it is resting on top of the rhinestone. Slowly and evenly press the tool to set the stone. Check the prongs and tighten them if needed.

3. Write out "mistress"
Using a ruler as a guide, write "mistress" across the top front of the bag with a white marking pencil. Move the ruler down to the middle of the bag, align the first letter with the first S in mistress and write "crafty" followed by an ellipsis. (You can also opt to use a stencil if your freehand isn't so hot.)

4. Begin setting hot fix crystals
Use a hot-fix applicator tool to set the crystals. Work letter by letter, placing crystals on the written letters and then using the tool to set them in place.

5. Finish setting crystals
Continue setting the hot fix crystals until all the letters are sparkly.

6. Set rhinestones into bag handles
Set seven evenly spaced rhinestones into each handle of the bag using the setting tool.

111

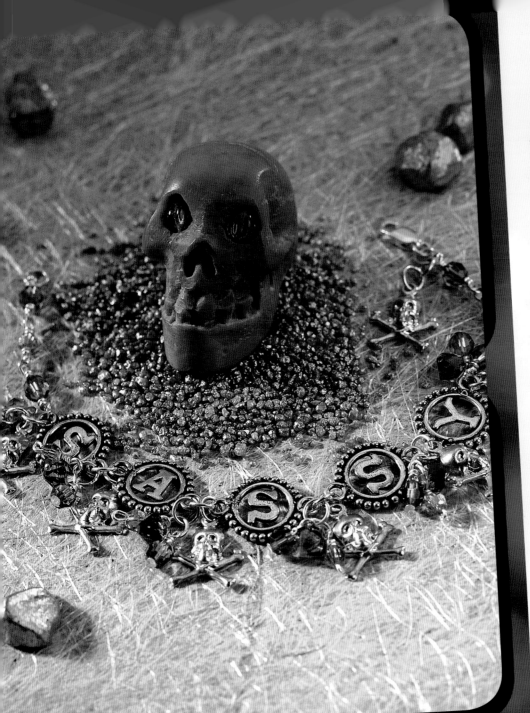

Sparkle Vixen

WHAT YOU WILL NEED

SPARKLIES, ETC.

five sterling letter connectors to spell "sassy"

ten 5mm olivine Swarovski rounds

eight 4mm lime AB Swarovski rounds

six 6mm topaz Swarovski top-drilled bicones

six silver-plated skull and crossbones charms

eighteen 22-gauge head pins

twenty-six 5mm sterling jump rings

one small sterling lobster clasp

UTILITIES

round-nose pliers

chain-nose pliers

flush cutters

SUPPLIES: CRYSTAL BEADS BY SWAROVSKI; STERLING FINDINGS BY MARVIN SCHWAB/THE BEAD WAREHOUSE; "SASSY" LETTERS FROM FIRE MOUNTAIN GEMS; SKULL CHARMS FROM SACRED KITSCH STUDIO

Pirate Jenny Charm Bracelet

Get your pirate attitude on with this sassy little number…and take no prisoners. Raise the flag, steer that ship toward shore and count your booty, matey.

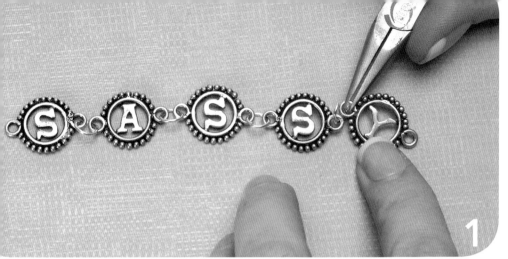

1. Link letters
Connect the letters with jump rings to spell "sassy."

2. Create dangles
Create six olivine coiled-loop head pin drops (see Bead Basics, page 14), but do not trim away the excess wire. Bend a small loop at the end of each excess wire, slide on a lime bead and create a coiled head pin drop. Make six of these dangles. Place one of each dangle style on a jump ring on each side of a top-drilled topaz bicone. Make a total of six jump ring dangles.

3. Link dangles
The dangles will fall on the jump rings in between the letters and at the outer link on the first and last letter. Place a skull on a jump ring and then a beaded jump ring on each of these links. Check back through the rings to ensure they are properly closed.

4. Build rosary chain
This rosary chain is built by linking segments directly to each other rather than by connecting them with jump rings. To begin, create four double-coiled 5mm olivine links. Thread a 6mm topaz bead onto a head pin and begin to bend the wire into a loop with pliers. While the loop is still open, slide one of the double-coiled 5mm olivine links onto it, as shown in the photo. Leaving the olivine link inside the bend in the wire, wrap the wire into a standard coil-topped link. Voilá, rosary chain. Thread the second end of the topaz link through a second olivine link and repeat. Make two three-link sections of olive, topaz and olive. Attach each rosary-style section to either end of the words with jump rings.

5. Attach clasp
Link a jump ring and a lobster clasp to a jump ring on the right side of the design. Add a skull on two jump rings. Add a final jump ring on the opposite end.

true craft
c o n f e s s i o n s

So, this was a necklace. Until I put it on my neck and realized it didn't hang right. That just wouldn't do. I made it into a charming charm bracelet and all was well with the world again. Don't throw the baby out with the bath water, because the baby is so cute—how could you do such a horrible thing? Ha.

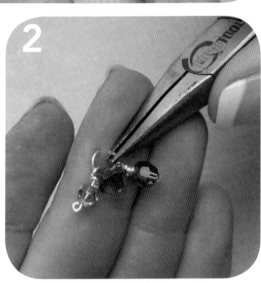

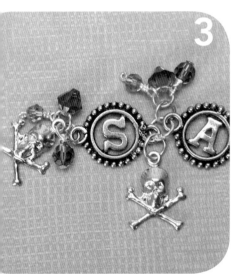

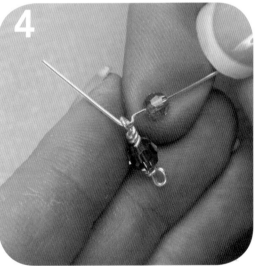

"Then they'll pile up the bodies and I'll say, 'That'll learn ya,' and the ship *The Black Freighter* disappears out to sea and on…it…is…me!"

—Pirate Jenny, in *Three Penny Opera* by Bertolt Brecht and Kurt Weill

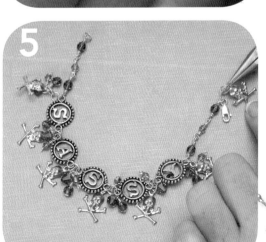

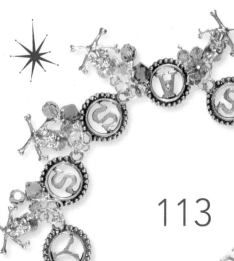

113

Sparkle Virgin

WHAT YOU WILL NEED

SPARKLIES, ETC.

racer-back black cotton/Lycra shelf bra tank top

twenty-eight 1⅞" (5cm) stainless steel safety pins

thirty-seven 1½" (4cm) stainless steel safety pins

thirty-two 11mm x 5.5mm jet Swarovski briolettes

thirty-three 11mm x 5.5 mm crystal AB Swarovski briolettes

sixty-five 5mm sterling or silver-plated jump rings

UTILITIES

white marking pencil

sharp scissors

craft knife

two pair of chain-nose pliers

cardboard form to fit inside of tank top

straightedge

nimble fingers

SUPPLIES: CRYSTALS BY SWAROVSKI; JUMP RINGS BY MARVIN SCHWAB/THE BEAD WAREHOUSE

Punk Couture Tank Top

Back in my wayward youth, my grandmother called me a "pock runker" and my mom told me I dressed like a "sea" urchin…but I got the idea…no one was thrilled when I came home from California looking like a freak-a-zoid. Well, no one but me! I never actually wore safety pins—except for a modeling job once, to be honest—but this design seemed so…right! Rock on, sparkle kitty!

1

2

3

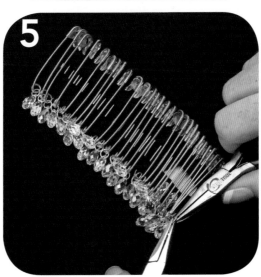

4

5

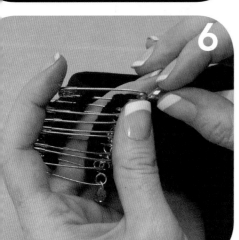

6

1. Mark slit placement
Use a white marking pencil to mark the placement of your slits.

2. Make holes
Use a craft knife to cut a small hole in the shirt, just below the shelf bra on the right side of the tank. Cut a second hole just to the right of the center of the tank top, down around waist level.

3. Cut slits
Cut two 5" (13cm) slashes using sharp scissors.

4. Begin to pin
Slide a piece of cardboard inside of the tank top. Working slowly from the bottom of the lower slash to the top, pin on approximately 28 safety pins, spacing them about 1/8" (3mm) apart. All the pins should hang with the bottom facing down. The pins should all enter and exit the fabric at approximately the same level. Repeat this process on the upper slash, working from top to bottom.

5. Link dangles to pins
Use jump rings and pliers to add the briolettes to the bottoms of the safety pins, taking your time to ensure that all jump rings are properly secured.

6. Finish tank
Cut the top right sleeve apart, cutting the seam out entirely. Attach the edges together with nine small safety pins.

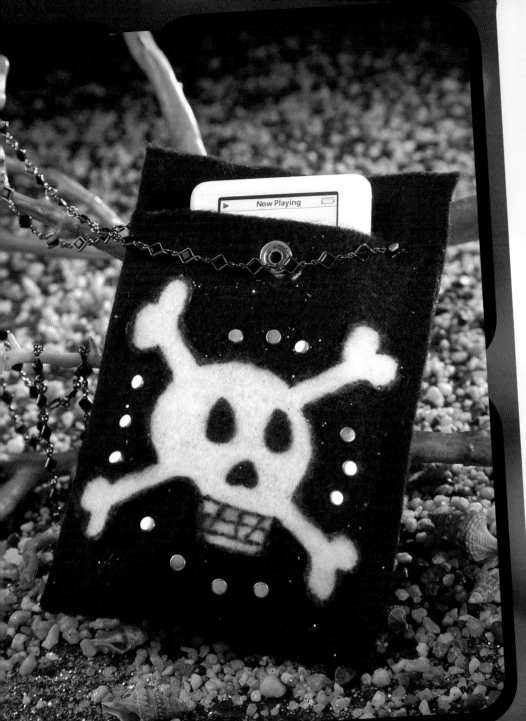

Sparkle Vixen

WHAT YOU WILL NEED

SPARKLIES, ETC.

black craft felt

red craft felt

white craft felt

fourteen 4mm silver-tone flat studs

32½" (83cm) jet rhodium-finish Swarovski crystal chain

two soldered 4mm jump rings

two 4mm jump rings

black heavy-duty sewing thread

silver-tone snaps or Velcro

UTILITIES

rhinestone setter tool

snap-setter tool

two pair chain-nose pliers

sewing needle

ruler

black permanent marker

chasing hammer

fabric glue

Skull + Crossbones iPod Case

Arrgh…here's a jaunty little carryall for your iPod, your passport, your various sundries, some pirate booty…whatever strikes your fancy. This is intentionally crafty and handmade. You can opt to make it perfect if that's your thang…it's your thang…do whatcha wanna do, baby!

SUPPLIES: FELT BY CPE, THE FELT COMPANY; STUDS AND STUD-SETTER TOOL BY NATURAL SCIENCE INDUSTRIES; SNAP AND SNAP-SETTER TOOL BY PRYM-DRITZ; JUMP RINGS FROM MARVIN SCHWAB/THE BEAD WAREHOUSE; CRYSTAL CHAIN BY SWAROVSKI

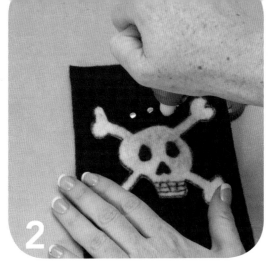

1

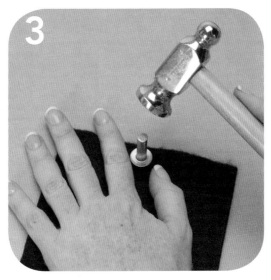
2

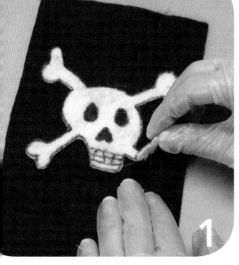
4

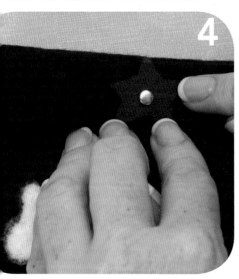
3

5

1. Adhere skull to black felt

Trace and cut the skull and crossbones and star using the templates on page 126. Cut out a 4½"x 6½" (11cm x 17cm) rectangle of black felt. Draw a skull face and outline the edges of the skull with a permanent marker. Glue the skull onto the front section of the felt pouch so the flap will not cover it. Allow the glue to dry.

2. Affix studs

Use a rhinestone/stud setter tool to place studs around skull (see Setting Studs 101, page 15). Don't worry—it's very easy to remove them if you make a boo-boo.

3. Secure snap

Fold the flap over and mark the top of the pouch. Glue the sides of the pouch together. Allow the pouch to dry. Attach the snap (or sew on Velcro) to secure the flap.

4. Adhere star to pouch

Set a stud in the center of the star with the stud-setting tool. Use fabric glue to adhere the star over the snap on the front of the flap.

5. Attach chain to pouch

Sew a soldered jump ring just inside of the flap on each side of the pouch. Attach regular jump rings to the ends of the crystal chain with pliers. Attach each jump ring to the sewn-on jump rings with pliers to secure the chain.

true craft
c o n f e s s i o n s

I had to redo the studs several times to get the placement right…the first three attempts were really bad. It's always better to try to fix your mistakes before you fling the project across the room and yell a naughty word. But sometimes the flinging and the yelling of the naughty word feel pretty darn good!

"You should be labeled with a skull and crossbones. You're a jinx to my soul."

—Sparkle Moore, in "Skull and Crossbones"

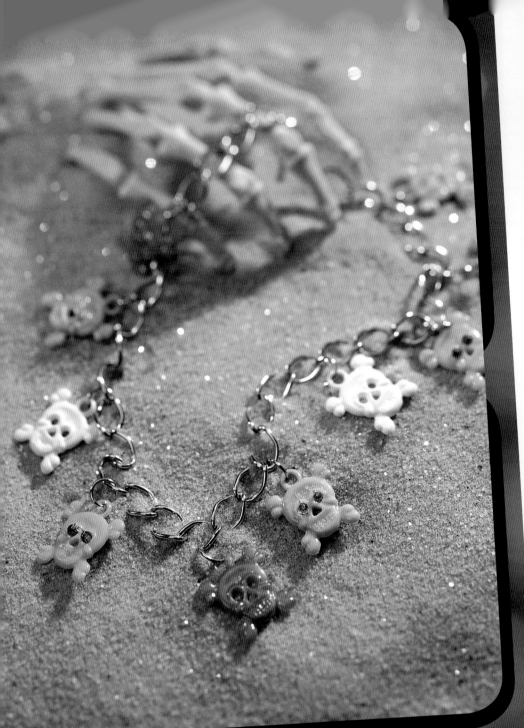

WHAT YOU WILL NEED

SPARKLIES, ETC.

NECKLACE

thirteen plastic skull bubblegum charms (three orange, two white, three blue, three yellow)

twelve 5mm crystal copper Swarovski rounds

twelve 5mm jonquil Swarovski rounds

thirteen 10mm heavy-duty silver-plated jump rings

one large silver-plated toggle clasp

33-link section extra large imitation rhodium-plated chain

thirteen 1" (3cm) sterling silver 22-gauge head pins

EARRINGS

two orange plastic skull bubblegum charms

two 5mm jonquil Swarovski rounds

two 10mm heavy-duty silver-plated jump rings

two sterling u-hook ear wires

UTILITIES

round-nose pliers

chain-nose pliers (two pairs, optional)

flush cutters

Walk the Plank Necklace

Hi diddly dee, a pirate's life for me. Can you sense a thread of continuity in the pirate theme here? Why settle for the life of a lusty wench when you can sail the seven seas in search of adventure, while wearing this happy little pirate necklace to boot? All you need is a sparkly eye patch and a jaunty tri-corner hat and you'll be ready to rock the boat. Arrrrgh.

P.S.: I chose these colors to match a very '70s looking Marcia Brady top, but you can switch them up to suit your wardrobe…because you are cool like that!

SUPPLIES: PLASTIC SKULL BUBBLEGUM CHARMS FROM SACRED KITSCH STUDIO; CRYSTAL BEADS BY SWAROVSKI; CHAIN AND JUMP RINGS FROM RINGS & THINGS; STERLING HEAD PINS FROM MARVIN SCHWAB/THE BEAD WAREHOUSE; TOGGLE CLASP BY BEADALON

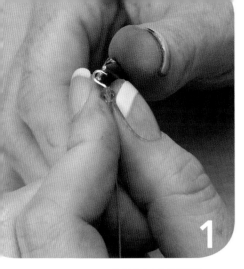

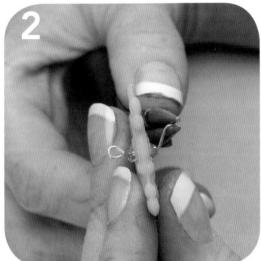

1. Begin sparkly skull eyes

Remove a section of chain using pliers. The chain is thick, so it takes a little effort, and the work is easier with two pair of chain-nose pliers. Attach the toggle components to the ends of the chain using pliers. Set chain aside.

Thread a crystal on a head pin. Slide it down, then cut off the end of pin and create a loop in the wire using round-nose pliers (see Bead Basics, page 13).

2. Finish sparkly skull eyes

Thread a beaded and looped pin through an eye socket in a skull and add a second crystal. Bend the wire flush to the top of the second bead and cut to approximately ⅛" (.3mm). Turn the end of the wire into a loop witih round-nose pliers.

Continue beading skull eyes as follows: two blue skulls with jonquil crystal eyes and three yellow skulls with crystal copper eyes.

3. Attach skulls

Link each skull to the chain with a large jump ring in the following sequence, beginning at the circle end of the toggle: yellow, orange, blue, white. End with a blue skull. Note: Every other skull should be embellished with crystal eyes, as shown here.

true craft
c o n f e s s i o n s

I made this necklace for a personal appearance, but it was so adorable I had to modify it for the book. It took me a while to figure out how to make the eye sockets sparkly, but I persevered and came up with this idea. Where there's a will, there's a way (and as my wise Aunt Shane says…a train every day).

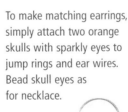

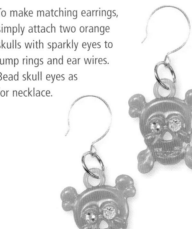

try this

Walk the Plank Earrings
Make a seaworthy pair of matching earrings for full-on pirate glamour.

To make matching earrings, simply attach two orange skulls with sparkly eyes to jump rings and ear wires. Bead skull eyes as for necklace.

WHAT YOU WILL NEED

SPARKLIES, ETC.

NECKLACE

five pewter token of love charms

three pewter winged heart charms

fifteen 11mm x 5.5mm crystal
AB Swarovski briolettes

seven 11mm x 5.5mm jet Swarovski briolettes

thirty-seven 3mm silver-tone jump rings

one 78-link segment, two 29-link
segments, one 25-link segment
silver-plated elongated cable chain

one 33-link section of silver-plated medium
curb chain

one small silver-plated swivel lobster clasp

EARRINGS

two pewter winged heart charms

two 1mm x 5.5mm crystal
AB Swarovski briolettes

two 11mm x 5.5mm jet Swarovski briolettes

six 3mm silver-tone jump rings

two 11-link sections of silver-plated
elongated cable chain

two ball French hook earwires

UTILITIES

chain-nose pliers (two pair optional)

round-nose pliers

bead mat

Hearts in Chains Necklace

Chains get their sparkle on in this tender and tough design for
formal rock star events, red carpet appearances…and when you
want to feel both badass and beautiful. Rock on, gorgeous.

SUPPLIES: WINGED
HEART CHARMS
BY SACRED KITSCH
STUDIO; TOKEN OF
LOVE CHARMS BY
ARTCHIX STUDIO;
CRYSTAL BRIOLETTES
BY SWAROVSKI; CHAIN
AND FINDINGS BY
BEADALON

1

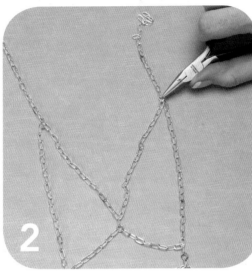

3

true craft

c o n f e s s i o n s

I had to rework this design several times to get the chains just right. I also had to try it on to see how it looked on a person. That's one of those "oh, yeah!" things. Try stuff on to be sure it works. Then if it doesn't, rework it until it does. It isn't all fun and games!

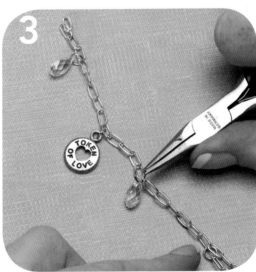

2

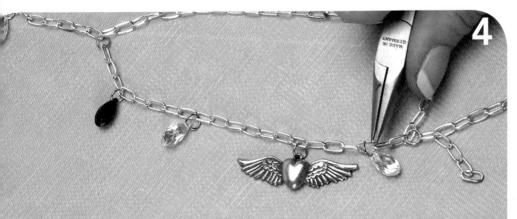

4

1. Lay out chains and jump rings
Separate chain segments by opening and closing chain links with pliers (see Bead Basics, page 15). Fold the 78-link segment in half and lay it on your work surface. This chain segment will be the core necklace. Arrange the remaining segments around the core chain as follows: 29-link segment at the 21st link from each end of core chain to the middle link on the core chain to create two swags; count in five links at each end on the 25-link segment and position those segments to link to the ninth link from the center on each of the 29-link swags. Position a jump ring at each point where the chain segments will connect.

2. Link chain segments
Use chain-nose and round-nose pliers to open each jump ring, then slide the appropriate links in the chain segments onto the jump rings. Close the jump rings with the pliers.

3. Link charms and beads to first chain segment
Slide all briolettes and charms onto jump rings. Beginning at the left top of the core chain, attach beads and charms as follows: crystal AB briolette at fourth link; token of love six links down from the briolette; crystal briolette four links down from the token of love.

4. Link dangles to first swag segment
Continue to link beads and charms to the necklace, this time on the swag on the left: jet briolette, crystal briolette, winged heart charm, crystal briolette. You may link the beads and charms exactly as shown here, or space them as you wish. Link a jet briolette to each end of the 25-link swag.

121

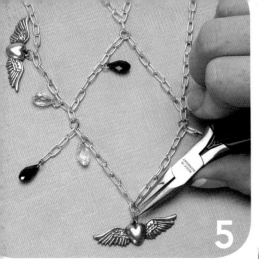

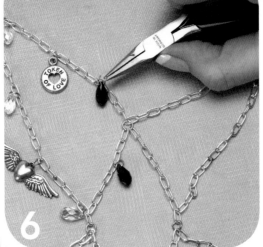

5. Link winged heart charm to center point of necklace

At the very center point of the necklace, link a winged heart charm to the chain with a jump ring.

6. Link dangles to inner swag

Continue to link dangles to the remaining chain segments of the necklace. Refer to the image shown here if you'd like to replicate the necklace exactly as shown, or place beads and charms however you wish.

7. Add dangle at clasp

Attach a lobster clasp to the right end of the necklace with a jump ring. Attach the 33-link extension chain to the remaining end of the necklace with a jump ring. To finish the necklace, add a token charm, a jet briolette and a crystal AB briolette to the bottom of the extension chain.

SPARKLY TIP:
rock and roll superstars

Some of the greatest rock and roll women you may never have heard of include: Patti Smith, Joan Armatrading, Debbie Harry, Big Mama Thornton, Heart, Annie Lennox, Nina Hagen, Siouxsie Sioux, Lene Lovich, Wendy O. Williams, the Go-Go's, Stevie Nicks, Mama Cass, Tina Turner, Janis Martin, Wanda Jackson, Sister Rosetta Tharpe (perhaps the first rock and roll singer), Grace Slick, Chrissie Hynde, Laurie Anderson and on and on the list goes. Check out these ladies if you need a little inspiration, or just something to listen to when you craft.

try this

Hearts in Chains Earrings

These luscious linear earrings complete your red carpet rock star look.

Attach a jet briolette to one end of one 11-link chain section with a jump ring. Attach a winged heart to the other end with a jump ring. Add a crystal AB briolette on a jump ring to the sixth chain link from the winged heart. Attach the chain to a French wire at the eighth link from the winged heart. Dangle the excess chain to opposite sides on each earring to make a right and a left.

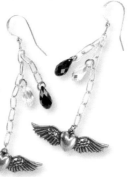

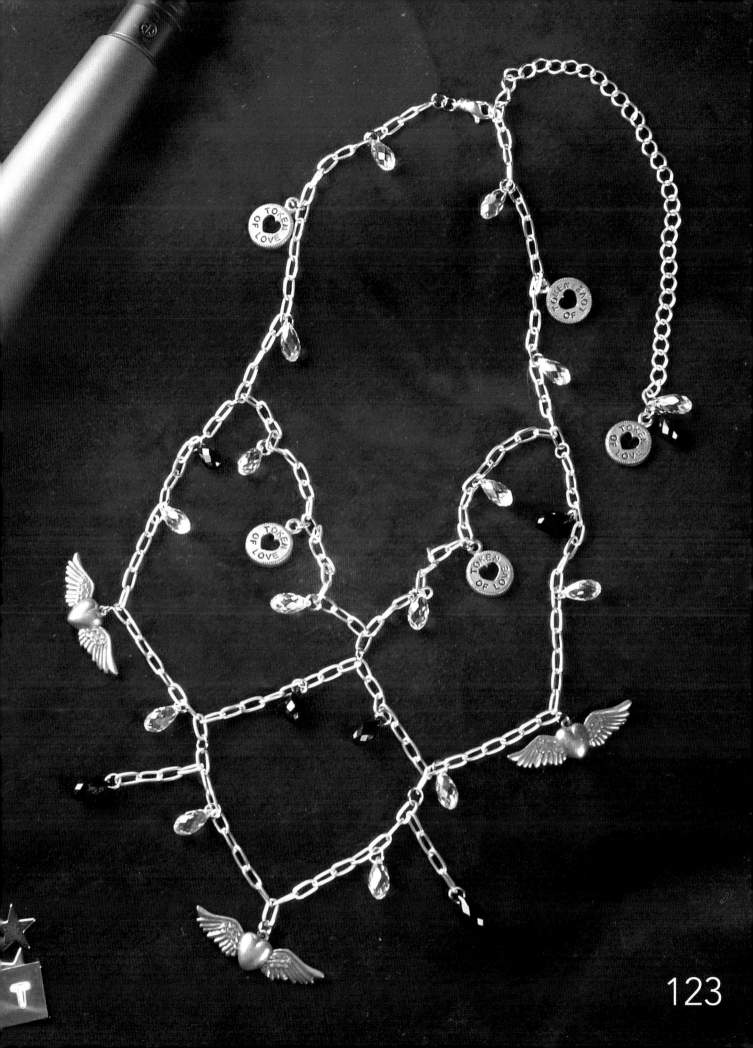

RESOURCES

*M*ost of the supplies used to make the projects in this book can be found in your local craft, hobby, bead or discount department stores. If you have trouble locating a specific product, contact one of the supply sources listed here to find a local or Internet vendor, or to request a catalog. Several of these suppliers generously provided product for this book.

AMACO
www.amaco.com
800.374.1600

ANITA'S STAMPS
www.docrafts.co.uk

AROUND THE BLOCK PRODUCTS
www.aroundtheblockproducts.com
801.593.1946

ARTchix STUDIO
www.artchixstudio.com
250.370.9985

BEADALON
www.beadalon.com
866.4BEADALON

BEDAZZLER™
www.mybedazzler.com
800.716.6743 (orders)

BERNAT
www.bernat.com
888.368.8401

BERWICK OFFRAY
www.berwickindustries.com
800.327.0350

BOND ADHESIVES
973.824.8100

CPE, THE FELT COMPANY
www.cpe-felt.com
800.327.0059

CRAFTER'S SQUARE
Greenbrier International Inc.
500 Volvo Parkway
Chesapeake, VA 23320

CREATIVE HANDS
www.creativehands.com

CREATIVE IMAGINATIONS
www.creativeimaginations.us

COATS AND CLARK
www.coatsandclark.com
800.648.1479

DARICE
www.darice.com
866.4Darice

DECOART
www.decoart.com
800.367.3047

EARTHENWOOD STUDIO
www.earthenwoodstudio.com
248.548.4793

EASTERN FINDINGS, INC.
www.easternfindings.com
800.332.6640

EURO TOOL, INC.
www.eurotool.com
800.552.3131

FIRE MOUNTAIN GEMS AND BEADS
www.firemountaingems.com
800.355.2137

GLOBAL CURIOSITY INC.
www.rucurio.com
877.495.3872

HEIDI SWAPP
www.heidiswapp.com
904.482.0092

HENKEL
www.henkel.com

I KAN DEE/PEBBLES INC.
www.pebblesinc.com
801.235.1520

INKADINKADO/ DIMENSIONS
www.inkadinkado.com
800.523.8452

J AND O FABRICS
www.jandofabrics.com
856.663.2121

JERZEES INTERNATIONAL

www.jerzees.com
800.321.1138

JEWELRYSUPPLY.COM

www.jewelrysupply.com
916.780.9610

JHB INTERNATIONAL

www.buttons.com
303.751.8100

JUNE TAILOR

www.junetailor.com
800.844.5400

KAREN FOSTER DESIGN

www.karenfosterdesign.com
801.451.9779

LARA'S CRAFTS

www.larascrafts.com
817.581.5210

MAKING MEMORIES

www.makingmemories.com
801.294.0430

MARVIN SCHWAB/ THE BEAD WAREHOUSE

www.thebeadwarehouse.com
301.565.0487

NATURAL SCIENCE INDUSTRIES

www.iqkids.net
877.2IQ.KIDS

NICOLE CRAFTS

www.nicolecrafts.com

PLAID ENTERPRISES, INC.

www.plaidonline.com
800.842.4197

PROVO CRAFT

www.provocraft.com
800.937.7686

PRYM DRITZ

www.dritz.com

PURE ALLURE, INC.

www.pureallure.com
800.536.6312

RINGS & THINGS

www.rings-things.com
800.366.2156

RUBBER SOUL

www.rubbersoul.com
360.779.7757

SACRED KITSCH STUDIO

www.sacredkitschstudio.com
516.781.0024

SHRINKY DINKS/K & B INNOVATIONS

www.shrinkydinks.com
800.445.7448

STEMMA/ MASTERPIECE STUDIOS

www.masterpiecestudios.com

STREAMLINE/BLUMENTHAL LANSING COMPANY

www.buttonsplus.com
563.538.4211

SWAROVSKI

www.create-your-style.com
800.463.0849

TOTALLY YOU! TOTE BAGS/LOEW-CORNELL

www.loew-cornell.com
201.836.7070

TULIP/DUNCAN CRAFTS

www.duncancrafts.com
800.438.6226

WALNUT HOLLOW

www.walnuthollow.com
800.950.5101

WESTRIM CRAFTS

www.westrimcrafts.com
800.727.2727

YORK NOVELTY IMPORT INC.

www.yorkbeads.com
800.223.6676

PATTERNS

All templates are shown here at full size.

DONNY VS. BOBBY WOODEN PURSE, PG. 102

GIT ALONG L'IL CELL PHONE POUCH, PG. 34

SKULL + CROSSBONES IPOD CASE, PG. 116

2 CUTE 4 WORDS CELL PHONE POUCH, PG. 86

Check out these other fabulous
jewelry and crafting titles from North Light Books.

The Impatient Beader
BY MARGOT POTTER

If you're creative but lack time, focus or motivation, *The Impatient Beader* is the book for you. Author Margot Potter guides you through over 50 sassy jewelry projects, from the sweet to the outright sizzling. You can finish each of the projects in just a few easy steps, and a skill level guide lets you know what you're getting into before you get going. An easy-to-follow techniques section shows you everything you need to get your bead on, and cartoon Margot pops up every few pages to give you tips on how to become a beading goddess.

ISBN-13: 978-1-58180-762-2
ISBN-10: 1-58180-762-7
PAPERBACK, 128 PAGES, 33431

The Impatient Beader Gets Inspired
BY MARGOT POTTER

Don't be afraid—get out there and find your inner art girl. You have terrific jewelry designs in your head just itching to get out. In a follow-up to her first beading book, jewelry designer Margot Potter gives you 40 sassy step-by-step jewelry projects plus the know-how you need to springboard off of her designs and create your own customized pieces. You'll also get regular visits from cartoon Margot, in outfits that match the theme of each chapter. Watch out for the item that inspired each piece—and don't be surprised if you get some ideas of your own.

ISBN-13: 978-1-58180-854-4
ISBN-10: 1-58180-854-2
PAPERBACK, 128 PAGES, Z0109

Pretty Little Things
BY SALLY JEAN ALEXANDER

Learn how to use vintage ephemera, found objects, old photographs and scavenged text to make playful pretty little things, including charms, vials, miniature shrines, reliquary boxes and much more. Sally Jean's easy and accessible soldering techniques for capturing collages within glass make for whimsical projects, and her all-around magical style makes this charming book a crafter's fairytale.

ISBN-13: 978-1-58180-842-1
ISBN-10: 1-58180-842-9
PAPERBACK, 128 PAGES, Z0012

These titles and other fine North Light Books are available at your local craft retailer, bookstore or from online suppliers.